INTERNATIONAL ARTS AND CRAFTS

Publisher and Creative Director: Nick Wells
Development: Sara Robson
Picture Research: Sara Robson, Melinda Revesz
Project Editor: Polly Willis
Editor: Sarah Goulding
Designer: Mike Spender

Special thanks to: Chris Herbert, Kelly Johnson, Geoffrey Meadon, Helen Tovey, Claire Walker

FLAME TREE PUBLISHING
Crabtree Hall, Crabtree Lane
Fulham, London, SW6 6TY
United Kingdom

www.flametreepublishing.com

First published 2005

05 07 09 08 06

3 5 7 9 10 8 6 4 2

Flame Tree is part of the Foundry Creative Media Company Limited

The CIP record for this book is available from the British Library.

ISBN 1 84451 262 2

Every effort has been made to contact copyright holders. We apologize in advance for any omissions
and would be pleased to insert the appropriate acknowledgements in subsequent editions of this publication.

While every endeavour has been made to ensure the accuracy of the reproduction of the images in this book,
we would be grateful to receive any comments or suggestions for inclusion in future reprints.

Printed in China

INTERNATIONAL ARTS & CRAFTS

Author: Michael Robinson Foreword: David Rudd

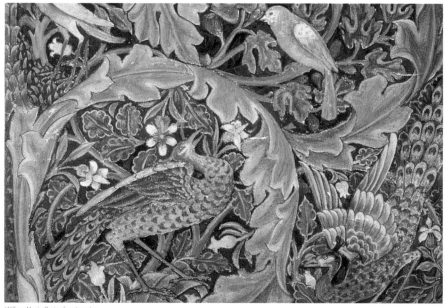

William Morris, Design for a tapestry

**FLAME TREE
PUBLISHING**

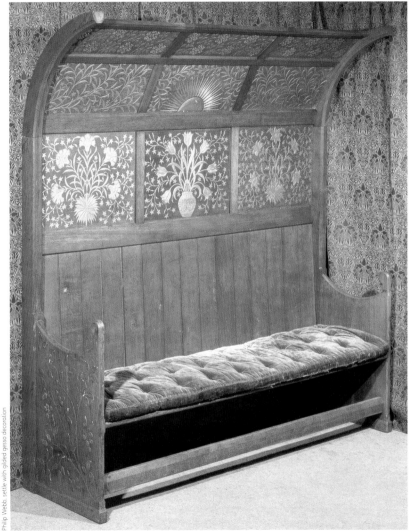

Philip Webb: settle with gilded gesso decoration

Contents

William Morris, *Trellis* design for wallpaper; William de Morgan, two-handled vase; Josef Hoffman, armchair

William Morris, pelmet for St James's Palace; William Morris, *Minstrel Angel with Cymbals*, stained glass; Charles Ashbee, inkwell with seven-sided floral design

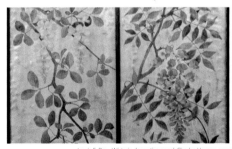
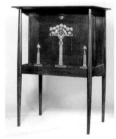
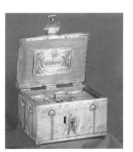

May Morris, Christening mittens; Gustav Stickley, interior of a Craftsman House; William Moorcroft, *Landscape* vase

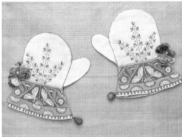
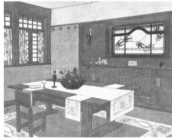
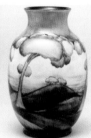

Lewis F. Day, *Wisteria* decorative panel; Charles Voysey, green-stained oak writing cabinet; Charles Rennie Mackintosh, jewel box

John Dearle, *Trail* furnishing fabric; William de Morgan, vase; Alexander Fisher, *The Peacock Sconce*

How To Use This Book

The reader is encouraged to use this book in a variety of ways, each of which caters for a range of interests, knowledge and uses.

- The book is organized into five sections: **Movement Overview**, **Society**, **Places**, **Influences** and **Techniques**.
- **Movement Overview** broadly covers the international Arts and Crafts phenomenon, providing a snapshot of the people involved and the origins of the movement.
- **Society** shows how the wider world in which the artists of this period lived had a bearing on their work, and explores their different interpretations of it.
- **Places** looks at the different geographical locations in which Arts and Crafts artists lived and worked, and how their feeling about a place is represented in their work.
- **Influences** reveals who and what provided the greatest influence in the Arts and Craft movement, and how they in turn were a source of inspiration and ideas for one another.
- **Techniques** delves into the different techniques and mediums used during this time.
- The text provides the reader with a brief background to the work, and gives greater insight into how and why it was created.

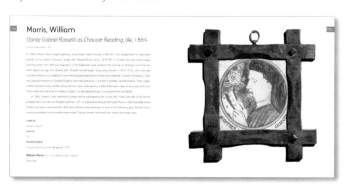

2. Name of artist, by surname then forename

1. Title of work

3. Date of work (if known)

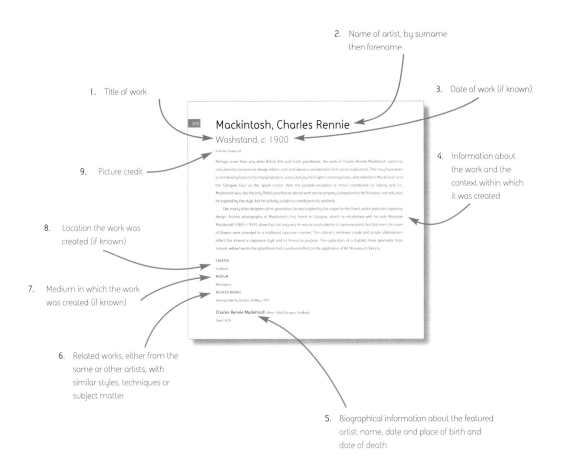

4. Information about the work and the context within which it was created

9. Picture credit

8. Location the work was created (if known)

7. Medium in which the work was created (if known)

6. Related works, either from the same or other artists, with similar styles, techniques or subject matter

5. Biographical information about the featured artist: name, date and place of birth and date of death

300

Mackintosh, Charles Rennie

Washstand, c. 1900

© Charlie's Images Ltd

Perhaps more than any other British Arts and Crafts practitioner, the work of Charles Rennie Mackintosh seems to articulate the concerns for design reform, over and above a consideration of its social implications. This may have been a contributing factor to his marginalization, particularly by his English contemporaries, who referred to Mackintosh and the 'Glasgow Four' as the 'spook school'. With the possible exception of Knox's contribution to Liberty and Co., Mackintosh was also the only British practitioner whose work can be properly categorized as Art Nouveau: not only was he inspired by the style, but he actively sought to contribute to its aesthetic.

Like many other designers of his generation, he was inspired by the vogue for the Orient, and in particular Japanese design. Archive photographs of Mackintosh's first home in Glasgow, which he refurbished with his wife Margaret Macdonald (1865–1933), show that not only was he an avid collector of Japanese prints, but that even the vases of flowers were arranged in a traditional Japanese manner. This cabinet's rectilinear mode and simple utilitarianism reflect this interest in Japanese style and its fitness for purpose. The application of a stylized, more geometric, than natural, willow tree for the splashback had a profound effect on the application of Art Nouveau in Vienna.

CREATED

Scotland

MEDIUM

Mahogany

RELATED WORKS

Serving table by Gustav Stickling, 1901

Charles Rennie Mackintosh *Born 1868 Glasgow, Scotland*

Died 1928

Foreword

The Arts and Crafts movement has been a life-long passion for many of us. The excitement created by another reference book on the subject can only be comprehended by those who have dedicated their professional and/or personal life to the quest for more information. Understanding what was actually happening during the last half of the nineteenth century, and moving into the modern movement of the twentieth century, is important to fully appreciate the wonderful objects produced both at home and internationally.

The period of time during which the Arts and Crafts movement was defining itself was one of exploration for individuals who had the foresight and understanding to know what the industrial movement was doing to society. They were on the leading edge of a society that was quickening its tempo and attempting to fulfil the enormous needs of an expanding population. This pace needed adjustment and it was a few great British scholars who recognized this.

At the onset of the Arts and Crafts period, some reformers felt it necessary to step back a century or more to a time when everything one lived with was made or decorated by hand. Others embraced the new period of industrialization and worked with it. Neither were right or wrong. This was a period of exploration, a time in which people were trying to identify who they were. In this book you will discover who these individuals were, and understand more about their attitudes towards this defining era.

I often believe there is a parallel between the turn of the twentieth century and the turn of the twenty-first. At the turn of the last century, the population was coping with the Industrial Revolution, and today we are in the midst of a technical one. As a dealer in historic objects I find myself sitting for hours in front of the computer, referring to my palm pilot or text messaging on my mobile phone. When my day is done I go home, turn on my Dirk van Erp lamp, sit in my Gustav Stickley Morris chair and relax. Was the original purpose of the Arts and Crafts movement much different from its effect today?

International Arts and Crafts will be a valuable asset to the ongoing research needed to understand the Arts and Crafts movement more fully – how it began and evolved. Michael Robinson explores the negative impact of the decorative arts displayed at the Great Exhibition of 1851 held at the Crystal Palace in London. He then moves through

the last half of the nineteenth century and into the early twentieth century, discussing and illustrating the relationships that moulded this important period of the decorative arts. Knowing and understanding the impact the Orient had on Britain, together with the impression made by the British on the American Arts and Crafts, French Art Nouveau and the Austrian *Wiener Werkstätte* movements, among others, is essential and fascinating. This is explored using a variety of examples that illustrate these influences.

It has long been documented that the relationships that the Arts and Crafts designers and artists had with one another were of great importance, as was the impact that their work had on one another. This book reiterates that fact, highlighting the dynamics of personality that were at work during this period.

Having been a dealer and a student of this period for nearly a quarter of a century, I find it exhilarating to see this latest research in the development of this period. From the early work written by John Crosby Freeman in the mid-1960s through to David Cathers' book on Gustav Stickley published in 2003, there have been a huge variety of books published on the Arts and Crafts movement. The role that Japan played in this international style has been recognized for many years; today, with the help of authors and scholars like Michael Robinson, we can fully understand what this role meant and how it evolved.

This book's simple layout and beautiful illustrations make it a joy to read, and a delight for those who have only just discovered this most fascinating of design movements. Sit back and enjoy!

David Rudd, *2005*

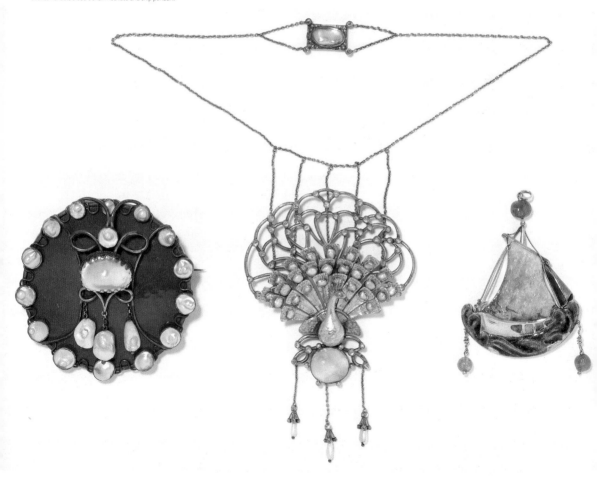

Charles Ashbee, brooch, chain necklace and ship pendant

Introduction

The term 'Arts and Crafts movement' usually posits it as a British phenomenon, with William Morris as its main protagonist. While not detracting from Morris's importance as a pioneer of design reform and the fact that he was a central figure to the early ethos of the Arts and Crafts movement, it invariably marginalizes other equally significant reformers, both in Britain and elsewhere. One such early Arts and Crafts reformer was Arthur Heygate Mackmurdo, who outlived Morris by nearly half a century. By the time of his death in 1942, he had witnessed the sweeping changes in design reform, from his studies of Gothic in the office of James Brooks in 1873, through the excesses of Continental Art Nouveau, to the conservative Modernism of Gordon Russell, who, although using mechanized production, still retained the community spirit and design aesthetics of the Arts and Crafts movement during the 1920s and 1930s. Mackmurdo had also witnessed, and been an integral part of, the adoption of the Arts and Crafts design reforming ideals by his American and Continental counterparts, making the Arts and Crafts movement an international phenomenon by the 1890s.

Significantly, Mackmurdo was born in 1851, the year of the Great Exhibition at the Crystal Palace in London. This was telling because it was this exhibition that showed the very worst excesses of Industrial Revolution design, with its over-ornamentation and, in many people's view, poor taste. Rightly or wrongly, ultimately it was the machine that was blamed for this decline in standards. Richard Redgrave, a design reformer at the official School of Design in London, remarked, "wherever ornament is wholly affected by machinery, it is certainly the most degraded in style and execution". However, he stopped short of outright condemnation of the use of machines, stating that "the best tastes are to be found in those manufacturers and fabrics wherein handicraft is entirely or partially the means of producing the ornament". The social reformer John Ruskin, on the other hand, felt that Redgrave had not gone far enough. Drawing on some, but not all of A. W. N. Pugin's ideas of design reform, Ruskin proposed a return to handcrafted workmanship as a way of dealing with declining standards, both in design and society as a whole. For Ruskin, the two were inextricably linked, and he abhorred the machine and its resultant division of labour, which he regarded as debasing factors in a 'sick' society.

Unlike Pugin, Ruskin did not want a return to a medieval society, which he saw as feudal and inappropriate for a modern Victorian Britain. Instead, he sought moral regeneration, advocating a simple life that sought out nature for

inspiration and repose, its apogee being the craftsman who enjoyed his work. Like Pugin, he saw Gothic as the only architecture and style suitable for Britain as an expression of its national identity.

The question of national identity was a preoccupation for much of the Western world in the last quarter of the nineteenth century. The Great Exhibition of 1851, as a forum of commercial trading power, was taken up in Europe and in America to further similar aspirations. British Arts and Crafts were first seen abroad at the 1876 Philadelphia Exhibition in America, and again at the 1878 exhibition in Paris through the work of Walter Crane and Lewis Day. Both the Americans and the Europeans saw this as an opportunity for design reform, based on the British model of seeking a national identity through its architecture and design.

By the late 1890s, and with Britain in full Arts and Crafts mode, the Americans and the Europeans had adopted different approaches to their specific design-reform problems. Western Europeans indulged in a curvilinear and organic approach to design, appealing mainly to the upper-middle classes, a style that became known as Art Nouveau, after the retail Parisian store that sold many of the stylized products. Many design historians have noted the precedent set for this style in the work of British Arts and Crafts practitioners, particularly Mackmurdo. After initially adopting these motifs, the Germanic centres of Dresden, Munich and later Vienna adopted a more rectilinear and geometric form, with a strong element of the Arts and Crafts aesthetic in their designs prior to 1910. Darmstadt and the Austrian *Wiener Werkstätte* were the apotheosis of this period, Darmstadt being a newly formed artistic colony near Munich that commissioned many of the most talented young European designers of the time, including Peter Behrens. These designs were, like their Parisian counterparts, intended for the haute-bourgeoisie. After 1910, design reform in much of Europe was leaning towards a Modernist aesthetic, initiated in one way or another by Behrens, and later at the Bauhaus with Walter Gropius. Here lay the beginnings of industrial design for mass consumption.

In the USA, the Arts and Crafts movement adopted a somewhat different approach during the 1880s and 1890s. As a nation with a larger middle class than Western Europe, design reformers in America sought to make design more democratic, affordable by many instead of an elite. These ideas had much in common with Britain through the writings of Ruskin and Morris, a social consideration not considered by their Continental counterparts. Britain and America realized the paradox of the Arts and Crafts movement and in their own ways attempted to resolve the issue: how could the craftsman make a reasonable living from his labour-intensive efforts, while at the same time making his product available and affordable to the widest possible market?

Unlike Britain, the American Arts and Crafts practitioners were unequivocal about the use of the machine, seeing it not as detrimental to the craftsman, but merely as another tool to be used. Frank Lloyd Wright adopted this principle, although most of his work was for upper-middle class so-called 'Prairie Homes'. He did, nevertheless, create a number of designs for standardized suburban housing and, perhaps more importantly, introduced design reform into the office environment, to create a more 'homely' atmosphere in the work place. One of the most successful of the American democratizing designers was Gustav Stickley who, like Wright, advocated the use of machinery and, as he did so, adopted a 'truth to materials' ethos; a central tenet of the Arts and Crafts movement. Stickley's 'Craftsman' furniture fulfilled the necessary requirements of the Arts and Crafts aesthetic, its rusticity being redolent of the pioneering spirit of the US, a key theme in the American search for its own cultural identity at this time.

Many of the ideals of the Arts and Crafts movement were made international with the help of specifically design-orientated journals. At the forefront was the British journal *The Studio* that began publication in 1893 and was read on the Continent and in the US. It also carried articles on some of the designs being created overseas for its home audience. Similarly, there were other journals in the US, such as *Home Beautiful* and *The Craftsman*, and on the Continent, such as *Kunst und Kunsthandwerk* and *Kunst und Handwerken*, that disseminated Arts and Crafts information and sometimes techniques. These journals were also a source of inspiration to the homemaker.

Archibald Knox belt buckle

By the time Mackmurdo had begun his design career in the 1880s, the Gothic Revival in Britain was seen as applicable only to church architecture, with domestic architecture and interiors becoming more vernacular. In many ways the die had already been cast with Philip Webb's design for William Morris's first home, Red House, in 1860. In subsequent years the Arts and Crafts aesthetic became lighter, with the assimilation of new influences, Richard Norman Shaw's introduction of the 'Queen Anne' style and the simpler, more geometric, forms of the Japanese-inspired Aesthetic movement. The British

Arts and Crafts practitioners were more organized by the mid-1880s with the formation of the Art Workers' Guild. More significantly, during this period the socialist ideals of the Arts and Crafts movement began to share centre stage with the aesthetic. Morris became more interested in socialism than in designing and Charles Ashbee formed his profit-sharing Guild of Handicraft, first in London and then at Chipping Camden in the Cotswolds, and actually lived the Ruskin-Morris dream.

Although the Arts and Crafts movement began in Britain and its ideals were disseminated to Continental Europe and America, its practices were not confined to these regions. Eastern Europe and Scandinavia both enjoyed a renaissance of 'folk craft', as did Japan. Unlike its forerunner, the Gothic Revival, the Arts and Crafts aesthetic was not governed by a set of rules and did not even consist of one particular recognizable style. It was in every sense an eclectic

John Dearle, portière tapestry

mix. Its influences varied, often according to region — some historical, as with Morris and Archibald Knox, and some specifically ahistorical, as with Josef Hoffman. Furthermore, it meant different things to different practitioners. To Mackay Hugh Baillie-Scott it represented homeliness; to Lindsay Butterfield it was about simplifying forms for a burgeoning industrial design market. For Charles Voysey it had spiritual and symbolic significance; while to Frank Lloyd Wright it was about national identity.

This book explores the complexities of the international Arts and Crafts movement through its practitioners and some of the artefacts they designed. Set within the framework of their respective social and cultural milieus, it provides an account of the seminal moment in the evolution of international design reform.

International Arts and Crafts

Movement Overview

Pugin, A. W. N
Curtain design, 1851

For Augustus Welby Northmore Pugin, Arts and Crafts was not a style but a principle, as advocated in his 1843 tract *An Apology for the Revival of Christian Architecture in England*. Pugin was the earliest exponent of a return to medieval design and craftsmanship that manifested the 'truth to materials' ethos and a celebration of the work of the craftsman, which for him was God-given. These principles were enshrined in his dogmatic and polemical approach to architecture and design. Earlier he had eschewed the designs he had made for Windsor Castle as a precocious teenager in his father's architectural practice. For him they were not authentic Gothic, but a pastiche, an eclectic mix of eighteenth-century 'gothick', used by architects for their more eccentric clients.

Pugin was among the first architects to value the use of fabric, but strongly believed that secular and religious fabrics should be different. In all his designs for textiles he advocated a flat motif devoid of illusion and excessive ornament. His designs were often simple and geometric, usually using only two or three complementary colours. The textiles were sometimes woven or, as here, printed. This design was probably exhibited in the Medieval Court at the 1851 Great Exhibition.

CREATED
Lancashire, England

MEDIUM
Block-printed glazed cotton

RELATED WORKS
Visual Aid by Ralph Wornum, 1848

A. W. N. Pugin *Born* 1812 London, England
Died 1852

Ruskin, John

Drawing, Byzantine Columns, Illustration for *The Stones of Venice*, 1853

Although not a designer or craftsman himself, the influence of John Ruskin on the aesthetic taste of the Victorian period is immeasurable. He was essentially a social reformer who believed that the machine was de-humanizing, and advocated a return to a craftsman-based society. Ruskin was a consummate draughtsman who slavishly portrayed the architectural details of his beloved Venice, in an attempt to enlighten and influence the architects and designers of his time. In his book *The Seven Lamps of Architecture*, published in 1848, Ruskin asked the question concerning all ornament: 'Was it done with enjoyment – was the carver happy while he was about it?'. He believed that the craftsmen of the Middle Ages enjoyed a freedom from the conventions of subsequent generations adhering to the Classical revivals, which he abhorred. In his famous essay 'The Nature of Gothic', which appeared as a chapter in *Stones of Venice* in 1853, Ruskin advocated the freedom afforded by Gothic, likening its variety to nature, stating 'We must no more expect to derive pleasure from an architecture whose ornaments are of one pattern, and whose pillars are of one proportion, than we should out of a universe in which the clouds were all of one shape, and the trees all of one size'.

CREATED

Venice

MEDIUM

Pencil and watercolour

RELATED WORKS

Column capitals at Trinity College Museum, Dublin, 1852–57, by Benjamin Woodward

John Ruskin *Born* 1819 London, England

Died 1900

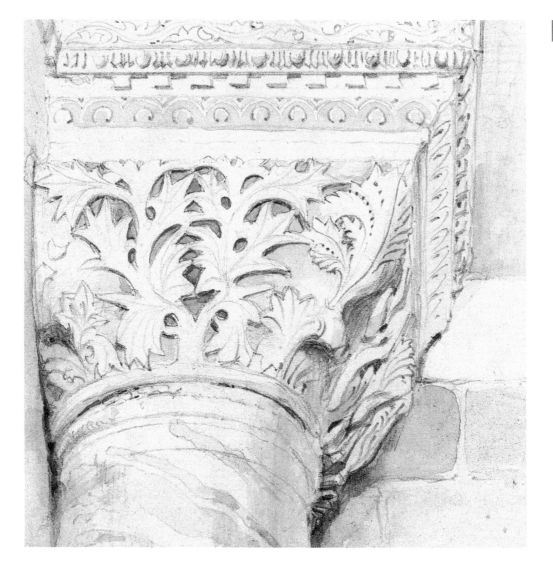

Webb, Philip

The Prioress's Tale, decorated wardrobe, 1859

This large wardrobe would have dominated William and Janey Morris's bedroom at Red House. It was designed by Philip Webb, the architect of the house and designer of many of its interior furnishings, which were lavishly decorated by the Pre-Raphaelite painter Edward Burne-Jones (1833–98). It was given to the couple as a wedding gift in 1859. William Morris (1834–96) had struck up friendships with Burne-Jones, while they were students at Cambridge, and with Webb, during their employment at the architectural practice of G. E. Street. The wardrobe is an example of the collaborative spirit that Morris wanted to engender among his friends, exemplified so well early on in his career at Red House.

The painting on the left-hand door depicts a scene from Geoffrey Chaucer's *The Prioress's Tale*, and reflects the interest in medievalism current at that time. It relates the story of the Virgin Mary resurrecting a murdered boy, allowing him once again to sing his beloved *Alma Redemptoris*. The model for the Virgin was Janey herself, who became a muse for other Pre-Raphaelite painters. The right-hand door again portrays the Virgin, and also has a portrait of Chaucer himself. The wardrobe was removed from Red House and presented to the Ashmolean Museum by Morris's daughter, May (1862–1938), in 1939.

CREATED

Bexleyheath, Kent

MEDIUM

Oil paint on wooden panel

RELATED WORKS

Oak cabinet by J. P. Seddon, 1862

Philip Webb *Born* 1831 Oxford, England

Died 1915

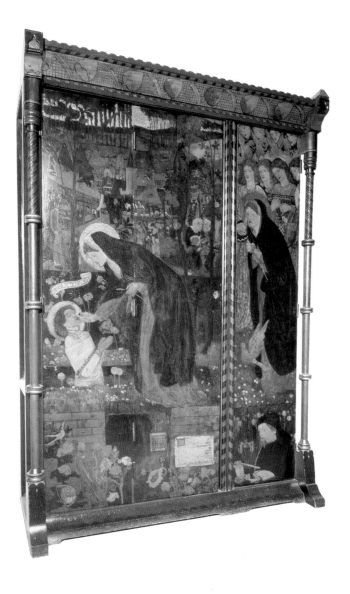

Morris, William

Trellis design for wallpaper, 1862

In this design, one gets a real sense of the spirit of collaboration among designers of the Arts and Crafts movement. This was the first of Morris's designs for wall coverings, with the birds actually drawn by Philip Webb. The design was inspired by the natural and rhythmical intertwining of roses through a trellis that Morris observed in the garden of his own Red House; a reaction to the chintzy and artificial designs of floral motifs used in contemporary machine-printed wallpapers. After the Great Exhibition, a number of designers sought a return to a flatter design that did not allude to perspective or realism. Among them was Owen Jones (1809–74), whose *The Grammar of Ornament*, published in 1856, was so influential in advocating a more formalist approach to design, utilizing conventional geometric patterns. The design, hand-printed from wooden blocks, enabled Morris to use slower drying and richer-coloured inks.

Philip Webb used the wallpaper when he created a new house for his client James Beale at Standen in West Sussex, using many of the British Arts and Crafts designers for the interior furnishings and accessories. The *Trellis* wallpaper was cleverly used in the conservatory corridor at the intersection between house and garden. Today, thanks to careful conservation by the National Trust, it can still be viewed in its original location.

CREATED

Probably Red House, Bexleyheath, Kent

MEDIUM

Wallpaper

RELATED WORKS

Wallpaper design for Jeffrey and Co. by Christopher Dresser, 1864

William Morris *Born* 1834 Walthamstow, England

Died 1896

Crane, Walter and de Morgan, William
Detail from the Arab Hall, 1877–81

Although the Great Exhibition of 1851 is generally seen as having a negative impact on design, the exhibits from some of the other world cultures, including India and Persia, had a very positive influence, fostering an interest in eclecticism and historicism. From the late 1860s and during the 1870s, the painter Frederic (later Lord) Leighton (1830–96) visited a number of key sites in North Africa and Asia Minor, acquiring a large collection of sixteenth- and seventeenth-century tiles from Damascus, Cairo and Rhodes. These tiles and mosaics were used in an extraordinary piece of eclectic design, the Arab Hall, in Leighton's specially designed house in Holland Park.

Many of the original tiles were damaged in transit, and Leighton asked William de Morgan to make some tiles that would replicate the originals in order that the Arab Hall could be finished. De Morgan and Walter Crane worked on the commission between 1877 and 1881, and perfected a way of matching the peacock-blue colour that is so prominent in the originals. Today it is still difficult to distinguish between the two. De Morgan actually lost money on the transaction due to his insistence on absolute perfection, a trait of most Arts and Crafts practitioners.

CREATED

Leighton House, London

MEDIUM

Ceramic tiles

RELATED WORKS

The Peacock Room by James McNeill Whistler, 1876

Walter Crane *Born* 1845 Liverpool, England

Died 1915

William de Morgan *Born* 1839 London, England

Died 1917

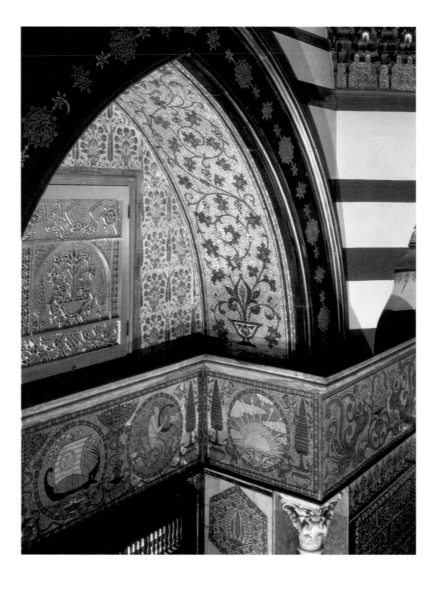

Morris, William

Honeysuckle design, 1883

'Have nothing in your houses that you do not know to be useful, or believe to be beautiful.'

Although not written down by William Morris until 1882, it was a credo that he had always believed in from the beginning of his career as a designer and entrepreneur. In 1861 he established the decorative arts firm of Morris, Marshall, Faulkner and Co. at 8 Red Lion Square in London; a partnership that included his Pre-Raphaelite friends Edward Burne-Jones and Dante Gabriel Rossetti (1828–82). It was established to provide a range of high-quality, hand-made products at affordable prices, a commercial opportunity that Morris seized on following his own frustrations when trying to decorate and furnish his newly built Red House.

Initially the firm relied heavily on Morris's friend, the architect of Red House Philip Webb, to provide many of the orders. However, other orders and commissions followed from many of the top architectural practices including G. E. Street and G. F. Bodley (1827–1907), who were both Gothic revivalists. In the early days, Morris and Co. were best known for their stained glass, designed by Rossetti, Burne-Jones, Ford Madox Brown (1821–93) and Morris himself.

The London telegraph address of Morris and Co. was 'Honeysuckle'.

CREATED

London, England

MEDIUM

Wallpaper

RELATED WORKS

Textile design by C. F. A. Voysey, 1888

William Morris *Born* 1834 Walthamstow, England

Died 1896

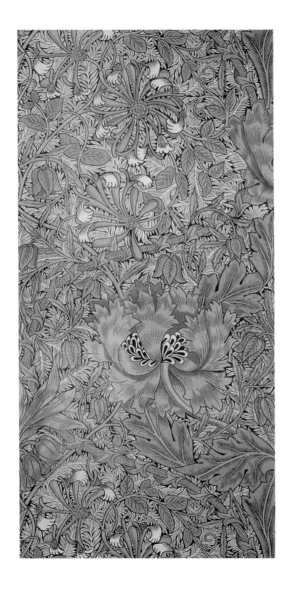

Mackmurdo, A. H.

Design for a wallpaper or a textile, *c.* 1882

Although Arthur Heygate Mackmurdo belongs to the second generation of Arts and Crafts practitioners, it is clear that Ruskin's call to use nature as an influence still had currency. This design, although based on a sea lily, is clearly abstracted from the naturalist motif and is possibly based on the biomorphic floral designs of Christopher Dresser (1834–1904) in the previous decade. During the 1880s, as the Arts and Crafts came to symbolize a movement in its own right rather than an extension to the now-waning Gothic revival, designers began looking at other motifs for inspiration. In Britain, this period coincided with an interest in Japan, which led, for example, to the ebonizing of furniture and to a revival of the Queen Anne style, which exemplified slim, elegant furniture with elaborate inlays of different coloured and exotic woods. This was a period of exquisite hand-made craftsmanship, which the late nineteenth-century Arts and Crafts practitioners sought to emulate.

The sinuous and organic lines adopted by Mackmurdo in his designs came to signify another particular direction for the next generation of designers, not just in textile or wallpaper designs but, particularly in Mackmurdo's case, furniture too. This sinuous motif was adopted by Continental Europe at the turn of the century as Art Nouveau.

CREATED

London, England

MEDIUM

Charcoal, watercolour and body colour

RELATED WORKS

Lilies Turned to Tigers, watercolour by Walter Crane, 1889

A. H. Mackmurdo *Born* 1851 London, England

Died 1942

Morris, William

Cray furnishing fabric, 1884

As the firm of Morris, Marshall, Faulkner and Co. developed their product range, it became necessary for William Morris to delegate the supervision of various departments to his trusted partners and staff. In the 1870s, for example, Edward Burne-Jones assumed responsibility for the stained glass, and the firm began to produce secular designs as well as the more traditional church motifs. The firm was very much centred on the involvement of family and friends. Morris's wife, Janey, and her sister Elizabeth Burden, together with Morris's daughter May and Burne-Jones's wife Georgina, organized and executed the work in the embroidery department. Faulkner's daughters Kate and Lucy looked after the ceramic decoration and wallpapers, and Morris's friend William de Morgan set up a kiln in the basement of his house to produce a range of tiles and pottery. Morris left Philip Webb in charge of furniture design and production.

By the late 1870s, Morris and Co. (as it became known after 1875), depended on its commercial success through the sales of a large number of textiles and wallpapers that were very distinctively the firm's designs, sold through its retail outlet in London's Oxford Street. Cray was a later addition to the range and was one of the most complex, requiring 34 print blocks for its execution.

CREATED

London, England

MEDIUM

Furnishing fabric in block-printed cotton

RELATED WORKS

Trail furnishing fabric by J. H. Dearle, 1891

William Morris *Born* 1834 Walthamstow, England

Died 1896

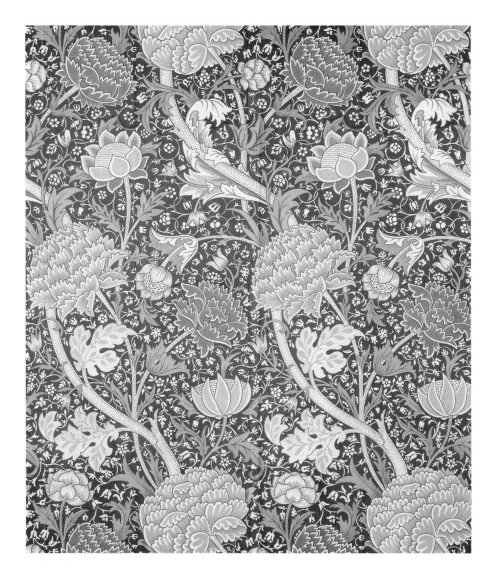

Morris, May
Tablecloth, 1895

William Morris became interested in embroidery design in the 1870s following his experiments with dyes and their application to silk thread. He designed for, among others, the Royal School of Needlework, where Janey's sister Elizabeth taught. This renaissance of embroidery work, so prominent in church altar frontals, was now adapted to secular work that included domestic interiors. Several Arts and Crafts designers, including Walter Crane, also designed patterns for embroidery work, and during the 1880s this became known as 'art needlework' under the auspices of Morris and Co.

The decorative arts of embroidery and tapestry suited middle and upper-class women at this time, as these handicrafts were considered delicate and suitably 'feminine', in line with the personification of Morris's ideal of the medieval lady so well portrayed in Pre-Raphaelite paintings of this period. May Morris, together with her mother Janey, became very accomplished embroiderers and executed many designs for domestic interiors. In 1885, May took over the running of the embroidery section of Morris and Co., following her father's more active role in politics. May gathered a group of very accomplished craftswomen around her to execute her own very distinctive designs.

CREATED

Possibly by Morris and Co.

MEDIUM

Linen, embroidered in silks

RELATED WORKS

Embroidery for the Leek Embroidery Society by Frances Mary Templeton, 1892

May Morris *Born* 1862 Bexley, England

Died 1938

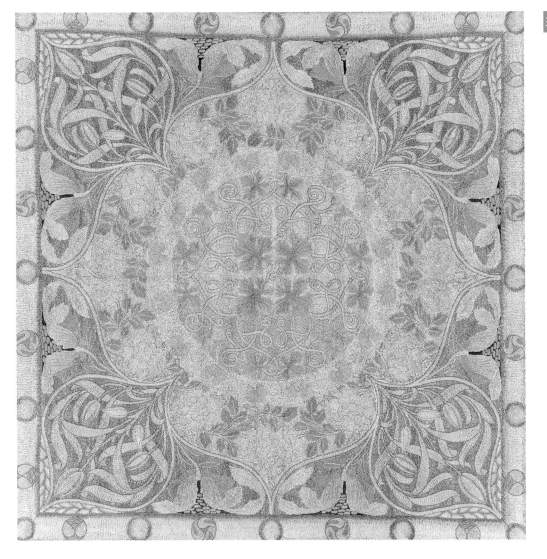

De Morgan, William
Two-handled vase *c. 1890*

Perhaps of all the crafts, pottery is probably the one that first springs to mind as encapsulating the essence of handicraft. In William de Morgan's hands it becomes very much an art object, the epitome of the Arts and Crafts movement and its aspiration to bring together the artist-designer and the craftsman. De Morgan liberated pottery from the hackneyed motifs of Neo-Classicism into a genuinely innovative and fresh, often whimsical, total work of art. After his training at the Royal Academy Schools, de Morgan began making tiles for Morris and Co. in response to an increasing demand for their domestic use. During his 'Chelsea period' between 1872 and 1881, de Morgan executed over three hundred of his own tile designs. Following a brief spell with William Morris at his Merton Abbey workshops, de Morgan moved to Fulham, and between 1888 and 1898 he produced the majority of his most exquisite work, experimenting with lustreware techniques.

De Morgan's frequent use of animal and plant motifs were in due deference to John Ruskin's advocacy of nature's influence in art. His later designs of the 1890s with their organic forms and sinuous lines clearly anticipate Art Nouveau.

CREATED

Fulham Pottery, London

MEDIUM

Earthenware with lustre glaze

RELATED WORKS

Pilkington's Lancastrian Pottery, 1890s

William de Morgan *Born* 1839 London, England

Died 1917

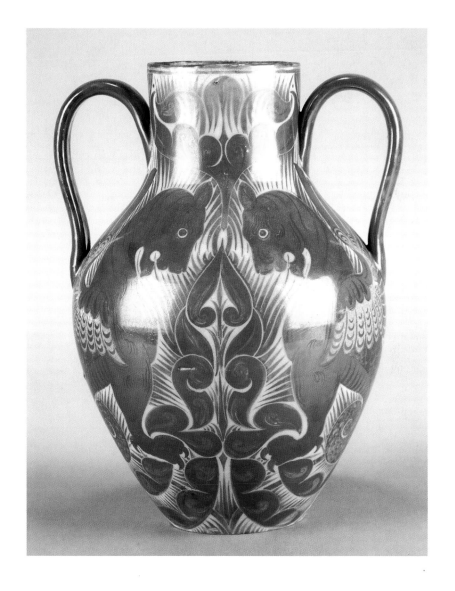

Day, Lewis F.
Design for a key plate, 1895

After the 1870s, there was a move away from the notion of revealing the construction of a designed item as exemplified by A. W. N. Pugin. Arts and Crafts designers, such as Lewis F. Day, were beginning to design for industry, in much the same way as Christopher Dresser had begun to do in the previous decade. Day had remarked of Morris, "He did all he could to forget six centuries or so and make believe we were living in the Middle Ages," signifying a key shift in attitude as the Arts and Crafts movement gained momentum. Significantly, Day, like Dresser, was an independent designer, and like him was one of the first to design for industry on a professional basis. The example shown here is one such artefact, which was designed to be reproduced a limited number of times, so retaining the essence of a handcrafted object. Day intended that even the most basic features of a room should have a designed aesthetic that was artistic and yet functional. This design was clearly in line with contemporary trends in Europe for Art Nouveau.

Day had an extensive knowledge of historic ornament and of Japan, and was a prolific writer on the Arts and Crafts.

CREATED

London, England

MEDIUM

Pencil and watercolour

RELATED WORKS

Carson, Pirie, Scott Store, Chicago by Louis Sullivan, 1899

Lewis F. Day *Born* 1845 England

Died 1910

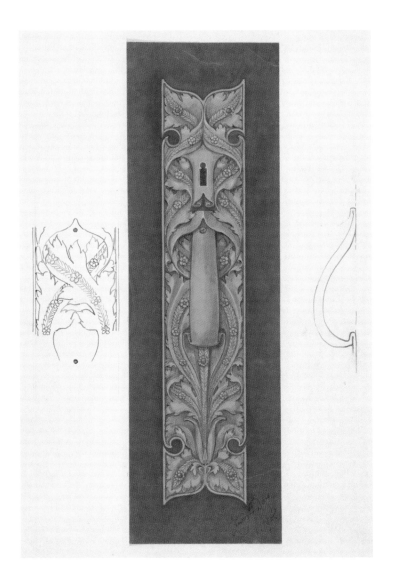

Benson, William
Teapot, 1895–1900

Unlike many of his contemporaries, William Arthur Smith Benson had no problem with the machine manufacture of his designs. He was, like Lewis F. Day and Christopher Dresser, a designer for industry, one of a growing band of designers who realized the benefits of using machine manufacture with the proviso that the article was properly designed in the first place. That is, without unnecessary ornament, and for its form to follow its function. Benson was primarily a designer of metalwork, usually in brass and/or copper. The white metal lining for the teapot was necessary to alleviate corrosion and avoid tainting the tea, whilst also ensuring an insulation; thus providing an aesthetically well-designed product that was very functional, a tenet of both the Arts and Crafts and Modern movements.

It is tempting to suggest that, with its 'whiplash' handle, the design anticipates the European vogue for Art Nouveau. Indeed, Benson actually designed products for sale at Samuel Bing's shop in Paris, *Maison de l'Art Nouveau*, which gave the movement its name. But clearly, it also anticipates the later generation of Peter Behrens' (1868–1940) modern designs, based on the Modernist credo of fitness for purpose. Significantly, Benson became a founder member of the Design Industries Association when it was founded in 1915.

CREATED

Hammersmith, London

MEDIUM

Machine-spun brass, with white metal lining

RELATED WORKS

Silver teapot by Charles Ashbee, 1901

William Benson *Born* 1854 London, England

Died 1924

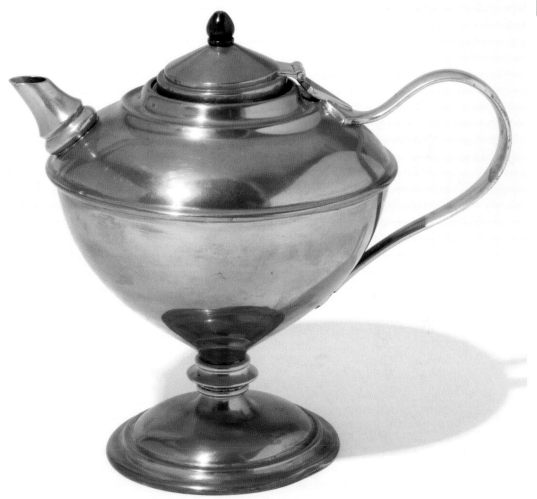

Fisher, Alexander

Tristan und Isolde belt buckle, 1896

Following Pugin's earlier revival of enamelwork, Alexander Fisher set up his own studio in London in 1887 and soon gained a reputation for exquisite enamelled jewellery and other decorative objects. He was also a trained goldsmith, and presented his enamelled objects set in both precious metals and steel. As a craft, enamelled jewellery lent itself well to fashionable accessories for the middle classes, replacing expensive precious stones and with the added advantage of incorporating a painted narrative in miniature. In Fisher's case it was in a late Pre-Raphaelite style, which had currency at that time

The subject matter of this work is also ideal as an Arts and Crafts-based work. The tragic love story of *Tristan and Isolde* is based on Arthurian legend, a popular subject at this time. It was recounted most famously in the poetry of Matthew Arnold, *Tristram and Iseult* of 1852, and Alfred Lord Tennyson's epic *The Idylls of the King*, 1857–85. Arthurian legend, as with other medieval motifs, was also a suitable subject for Pre-Raphaelite painting, as in Edward Burne-Jones' *The Beguiling of Merlin* from 1874. Earlier in 1862, Burne-Jones and William Morris had also designed a series of stained-glass windows based on *The Story of Tristram* for the Music Room at Harden Grange in Yorkshire.

CREATED

London, England

MEDIUM

White metal and enamel

RELATED WORKS

Silver and enamel buckle by Archibald Knox, 1901

Alexander Fisher *Born* 1864 England

Died 1936

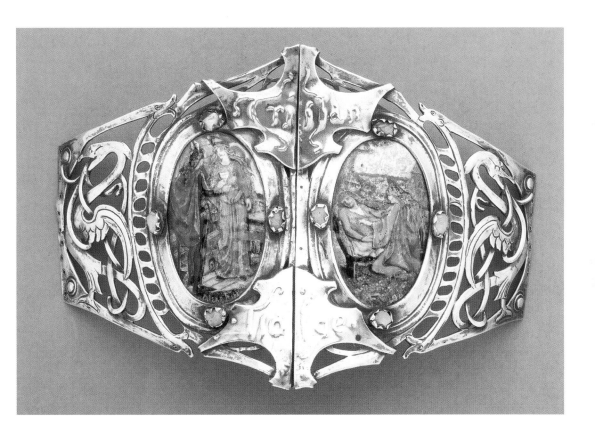

Butterfield, Lindsay P.

Tiger Lily design for a printed textile, 1896

Lindsay Butterfield came to prominence in the 1890s as a designer of textiles and wallpapers. This period was one of phenomenal growth in the textile industry, with many British fabrics being exported, particularly to America. Butterfield was a freelance designer, but usually worked under exclusive contract for textile companies such as Alexander Morton and Co. and Sanderson's. Butterfield's distinctive designs emanate from a period of botanical study. His designs are reminiscent of Christopher Dresser, himself a trained botanist, in their individual stylization and attention to detail of the plant forms. Like Morris, Butterfield's designs contain a restrained geometry, but careful consideration has been given to how the fabric will hang.

Once again the inspiration for these floral designs emanates from Ruskin's call to seek out nature for inspiration. By the 1890s, the consumers for the Arts and Crafts style had become more sophisticated and were seeking a more genteel way of living. As often as not, however, they needed access to the city and their homes were often in the new and burgeoning suburbs. There was a need to bring aspects of the garden into the living areas to accommodate this, and designs like Butterfield's were well suited to that purpose.

CREATED

England

MEDIUM

Pencil and watercolour

RELATED WORKS

The Strawberry by C. F. A. Voysey, 1901

Lindsay P. Butterfield *Born* 1869 England

Died 1948

Voysey, Charles
Design for a woven textile, 1896–1900

© Estate of Charles Voysey/Victoria & Albert Museum, 2005

As the last century drew to a close, the Arts and Crafts movement became mature, its proponents leaving behind its Gothic revival ancestry in favour of a more rural and welcoming 'homeliness' in keeping with the liberal middle classes. These more pragmatic notions of domestic pleasures were accommodated by some of the second generation of Arts and Crafts practitioners that included Charles Francis Annesley Voysey. For them, a building and its interior needed to look 'commonplace'. Voysey saw himself as an inheritor of some of Pugin's design ideals, particularly aspects of heraldry and its symbolism and the use of regional materials in his architectural projects.

For a time, Voysey lived in one of the artists' house-studios at Bedford Park in West London. This development was created during the final quarter of the nineteenth century, as a community of affordable studio space and accommodation for artists and artisans. The ethos of Bedford Park followed John Ruskin's maxim that 'Beautiful art can only be produced by people who have beautiful things around them'. Although the houses were more in keeping with the Queen Anne revival, there were many aspects of the development that are pure Arts and Crafts, not least of which was the idea of a harmonious community.

CREATED

Darvel, Scotland

MEDIUM

Woven wool

RELATED WORKS

Burmese *kalaga* hangings, late nineteenth century

Charles Voysey *Born* 1857 Yorkshire, England

Died 1941

Ashbee, Charles

Detail of carved inlay on cabinet, *c.* 1898–99

Although Charles Robert Ashbee eschewed notions of an influence on the European Art Nouveau movement, it is clear from his designs that, at the very least, there was a cross-fertilization of ideas between Britain and Europe at the *fin de siècle*. The organic 'tulips' and the 'whiplash' motif of their stems are its indications. The reason for Ashbee to shun such recognition was his belief in the primary importance of the socialist ideals of Arts and Crafts over and above purely aesthetic considerations. He would have considered Art Nouveau to be bourgeois decadence in the extreme, a movement that his contemporary Walter Crane described as "a strange decorative disease". What this design does show is the eclecticism present in the majority of Arts and Crafts work at this time, not just historical eclecticism, but a combination of motifs and ideals from the movement itself. Ashbee, an enthusiast of Ruskin, remembered to seek out nature for inspiration, and is following Morris in the application of a stylized floral motif.

Ashbee was also renowned for his metalwork designs, and the elaborate 'whiplash' brass handles used on these cabinets, echoing the main panel design, are the testimony.

CREATED

Guild of Handicraft, London

MEDIUM

Mahogany, holly and brass

RELATED WORKS

Hill House interior, Glasgow, by Charles Rennie Mackintosh, 1903

Charles Ashbee *Born* 1863 Isleworth, England

Died 1942

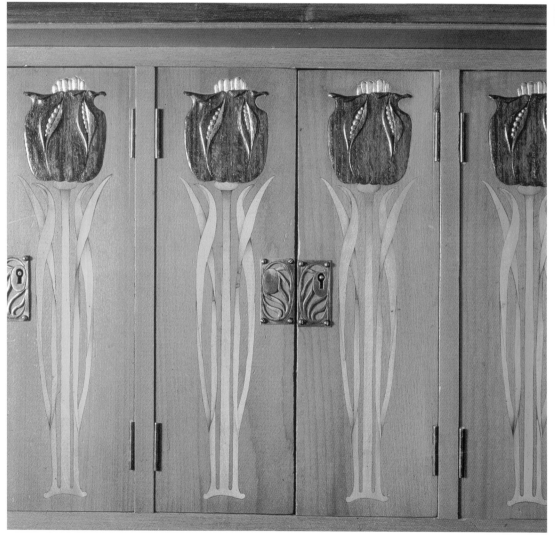

Baillie-Scott, Mackay Hugh
A large buffet

© Estate of Mackay Hugh Baillie-Scott/Christie's Images Ltd

In contrast to some of his contemporary furniture designers who favoured the elegance and simplicity of the Queen Anne revival, Mackay Hugh Baillie-Scott (1865–1945) favoured a more 'rude' vernacular furniture, reminiscent of a former age. For him, the craft should be exposed in much the same way as Pugin's was, with a strong structural sense of utility and fitness for purpose. Baillie-Scott was an architect who, like many others, insisted on designing the utilitarian parts of a home including its furnishings. There was a strong sense of 'folk art' in his designs that had a very 'homely' ambience about them. He always designed his interiors with the family in mind. His houses were designed with large hallways, which he referred to as 'Living-Halls,' an area for the family to meet, greet and converse.

The Studio, a monthly journal concerned with edifying the general public about the Arts and Crafts, was instrumental in 'spreading the gospel' of the discipline and its different aspects. Baillie-Scott was a good self publicist, and wrote a contributing article for the journal in 1894 called 'The Ideal Suburban House', in which he expanded on his views for comfortable living. He also published a book in 1906 called Houses and Gardens, showing his own contributions to the Arts and Crafts movement.

CREATED

England

MEDIUM

Oak with repoussé copper panel, gilt inlay and gilt wrought-iron hinges and lock plates

RELATED WORKS

Buffet by Peter Behrens and Anton Blüggel, 1902

Mackay Hugh Baillie-Scott Born 1865 Ramsgate, England

Died 1945

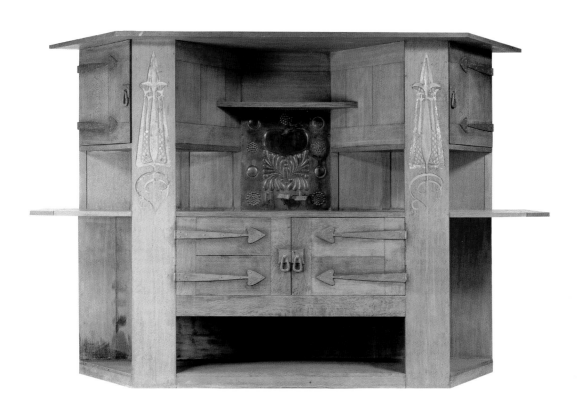

Crane, Walter

Francesca wallpaper design

The excesses of Gothic, a style that was very much on the wane in the 1890s, were tempered by the influences of the Aesthetic movement as the century drew to a close. This was somewhat ironic, since it was the excesses of Aestheticism that were first curtailed by John Ruskin and then William Morris. Walter Crane seemed to have had a foot in both camps. Crane, like Christopher Dresser, was influenced by Japanese motifs, a key aspect of Aestheticism. What appealed to them was the removal of all superfluous detail in the original designs that demonstrated simplicity and economy of line. Dresser had travelled to Japan, and in 1879 opened a shop in London selling Japanese goods, fuelled by the British people's curiosity and appetite for the exotic notions of the Orient.

Japan was in vogue in Britain and on the Continent during the 1860s and 1870s, with artists such as James McNeill Whistler (1834–1903) and Claude Monet (1840–1926) using it as a decorative motif for their paintings. However, by the end of the century, references to Japan and its culture were more subtle, with the emphasis on horizontals and verticals, simpler and more elegant lines, and ebonized furniture.

CREATED

England

MEDIUM

Wallpaper

RELATED WORKS

Snowdrop textile design by Lindsay P. Butterfield, 1905

Walter Crane *Born* 1845 Liverpool, England

Died 1915

Moser, Koloman

Armchair

At the *fin de siècle*, the cross-fertilization of ideas between Britain and the Continent had encouraged the formation of a Secession movement in Munich and Vienna, which was formed against their respective oppressive academic traditions. Many of Britain's ideas concerning the Arts and Crafts had infiltrated Vienna through Charles Rennie Mackintosh (1868–1928), who was invited by the Secession to display his work, with that of the 'Glasgow Four,' at their 1900 exhibition. There are, however, marked differences in the ethos of the movement between Vienna and Britain. A major banker, Fritz Wärndorfer, funded the Viennese enterprise. He provided the funding for the *Wiener Werkstätte*, a group of workshops for designers and craftspeople to make a range of designed goods for the bourgeoisie. The socialist ideals of Britain were not as evident in Vienna. Although staffing was egalitarian in terms of gender, the workshop's products were designed with the elite upper-middle classes in mind.

The emphasis in Vienna was also different. They rejected historicism, relying instead on both the rectilinear influences of Japan and the organic motifs of Continental Art Nouveau, without adopting its excesses. The example shown here, after a design by Kolomon Moser demonstrates the Japanese influences in structure and materials.

CREATED

Vienna, Austria

MEDIUM

Oak, rope-work seat and back

RELATED WORKS

Cane chair by Edward Godwin, 1880s

Koloman Moser *Born* 1868 Brünn, Austria

Died 1918

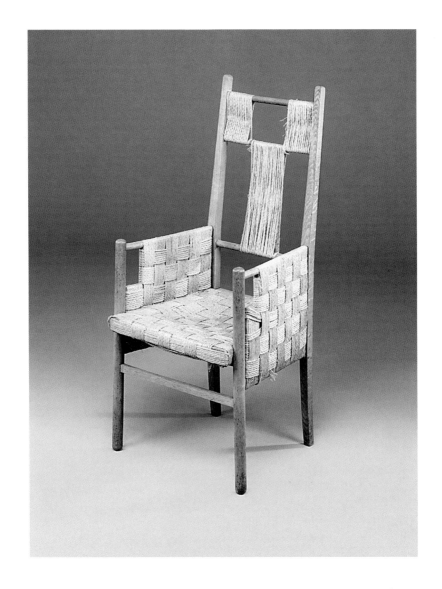

Knox, Archibald

Belt buckle, 1903

Another influence on the Arts and Crafts movement at the turn of the century was a revival of Celtic traditions. The Celts became very proficient in metalwork, often embellishing their designs with enamelwork. The Celtic craft tradition is based on style rather than emulating or copying nature, and an example of this early work is the famous 'Tara Brooch'. Following on from Owen Jones' depiction of Celtic motifs in his seminal design manual *The Grammar of Ornament* of 1856, there was an interest in these traditions in much the same way as there had been for others, such as Persian and Egyptian.

Archibald Knox, who was born on the Isle of Man, was perhaps persuaded by the sense of his Celtic heritage to become a designer himself. His subsequent arrival in London in 1897 brought him into contact with Arthur Lazenby Liberty (1843–1917), whose store in central London had already established a reputation for its well-designed Arts and Crafts products, such as Lindsay Butterfield's fabrics. Knox's designs for the 'Cymric' and 'Tudric' work enhanced the reputation of Liberty and Co. and became synonymous with their name.

CREATED

Birmingham, England

MEDIUM

Mixed media

RELATED WORKS

Belt buckle by Alexander Fisher, 1896

Archibald Knox *Born* 1864 Isle of Man

Died 1933

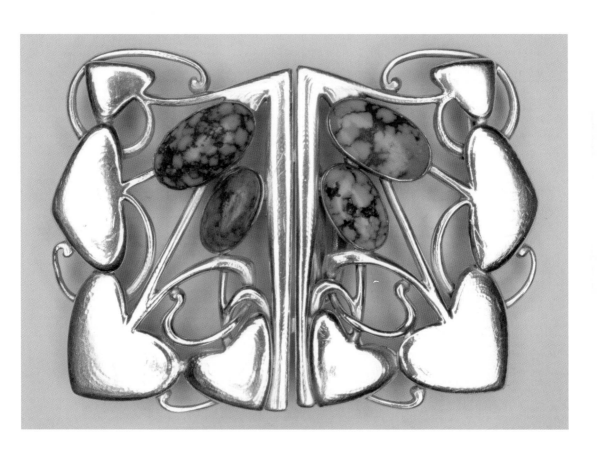

Ashbee, Charles

Brooch, c. 1903

As the twentieth century opened, the Edwardian desire for elegance seemed to know no bounds, an opportunistic time for an Arts and Crafts movement seeking a regenerative approach to its designs. Probably more than any of his contemporaries, Charles Ashbee's enthusiasm for this opportunity also knew no bounds. Although he was designing for the upper echelons of society, he firmly believed in the socialist ideals of John Ruskin – namely that good design and craftsmanship depended on good social conditions. He also believed, like Ruskin, in asking the question, 'What *ought* to be made?'.

Ashbee, following on from Ruskin's model, founded the Guild of Handicraft in 1888, and by the time this brooch was made, he had realized his Utopian dream of a community workshop at Chipping Camden in the Cotswolds, where he also founded the School of Arts and Crafts in 1904. The workshops were to provide a model for similar European and American enterprises. The guild produced a number of exquisite pieces of jewellery in its workshops, such as brooches and pendants, to Ashbee's designs, often with enamel work or semi-precious stones such as aquamarine rather than precious stones. The ship as a motif was one of Ashbee's hallmarks.

CREATED

Chipping Camden, England

MEDIUM

Enamelled gold

RELATED WORKS

Silver and enamel brooch by Archibald Knox, 1899

Charles Ashbee *Born* 1863 Isleworth, England

Died 1942

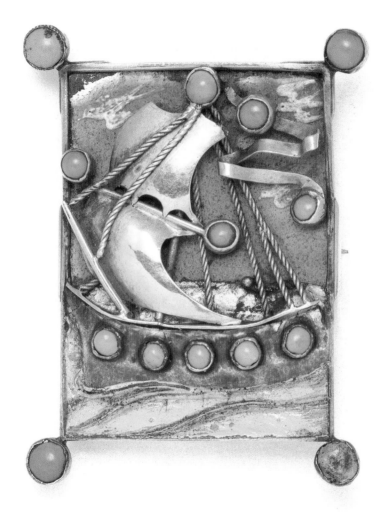

Mackintosh, Margaret MacDonald
Panel for lampshade, *c.* 1903

Margaret MacDonald Mackintosh, an independent artist-designer in her own right, is often overshadowed by her husband Charles Rennie Mackintosh's fame. Margaret's sister Frances MacDonald (1874–1921) was married to Charles's fellow artistic friend Herbert MacNair (1868–1953). They became known as the 'Glasgow Four' and between them developed the 'Glasgow Style'. By the 1890s, Glasgow had become a major industrial city with its own cultural identity, and was enjoying a period of national identity through the revival of Celtic ideas that were gaining currency at the turn of the century.

As part of that cultural identity and revival of Celtic tradition, Margaret used a Glasgow Rose motif in much of her work. There is also a strong sense of the Japanese influence in her work, particularly her elongated poster designs that resemble *Kakemono*. The sinuous lines and 'whiplash' motif indicate an understanding of the Continental vogue for Art Nouveau. Aside from her competence as a watercolourist, Margaret was also a craftsperson, her skills extending to *repoussé* metalwork, gessoed panels and embroidery. Her ideas were linked with the past but not actually bound by it, as were those of most Arts and Crafts practitioners at the turn of the century.

CREATED

Scotland

MEDIUM

Embroidered cream silk with beads, ribbons and braid

RELATED WORKS

Screen for the Scottish section at the Turin International Exhibition by E. A. Taylor, 1902

Margaret MacDonald Mackintosh *Born* 1865 Scotland

Died 1933

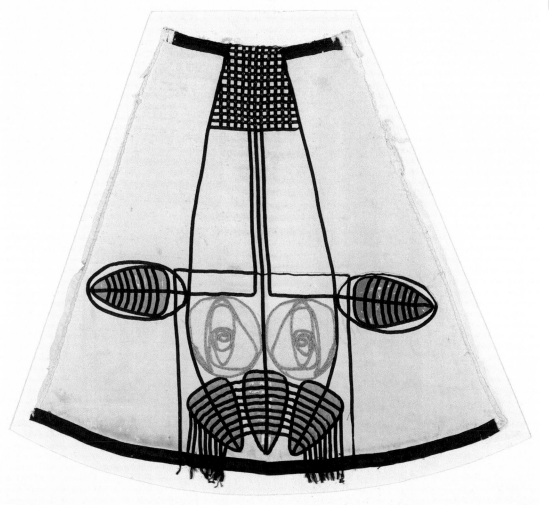

Hoffman, Josef

Armchair, c. 1905

Josef Hoffman was, with Koloman Moser, a founder member of the *Wiener Werkstätte* in Vienna. The *Werkstätte* was set up to redress the falling aesthetic standards of design associated with mass production. In much the same way that Britain had referred to an earlier model to redress the same problem, the Viennese looked to the 'Biedermeier' style that was prominent in Austria in the early nineteenth century. Hoffman's choice of light-coloured woods emulates that style.

Prior to the setting up of the *Werkstätte*, Hoffman and Moser's new style was first seen in public at the 1900 Secession Exhibition, alongside that of the 'Glasgow Four'. The influence of Japanese linearity can clearly be seen in the work of both the Scottish and Viennese designers, which acted as a stimulus for future work. Following this exhibition, the work of the *Werkstätte* was featured in *The Studio* and other English-speaking journals, which helped to develop an international appreciation for the 'Viennese School'. Hoffman and Moser created the *Kunstgewebereschule* (Vienna School of Arts and Crafts) to train subsequent generations of designers and craftsmen. Hoffman's earlier furniture designs are redolent of Mackintosh, but by the period of this chair, he had developed a less decorative style in which ornament became subservient to function.

CREATED

Vienna

MEDIUM

Wood with cane seat

RELATED WORKS

Chair for the Vienna Savings Bank by Otto Wagner, 1906

Josef Hoffman *Born* 1870 Moravia

Died 1956

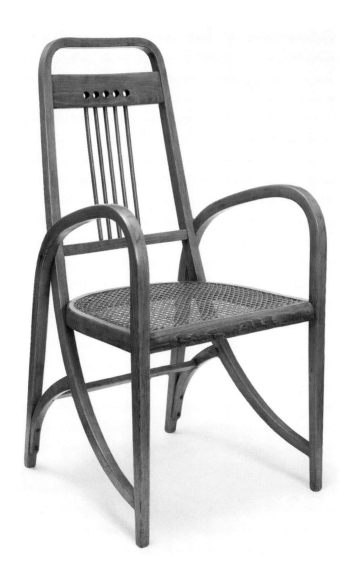

Riemerschmid, Richard
Bedroom suite, c. 1908

Courtesy of Christie's Images Ltd/© DACS 2005

Richard Riemerschmid is an example of the link between the Arts and Crafts, and the industrial design ethos of the twentieth century that showed it due deference. Riemerschmid was the founder of the Munich-based *Vereinigte Werkstätt für Kunst im Handwerk* (arts and crafts workshop), where he began designing furniture and other items from 1897. Like the *Wiener Werkstätte* practitioners, he was also uninterested in social reform. Riemerschmid designed items for the *Dresdener Werkstätten für Handwerkskunst* (Dresden Workshops for Arts and Crafts), where he also experimented with ideas for machine-made, mass-produced furniture.

In 1907 he became a founder member of the *Deutscher Werkbund*, working alongside Peter Behrens and others to create individually designed objects that could be commercially mass produced to a high quality. The *Werkbund* was an association of mainly German and Austrian designers and craftsmen, architects and workshops, which became the paradigm shift in design ethos. Riemerschmid was also an educationist, who shared his ideas and ethos of the designed object emanating from modern life with the next generation of aspirant designers. In 1913 he became the director of the Munich *Kunstgewebereschule*, where he continued to exercise considerable influence.

CREATED

Dresden, Germany

MEDIUM

Ashwood and pine

RELATED WORKS

Salon cupboard by Henry van de Velde, 1900

Richard Riemerschmid *Born* 1868 Munich, Germany

Died 1957

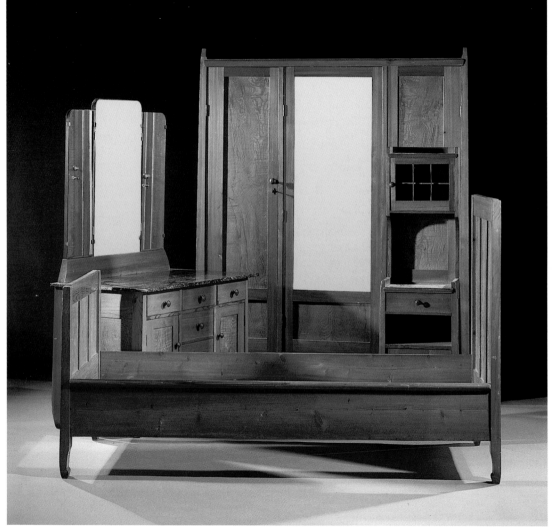

Lloyd Wright, Frank
Oak flat-print file, *c.*1909

There are many influential elements in the designs of Frank Lloyd Wright, and yet his work is distinctive in its originality, with few, if any, historical references. At the beginning of his career in 1889, Wright was a founder member of the Chicago Arts and Crafts Society, which was based on Ashbee's contemporary Guild at Toynbee Hall in London. Like Ashbee, Wright admired both Ruskin and Morris, but parted company with them concerning machine manufacture, stating, "the machine is the normal tool of civilization".

However, in deference to Ruskin and Morris, Wright was able to exercise a 'truth to materials' in his work. During the first decade of his career, he had designed over 50 houses and interiors using regional materials such as oak, creating 'homely' environments similar to those of Charles Voysey but with a distinctive modernity that is pure Wright. To achieve this, Wright used the rectilinear aspects of Japanese design that emphasized the horizontals. The structural strength emphasized in his designs, using geometric forms and intersecting horizontal and vertical planes, make the work modern, and yet rustic with the use of natural materials.

CREATED

Chicago, USA

MEDIUM

Oak

RELATED WORKS

Print file for Gustav Klimt by Joseph Hoffman, 1904

Frank Lloyd Wright *Born* 1867 Wisconsin, USA

Died 1956

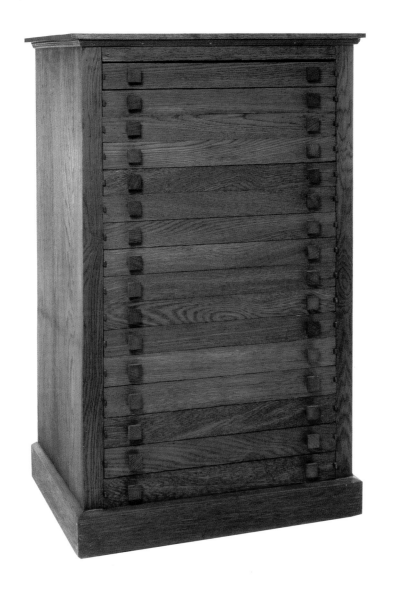

Dearle, John

Portière tapestry, c. 1910

Following the death of William Morris in 1896, his protégé John Henry Dearle took over the running of Morris and Co. Dearle had worked with Morris for many years and had assisted him on many of his wallpaper and textile designs, and designed some in his own right including the popular *Daffodil* in 1891. However, in contrast to Morris's ideals of the authorship of a design, many of Dearle's designs were accommodated within the Morris and Co. umbrella. The subsequent mythologizing of Morris's prolific output as a designer was thus undermined, a situation that historians have only recently revealed.

In spite of developments on the Continent towards industrial design and the modern movement, Britain remained entrenched in a conservative modernism that saw a continued loyalty to the Arts and Crafts movement until well after the First World War. In particular, a continued evolution of 'homeliness', which extended to the new suburbs, also saw a continuation of the Morris and Co. bandwagon and little change to its design ethos. The *portière* figured in many middle-class houses, although its cost as a tapestry at about £100 was prohibitive to most budgets. This gap was filled by Morris and Co. chintzes.

CREATED

England

MEDIUM

Embroidered wool

RELATED WORKS

Embroidered panel for the Battye family by May Morris

John Dearle *Born* 1860 England

Died 1932

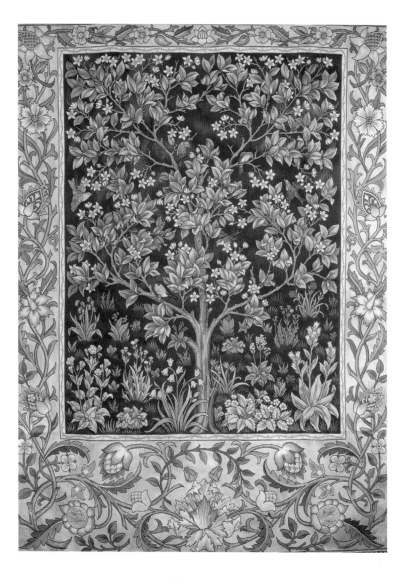

Stickley, Gustav

Colour illustration of the interior of a Craftsman House, c. 1910–11

Since regional considerations are at the heart of the Arts and Crafts movement, it is hardly surprising that American vernacular architecture would follow a different path to that in Europe. Gothic existed in America as a style and not an ideal based on tradition, and it therefore follows that American architects and designers sought reference to their own cultural history as a stimulus for their own brand of arts and crafts. America, like Europe was dogged by many examples of inappropriate architecture and design that ignored fitness for purpose. However, not everyone agreed as to how the problem should be redressed. One faction looked directly to Britain and the adaptation of historical precedents in America such as Tudor or Gothic; the other sought inspiration at home, in the American landscape.

Gustav Stickley belonged very much to the second faction. His 'Craftsman Workshops' produced a range of 'rustic' affordable furniture, suitable for the middle classes. His journal *The Craftsman* also advertised low-cost Arts and Crafts houses. *The Craftsman*, which began publication in 1901, also provided the dissemination of Arts and Crafts ideals and styles to America. The 'Craftsman Living Room' is heavily borrowed from the British architects Charles Voysey and Baillie-Scott.

CREATED

New York, USA

MEDIUM

Periodical: *The Craftsman*

RELATED WORKS

Houses and Gardens (book) by Mackay Hugh Baillie-Scott, 1906

Gustav Stickley *Born* 1857 Wisconsin, USA

Died 1942

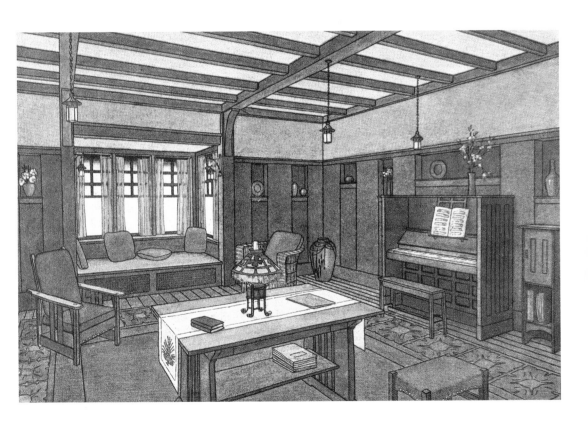

Gimson, Ernest

Sideboard with plate-stand, 1915

This late Arts and Crafts sideboard was one of the last pieces of work by Ernest Gimson and is a testament to his style as a designer and technique as a craftsman. The design is very strongly based on Japanese influences. The first clue is in the ebonized legs and rail, with an arched centre section alluding to a Japanese bridge. The plate stand, also ebonized, suggests a Japanese screen, and as a whole, the cabinet's design emphasizes its horizontality. Another dimension, which is peculiar to Gimson's work, is the chamfering of the legs on the cabinet.

Although Gimson was a craftsman, he preferred to design and leave the construction to his associates Ernest (1863–1926) and Sidney Barnsley (1865–1926), who were also designers in their own right. Gimson and the Barnsleys left London in 1893 to set up a workshop in the Cotswolds, and later brought other skilled craftsmen into the firm, most notably Peter van der Waals. Gimson was also an accomplished rush weaver and designed a number of chairs with rush seating and ebonized frames and legs. Having always resisted machine manufacture, Gimson rejected an offer in 1916 to join the Design Industries Association, a body set up in response to the *Deutscher Werkbund*, and their aspirations for industrial design.

CREATED

Cotswolds, England

MEDIUM

Walnut

RELATED WORKS

Oak sideboard by Sidney Barnsley, 1924

Ernest Gimson *Born* 1864 Leicester, England

Died 1919

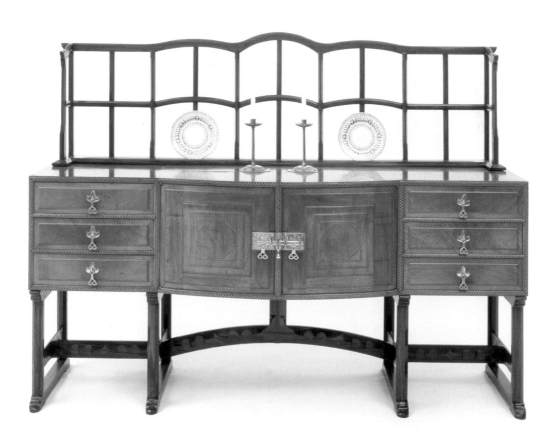

Leach, Bernard

Vase, c. 1931

An industry equally effected by mass production was pottery, particularly the old English pottery whose traditions had died out. Bernard Leach revived those traditions after returning to England from Japan where he studied Oriental pottery techniques. The old traditions Leach revived included the original techniques of slipware brought to Britain by the Romans but not used as a decorative craft technique since the eighteenth century.

In true Arts and Crafts style, Leach set up a loose community of potters in St Ives in Cornwall during the 1920s, and then later his own pottery in Devon. The Leach Pottery was initially a failure, and Leach himself had to send for technical assistance from Tsuronosuke Matsubayashi in Japan. The kiln was rebuilt using traditional Japanese methods and it remained in service until the 1970s. The continued collaboration in setting up the St Ives pottery of Leach and Shoji Hamada (1894–1978), who accompanied Leach on his return to England, the revival of old traditions and the dissemination of their techniques, fuelled a new generation of potters keen to learn these skills. They included Michael Cardew (1901–83) and Katherine Pleydell-Bouverie (1895–1985). Leach was also a good educationalist and wrote more than a dozen books on pottery between 1920 and 1978.

CREATED

England

MEDIUM

Stoneware

RELATED WORKS

Stoneware vase by W. Staite Murray, 1923

Bernard Leach *Born* 1887 Hong Kong

Died 1979

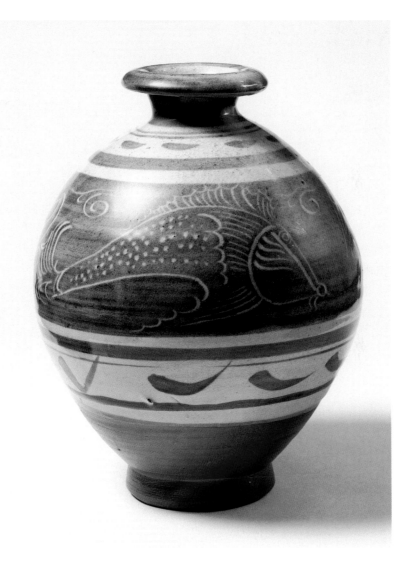

Hamada, Shoji

Bottle, c. 1931

Travelling with Bernard Leach on his journey to England in 1920 was the Japanese ceramicist Shoji Hamada, who had seen Leach's work at his 1919 exhibition in Tokyo. During his three-year visit to England, Hamada spent the first few months studying English slipware at the British Museum, before travelling down to St Ives to help Leach set up his pottery. The two potters worked very closely, encouraging each other's enterprises and developing a highly innovative Anglo-Japanese style of 'art' pottery. Early English slipware was an earthenware decorative technique popular in the seventeenth century and made mostly in Staffordshire. 'Slip' is a thinner mix of clay, sometimes the same colour, but usually a contrasting colour, that is applied to a ware either by 'pouring' a design or dipping it for overall coverage. It was then lead glazed before firing, the result being known as 'slipware'. Hamada has used the technique in this vase, the slip over-painted with a Japanese motif. The whole vase was then fired.

Although he returned to Japan, Hamada was a frequent visitor to St Ives as part of his worldwide lecturing tours on Japanese and English pottery techniques, adopting a 'folk craft' aesthetic that became known as *Mingei*.

CREATED

Probably Japan

MEDIUM

Stoneware

RELATED WORKS

Jar with painted decoration by Bernard Leach, 1925

Shoji Hamada *Born* 1894 Tokyo, Japan

Died 1978

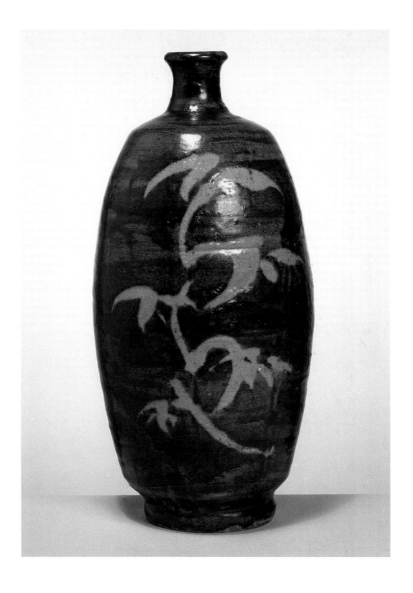

International Arts and Crafts

Society

Pugin, A. W. N.
Encaustic tile, 1847–50

The Gothic revival, which in many ways was the forerunner to the Arts and Crafts movement, involved renewed interest in some medieval and long-forgotten techniques. These were necessary to make replica items for new buildings as well as providing replacements for some of the old ones. The encaustic tile was one such item. Revived during the 1830s, it was used extensively in church interiors and later in secular buildings as well. Although the technique of using contrasting clays to achieve this effect is pure Arts and Crafts, the tiles were actually made in large quantities by firms such as Minton and Co.

This dilemma of separating machine manufacture from individual craftsmanship was one that would continually dog the Arts and Crafts practitioners until well into the twentieth century. The dilemma existed for even the most determined practitioners who wanted to retain hand-made craft such as A. W. N. Pugin and later William Morris, who seemed to reach a pragmatic accommodation for items such as furniture by having certain components machine-made and then using hand assembly and finishing. This was, however, anathema to John Ruskin (1819–1900) who, as a theorist, did not have to deal with the practicalities of manufacture.

CREATED

Staffordshire, England

MEDIUM

Encaustic tile

RELATED WORKS

Minton and Co. encaustic tiles, 1850–60

A. W. N. Pugin *Born* 1812 London, England

Died 1852

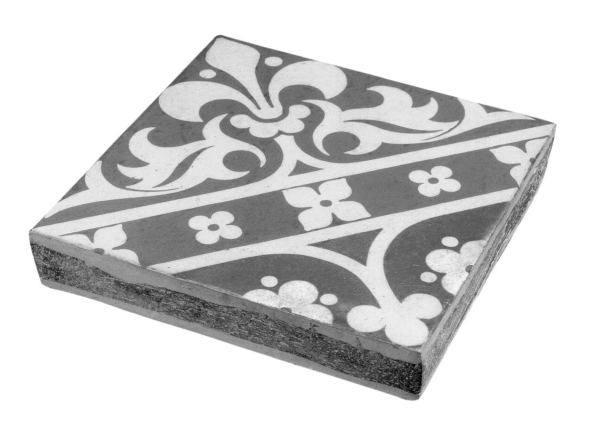

Pugin, A. W. N.

Wallpaper design, new Palace of Westminster, 1851

In April 1840 the foundation stone of the new Palace of Westminster was laid, following an architectural competition won by the architect Charles Barry (1795–1860). The competition stipulated that its design was to be either Gothic or Tudor, signifying the relevance of these medieval styles as appropriate to the seat of government. The young Augustus Welby Northmore Pugin, who subsequently designed most of the interior and furnishings, assisted Barry's submissions for the design. This work was to occupy most of Pugin's life up until the time of his early death in 1852. This was the opportunity for Pugin to exercise his full talents in the application of Gothic to secular, as well as ecclesiastical, commissions.

Officially appointed as supervisor on wood carving, Pugin commissioned the work to be executed in the medieval perpendicular style by the Thames Bank workshops. In the same style was the sovereign's throne used at the State opening of Parliament, based on the fourteenth-century coronation chair at Westminster Abbey. The throne chair was flanked on either side by huge, brass floor-standing candelabra designed by Pugin and executed by John Hardman of Birmingham. Although the later Arts and Crafts movement later adopted Pugin's advocacy of Gothic, its early practitioners eschewed his outside commissioning of craftsmen.

CREATED

England

MEDIUM

Pencil and wash

RELATED WORKS

Wallpaper design for Queen Victoria's Diamond Jubilee by C. F. A. Voysey, 1897

A. W. N. Pugin *Born* 1812 London, England

Died 1852

Pugin, A. W. N.
Chasuble (detail), *c. 1848*

In 1841, A. W. N. Pugin published his *True Principles of Pointed or Christian Architecture* in which he formalized the rules for the Gothic revival: that there should be no features that are not necessary for convenience, construction or propriety, and that all ornament should consist of enrichment of the essential construction of the building. Thus all detail should have meaning in accordance with the purpose for which it was designed. Pugin believed that this truth and honesty to materials were related to the same values in humans, which were present in the craftsmen of the Middle Ages. To him, medieval Gothic architecture and design were indissoluble from belief in the religion of the Gothic age, and to recreate this in the nineteenth century was to offer both a superior design for the age, and salvation for those who embraced it.

Pugin wished to revive Gothic ornament in order to encourage the revival of authentic worship. Some aspects of the Gothic revival interiors are pointed arches, murals in polychromatic designs, encaustic floor and wall tiles with a flat patterning, diapered mosaics, medieval forms of iconography, traditional stained-glass windows depicting biblical scenes and, in Pugin's case, a rood screen.

CREATED

England (probably Mrs Powell's Workshop, Ramsgate)

MEDIUM

Woven silk and silk braid

RELATED WORKS

None contemporary. Reference to fourteenth- and fifteenth-century Italian chasubles

A. W. N. Pugin *Born* 1812 London, England

Died 1852

Pugin, A. W. N.
Design for wallpaper and tiles, *c.* 1851

A. W. N. Pugin's contribution to the Arts and Crafts movement was his continued espousal of the supremacy of Gothic that led to its revival as a movement. For him, there were three rules concerning architecture and, by extension, design; rules that to a large extent would be adopted by the Arts and Crafts practitioners of the next and subsequent generations. Firstly, that there should be a structural honesty that revealed itself in its execution; secondly, an originality in design that avoided copying; and thirdly, that wherever possible there should be a 'truth to materials' in the use of local or regional materials. Pugin saw Classical and Classical revival architecture as pagan and therefore inappropriate for a Christian society. His writings were very influential in this regard, particularly the early *Contrasts*, and *The True Principles*.

Pugin's influence was immense. In his often polemical writing, irrepressible energy and passion for Gothic he is unsurpassed. Although Pugin did not have a problem with the machine aesthetic *per se*, his attention to every detail and use of only the finest craftsmen ensured a quality control that was second to none.

CREATED

England

MEDIUM

Pencil, wash and body colour

RELATED WORKS

Ogival pattern for block-printed paper by Woollams, *c.* 1850

A. W. N. Pugin *Born* 1812 London, England

Died 1852

Pugin, A. W. N.
Table, 1852–53

Along with many of his contemporaries, Pugin was keen to exhibit his decorative arts and further the cause of Gothic at the Great Exhibition of 1851. Pugin was not, however, impressed with Paxton's Crystal Palace, considering it inappropriate for exhibiting Gothic designs and referring to it as a 'cucumber house'. Nevertheless he succeeded in establishing the Medieval Court "which will excite great notice", and involving his manufacturing collaborators. The Medieval Court as a phenomenon was well publicized in newspapers and magazines, including *The Illustrated London News*, which helped to underpin and promote Gothic as the national style.

Needless to say, the exhibition contained many examples of church design including a rood screen, commissioned for St Chad's church in Birmingham, and an elaborate font from his own church in Ramsgate. There were also items of secular design, such as a section of a Gothic staircase and a design for an octagonal table. Pugin, as ever his own apologist, also exhibited a morocco-bound copy of *Glossary of Ecclesiastical Ornament and Costume*, with his own design on the cover. The Medieval Court of 1851 was repeated again at the International Exhibition of 1862 when a new generation of Gothic revival designers, including William Morris, exhibited stained glass and brightly coloured Gothic furniture and embroidery.

CREATED

London, England

MEDIUM

Oak

RELATED WORKS

Trestle table by Philip Webb, *c.* 1863

A. W. N. Pugin *Born* 1812 London, England

Died 1852

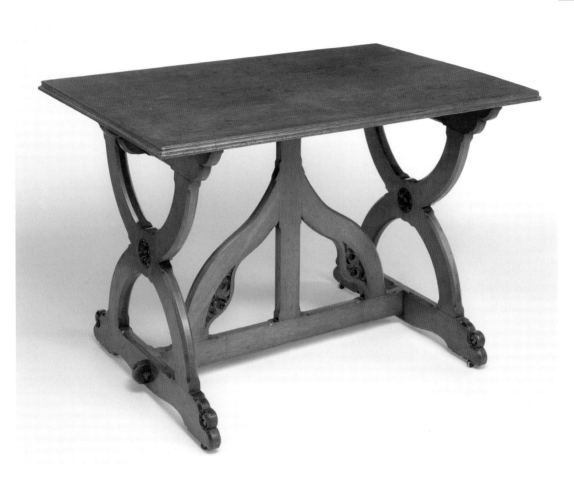

Pugin, A. W. N.

Glossary of Ecclesiastical Ornament, end page, 1844

A. W. N. Pugin was a zealous Catholic. Although often an irrational polemicist, he was a meticulous and fastidious man, who prayed twice a day. The design for his first family home, St Marie's Grange in Alderbury, Wiltshire was in the Gothic style (1835) and incorporated a double-height chapel with its own sacristy. The unusual use of red brick in its construction anticipated Philip Webb's (1831–1915) Red House for William Morris by a quarter of a century. Pugin's later St Augustine's Church at Ramsgate, which he built next to his own home, was more conventionally Gothic, constructed using 'truth to materials' local flint with stone dressings.

Pugin's religious fervour extended beyond architecture, interior design and furnishings. In his most scholarly and lavish book, *Glossary of Ecclesiastical Ornament and Costume* (1844), he designed elaborate garments and woven braids for stoles and chasubles for the clergy. He also designed a bishop's mitre and elaborately embroidered altar frontals. For Pugin these accessories were every bit as important as a church's fabric, in the celebration of mass. At St Augustine's, Pugin organized the liturgy to his own taste using plain chant medieval singing, with him as cantor. The church is also the family burial place, where Pugin himself was laid to rest.

CREATED

England

MEDIUM

Bookplate

A. W. N. Pugin *Born* 1812 London, England

Died 1852

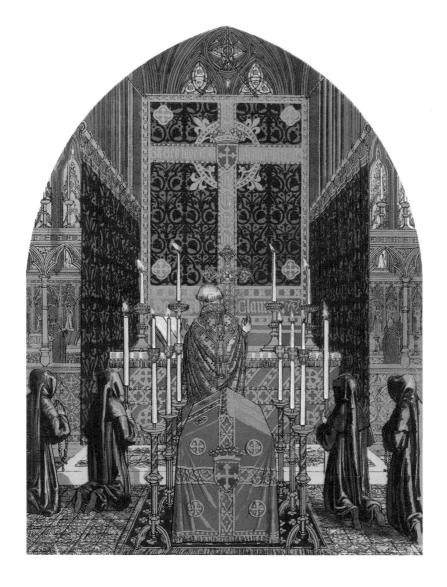

Ruskin, John

A Window in the Foscari Palace, watercolour, 1845

John Ruskin rejected utterly the machine and mass production. Aside from spawning dangerous and life-threatening conditions, he believed that it threatened to destroy the individual work ethic and freedom of expression. In his 1853 essay *The Nature of Gothic*, he wrote:

'We have much studied and much perfected of late, the great civilized invention of the division of labour, only we give it a false name. It is not, truly speaking, the labour that is divided, but the men. We are always in these days endeavouring to separate labour and intellect. We want one man to be always thinking and another to be always working and we call one a gentleman and the other an operative; whereas the worker ought often to be thinking and the thinker often to be working, and both should be gentlemen in the best sense. As it is we make both ungentle, the one envying, the other despising his brother; and the mass of society is made up of morbid thinkers and miserable workers.'

Ruskin continued:

'Never encourage the manufacture of any article not absolutely necessary; never demand an exact finish for its own sake, but only for some noble or practical end; and never encourage imitation or copying of any kind except for the sake of preserving record of great works.'

CREATED

Venice

MEDIUM

Pencil and watercolour

John Ruskin *Born* 1812 London, England

Died 1900

Ruskin, John

Bookplate for *The Seven Lamps of Architecture*, 1849

A continual theme in John Ruskin's writing was the study of nature as an inspiration for architecture and design. Even before Charles Darwin published his controversial *On the Origin of Species* in 1859, Ruskin, a keen naturalist, had alluded to new perceptions about the Earth's geological formation in his 1851 book *The Stones of Venice*. He suggested that the Venetians themselves were inspired by these natural forms and had decorated their façades in anticipation of these discoveries.

However fanciful Ruskin's arguments were, his writing had an enormous effect on the next generation of architects and designers in the high-Victorian period. Many of these buildings, both religious and secular, were constructed using layers of variously coloured bricks and stonework reflecting a growing interest in geology and natural history. The Natural History Museum in London (1873–81) and the Oxford University Museum of Natural History, in which Ruskin himself was involved, are supreme examples of the style. The interiors are decorated with various hand-carved ornamental motifs of animal and plant species, reflecting the buildings' purposes.

CREATED

England

MEDIUM

Bookplate

John Ruskin *Born* 1812 London, England

Died 1900

Ruskin, John

The Ducal Palace, lithograph, 1851

In *The Seven Lamps of Architecture*, published in 1849, John Ruskin sought to inform and persuade a new generation of designers to accept certain principles of good design practice. His was a moral crusade rather than a practical guide to design, based on what he considered to be the degenerative and immoral designs of the Classical revival and the use of modern materials. For Ruskin, as articulated in the chapter 'The Lamp of Truth', the remedy was in the adoption of the Gothic aesthetic, an insistence on honesty of construction and a 'truth to materials'. His approach was less dogmatic than Pugin's, allowing, for example, the painting of walls and the use of coloured materials in building construction. According to Ruskin, Gothic was practical, since it did not have to obey the orders of Classical architecture. The lack of symmetry in a Gothic building meant that if a window was needed in a design then the architect could just add one, regardless of conventions.

In 1877 Ruskin joined William Morris's Society for the Protection of Ancient Buildings, (affectionately known as 'Anti-Scrape'), in order to combat the over-restoration of medieval buildings, a problem much in evidence at this time. Ruskin's eloquent and polemical prose did much to raise the profile of this organization.

CREATED

England

MEDIUM

Bookplate lithograph

RELATED WORKS

Design for the offices of General Credit and Discount Co., London by George Somers Clarke the elder, 1866

John Ruskin *Born* 1812 London, England

Died 1900

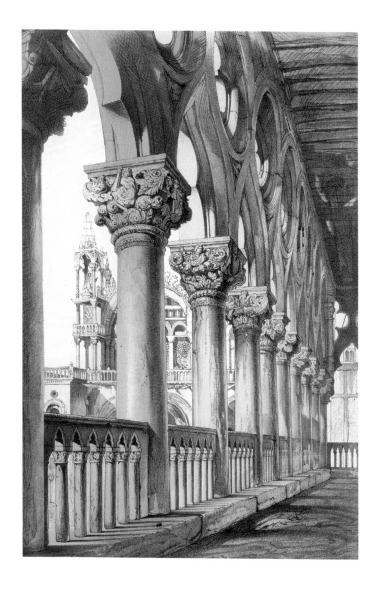

Ruskin, John

Illustration for the *Stones of Venice*, 1851

John Ruskin felt that the social ills of his time could be remedied by good art and good design. He was a tireless crusader for social justice, through his many writings and lectures on art, architecture and design. In a lecture given in March 1859, he put forward his ideas in opposition to the *laissez-faire* capitalism of mass production prevalent at that time. He suggested that a return to the ethos of the Middle Ages would be counter-productive since it was based on a feudal system of inequality. Instead, Ruskin advocated better modern circumstances, which would influence better design and craftsmanship. He said, "beautiful art can only be produced by people who have beautiful things around them".

Putting these ideas into practice was, however, more difficult for Ruskin. In 1871 he founded the Guild of St George, a short-lived regenerative venture set up to encourage good design and craftsmanship in comfortable surroundings. Its craftsmen received fair pay and shared the produce from community farms. The emphasis was on clean and healthy living, but its inhabitants were bound by Ruskin's strict codes of morality and religious beliefs. It did, however, set the precedent for future guilds by Ruskin's followers, such as the Century Guild set up by Arthur Heygate Mackmurdo (1851–1942) in 1882.

CREATED

England

MEDIUM

Bookplate

John Ruskin *Born* 1812 London, England

Died 1900

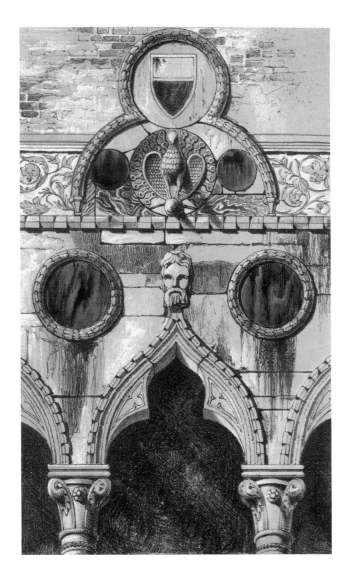

Ruskin, John

A Coronet of Acorns and Leaves, drawing

The Gothic revival became the national characteristic for architecture and design after the middle of the nineteenth century, particularly following the decision to rebuild the Palace of Westminster in the Gothic style. John Ruskin ably assisted the enterprise in his unequivocal espousal of Gothic, summed up in this extract from *The Flamboyant Architecture of the Valley of the Somme*:

'Commonly it is said of all Gothic, that it rose in simplicity, that it declined by becoming too florid and too rich. Put that error at once out of your minds. All beautiful and perfect art, literature or nature is rich. Titian is rich, Beethoven is rich, Shakespeare is rich, and the forests, and the field, and the clouds are richest of all. And the two most beautiful Gothic pieces of work in the world – the South door of the Cathedral of Florence, and the North transept door of the Cathedral of Rouen, – were both in the thirteenth century covered with sculpture as closely as a fretted morning sky with sands of cloud.'

In Ruskin's mind, the design and execution of handcrafted ornament and religious belief were inextricably linked. The execution of the Gothic motif was in Ruskin's words 'the expression of man's delight in God's work'.

CREATED

England

MEDIUM

Pencil and watercolour

John Ruskin *Born* 1812 London, England

Died 1900

Morris, William

Dante Gabriel Rossetti as Chaucer Reading, tile, 1864

In 1856 William Morris began painting, using Dante Gabriel Rossetti (1828–82), the established Pre-Raphaelite painter, as his mentor. Sharing a studio with Edward Burne-Jones (1833–98) in London, the two artists began painting scenes from Arthurian legends in a Pre-Raphaelite style, based on the writings of Tennyson and Chaucer, often depicting tragic love. Shortly after, Rossetti himself began using Janey Burden (1839–1914), who was later married to Morris, as a model for his own ethereal paintings based on these same legends. Chaucer's *Canterbury Tales* was popular literature in Victorian England and inspirational for a number of painters and illustrators. Their subject matter was particularly suitable, along with the more contemporary medieval Romantic tales of Tennyson and Scott. These enigmatic paintings of medieval subjects usually depicted tragic or unrequited love and death.

In 1862, Rossetti's wife committed suicide and he subsequently fell in love with Janey, the wife of his former protégé. Morris, his wife and Rossetti lived from 1871 in a shared tenancy at Kelmscott Manor in the Cotswolds where Rossetti and Janey continued their affair during Morris's long absences. In June of the following year, Rossetti had a nervous breakdown and the relationship ended. Chaucer himself could well have written this tragic story.

CREATED

London, England

MEDIUM

Tile

RELATED WORKS

Dust-pressed tiles by Josiah Wedgwood, 1878

William Morris *Born* 1834 Walthamstow, England

Died 1896

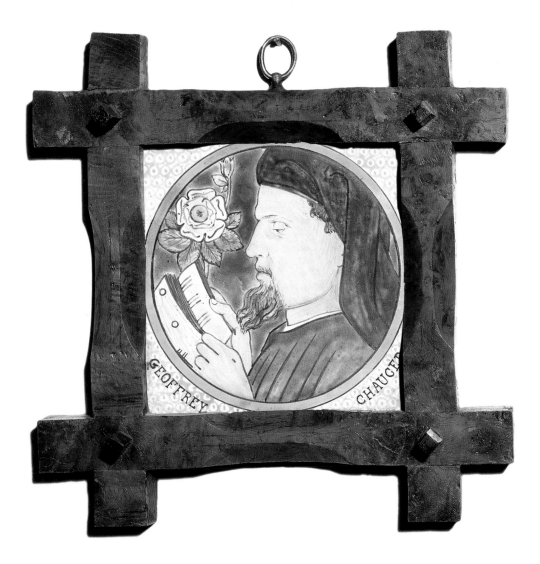

Morris, William

Chrysanthemum wallpaper, 1877

By the middle of the nineteenth century, the justifiable criticism of the early machine-made Victorian wallpapers, with their absurd illusions and garish colours, heralded a new style of design by practitioners such as A. W. N. Pugin. His designs were more formal, often in heraldic colours, but advocated flat patterning and simpler designs such as the *fleur-de-lys* and other abstracted floral motifs. William Morris, accepting the challenge of John Ruskin's call for artists and designers to be influenced by nature, began designing and producing a range of wallpapers between 1862 and 1896. They were often in collaboration with his pupil, J. H. Dearle (1860–1932), and were much lighter and fresher in style than Pugin's formalist geometry. Morris's designs satisfied the Victorian appetite for floral decoration, while maintaining the flat patterning that eschewed false illusion.

The *Chrysanthemum* pattern was created in 1877 and was typical of those sold through the retail outlet of Morris, Marshall, Faulkner and Co. (later Morris and Co.) in London's Oxford Street. The shop provided a showroom for the designs of all their products including furniture, hand-woven carpets and rugs, textiles and tiles. It also provided financial security, since many of their orders came through the retail outlet.

CREATED

England

MEDIUM

Wallpaper

RELATED WORKS

Indian wallpaper by George Gilbert Scott, 1878

William Morris *Born* 1834 Walthamstow, England

Died 1896

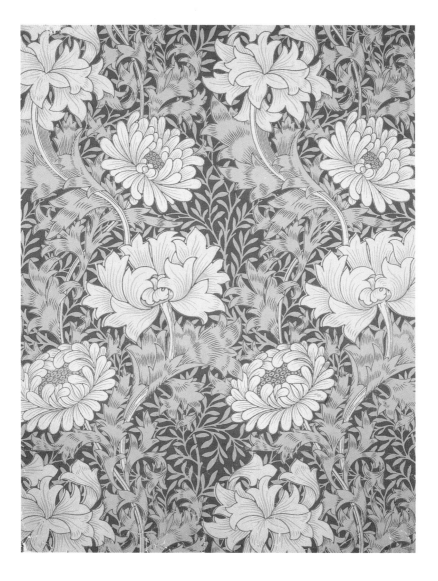

Morris, William

Pelmet for St James's Palace, c. 1881

Following John Ruskin's earlier example, a number of Arts and Crafts Guilds were set up from the 1880s onward. Their aims were varied but the ethos of each was to raise the profile and status of the decorative arts, and to highlight the role of the designer as the originator and sometimes executor of the object.

The first of these was A. H. Mackmurdo's Century Guild, founded in 1882, whose aim was to raise the profile of the crafts of pottery, woodworking and metalwork as well as interior decoration, and afford them equal status with the fine arts of painting and sculpture. The Art Workers' Guild was founded in 1884 and elected William Morris as its master during 1892. However, these Guilds, including C. R. Ashbee's (1863–1942) Guild of Handicraft, were exclusively male. They were, in fact, little more than gentlemen's clubs that occasionally held 'ladies' nights'. Significantly, women were seen as homemakers and therefore not required to earn a living from their labours. Embroidery, an essentially home-based activity not requiring a studio, was the only craft in which males did not seek to dominate. One of its main practitioners was Morris's daughter May (1862–1938), who set up her own Women's Art Guild in 1907. In many ways this was too little, too late.

CREATED

London, England

MEDIUM

Hand-woven silk

William Morris *Born* 1834 Walthamstow, England

Died 1896

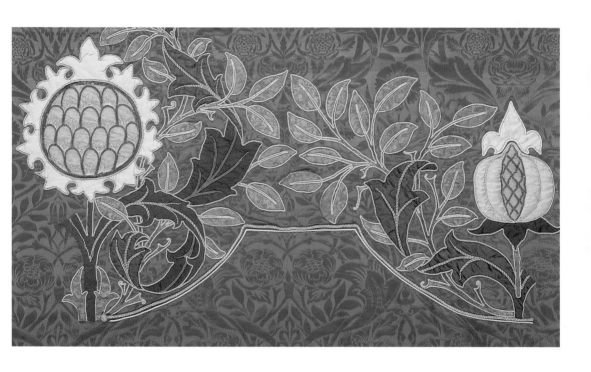

Morris, William

Saville chair, 1890

© Victoria & Albert Museum, 2005

The Industrial Revolution created not only a new industrial factory-owning middle class, but a new, and burgeoning, group of professional classes such as lawyers to meet their commercial needs. One such firm of lawyers was Beale and Co., based in the industrial heartland of Birmingham and instrumental in assisting the Midland Railway to expand their operation. This culminated in the opening of their terminus at St Pancras in London, in 1868. George Gilbert Scott's (1811–78) Midland Hotel (1868–74) in the Gothic style, fronting the station, is a testimony to the significance of the terminus.

When the young James Beale was asked to set up a London office for the firm, he was newly married and lived for several years in fashionable Holland Park. In 1880, the house was completely redecorated by Morris and Co. under the direction of Philip Webb. Like many affluent professionals of the time, Beale sought a house in the country and, not surprisingly, he chose Webb as the architect. The result was Standen, a thoroughbred Arts and Crafts house furnished exclusively in the appropriate style with most of the fabrics, textiles and carpets provided by Morris and Co. An example of the Saville chair can be seen in the hallway.

CREATED

England

MEDIUM

Mahogany, with Utrecht velvet upholstery

RELATED WORKS

Bergère armchair by George Jack, 1893

William Morris *Born* 1834 Walthamstow, England

Died 1896

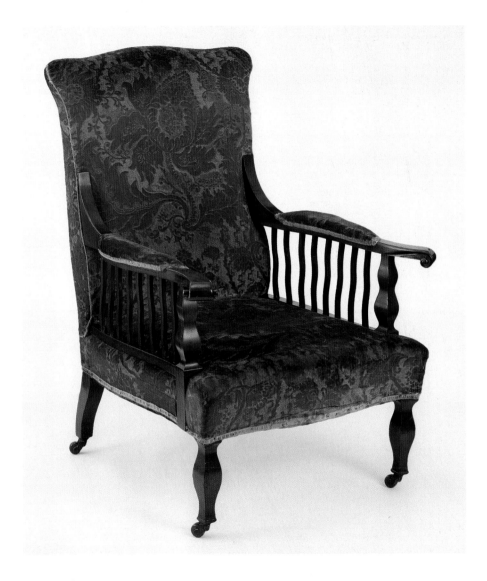

Morris, William
Tulip and Lily carpet, 1870–75

In 1877, William Morris was reported as saying, "I spend my life ministering to the swinish luxury of the rich". His comments came in the wake of a realization that despite his best efforts to make 'An art for the people, by the people' his designed goods were not affordable to all, particularly the working and lower-middle classes. He had designed and manufactured hand-knotted carpets for his upper-class patrons such as the Honourable Percy Wyndham, who were wealthy enough to afford them, but sought a way to be able to provide high-quality products to the less affluent.

Although Morris, like Ruskin, rejected mass production as an ideal, one answer to this dilemma was the machine manufacture of certain selected labour-intensive products or their components. The *Tulip and Lily* carpet design by Morris was as one such candidate. In 1875 the Heckmonwike Co. at Kidderminster manufactured the carpet, but it was still affordable by only the middle classes. An example is in the North Bedroom at Standen. Morris also used machine manufacture for certain components of the Sussex chair to make it more cost-effective and affordable. However, the assembly and finishing were undertaken in their own workshops.

CREATED

Yorkshire, England

MEDIUM

Machine-woven carpet, using three-ply wool

RELATED WORKS

Sultan woven-silk fabric by Owen Jones, 1870–74

William Morris *Born* 1834 Walthamstow, England

Died 1896

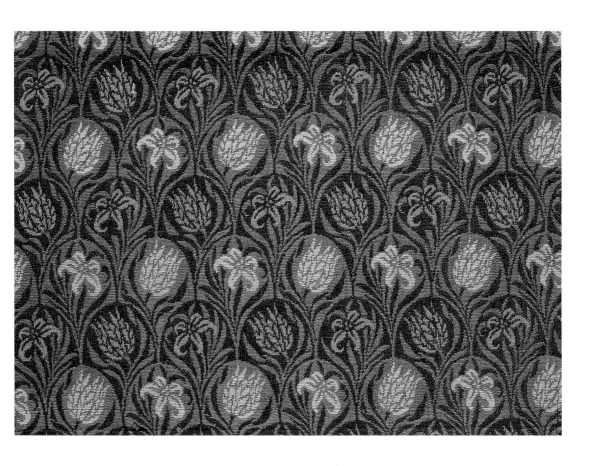

Morris, William

The Life and Death of Jason, book cover, 1882

In 1889, William Morris set up his own publishing and printing works in Hammersmith called the Kelmscott Press. Morris was already involved in manuscript illumination and had written a number of poems including 'The Earthly Paradise', which was developed during his time at Red House, and 'Love is Enough'. The Chiswick Press had also recently printed his first book, *The House of the Wolfings*. One of his earliest poems, 'The Life and Death of Jason', had a particularly modern idiom suited to contemporary life: 'When we light the lamp and draw the curtains after a hard day's work on some autumn evening, comes the turn of the poet who is willing and able to amuse us.'

The books that Kelmscott produced were very expensive. Morris himself produced over 600 individual designs for covers, borders and title pages, and his friend Edward Burne-Jones produced over 80 illustrations. His *News From Nowhere* (1890) is an allegory of a utopian ideal conveying key socialist themes. In recognition of Ruskin's significance and influence on him personally, Morris produced an illuminated version of John Ruskin's *The Nature of Gothic* in 1892, through Kelmscott Press.

CREATED

Kelmscott Manor, Oxford, England

MEDIUM

Leather, inlaid with gilt

RELATED WORKS

The Pilgrim's Progress, Essex House Press, 1899

William Morris *Born* 1834 Walthamstow, England

Died 1896

Morris, William
Design for a tapestry, 1879–81

Although the Arts and Crafts movement began, at least in part, as a reaction against the badly designed and shoddy mass-produced goods as exemplified at the Great Exhibition, there was an awareness from William Morris that the exhibition was a commercial success and therefore a good forum for promotion. Consequently, Morris and Co. took two stalls at the International Exhibition of 1862, where they exhibited samples of stained glass and brightly painted Gothic furniture.

The first specifically Arts and Crafts exhibition was under the aegis of the Arts and Crafts Exhibition Society in 1878, and was an opportunity to promote the ideals of the Arts and Crafts movement and for crafts people to display their talents. Morris himself gave a demonstration of weaving. It was at this time that Morris had perfected a range of natural dyes that could be used on silks and wools for embroidery, tapestry and weaving. Morris had reservations about the society's call to credit the craftsperson as well as the designer of the work exhibited, stating that "it was not by printing lists of names in a catalogue, that the status of a workman could be raised". These remarks seem to be counter to the Arts and Crafts ethos, but Morris may well have been protecting his own 'corporate' Morris and Co..

CREATED

London, England

MEDIUM

Pencil, pen and ink, watercolour and body colour

RELATED WORKS

Batt woven silk by G. C. Haité, *c.*1880

William Morris *Born* 1834 Walthamstow, England

Died 1896

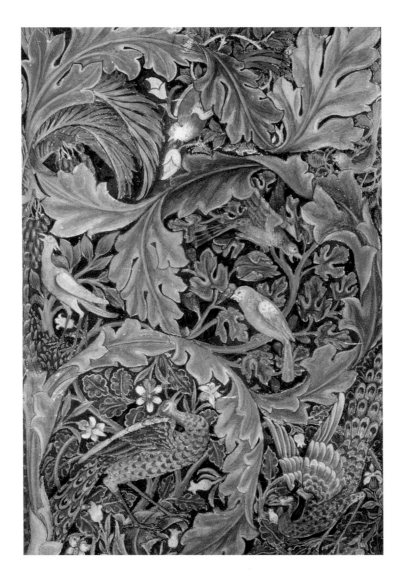

Morris & Co.

Bookcase

During the 1880s, there was a much more widespread interest in the Arts and Crafts. The Victorian middle classes of the high to late Victorian period were burgeoning and good design became more accessible to more people. Morris and Co. were able to provide almost everything for a home's interior decoration, from wallpapers to furnishing fabrics, tiles to carpets, and decorative ceramics to furniture. To show design ideas and market them to this burgeoning clientele, a number of magazines and journals sprang up during the 1880s and 1890s. By far the most important of these journals was *The Studio*, set up by Charles Holme in 1893. This journal, with its lavish illustrations, broke the mould of its existing competitors in that it catered not just for those with interior-decorating aspirations, but for those with an interest in art, as part of a move to integrate the two. This was in the true spirit of Ruskin and Morris.

There was also a growing interest in the techniques of home-based arts and crafts such as embroidery, pottery and painted ceramics. To accommodate this market there were specialist journals such as *Embroidery*, and the all-embracing ones as exemplified by Arthur Heygate Mackmurdo's *Hobby Horse* from 1884 onwards.

CREATED

England

MEDIUM

Mahogany

RELATED WORKS

Sideboard by George Jack, 1887

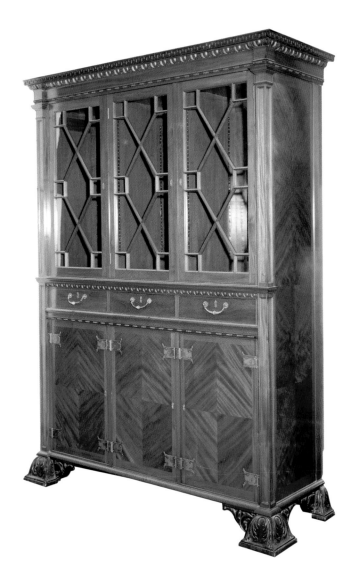

Morris, William

Minstrel Angel with Cymbals, stained glass, 1869

By the beginning of the nineteenth century, the technique of traditional stained-glass craftsmanship was almost forgotten. Among the first commissions in the early 1860s that the Morris partnership enjoyed, was the manufacture of stained-glass panels for the new Gothic revival churches and for the old medieval ones that were being restored or added to. One such church was St Michael's at Tilehurst in Berkshire, a fourteenth-century church in need of restoration and additional accommodation for a burgeoning congregation. The architect involved in this restoration was G. E. Street, with whom Morris was apprenticed on leaving Cambridge in 1856. The commission was to provide a number of panels for the east window of the newly created Lady Chapel in the oldest part of the church.

In 1877, having already ceased acceptance of further stained-glass commissions, Morris moved to found the Society for the Protection of Ancient Buildings, in the wake of over-zealous restoration of medieval buildings. He was particularly angered at George Gilbert Scott's proposed restoration of Tewksbury Abbey. Morris objected to over-restoration of these buildings by nineteenth-century craftsmen saying, "The workman of today is not an artist as his forefather was; it is impossible under his circumstances that he could translate the work of the ancient handicraftsman".

CREATED

England

MEDIUM

Stained glass

RELATED WORKS

King Rene's Honeymoon by Edward Burne-Jones, 1863

William Morris *Born* 1834 Walthamstow, England

Died 1896

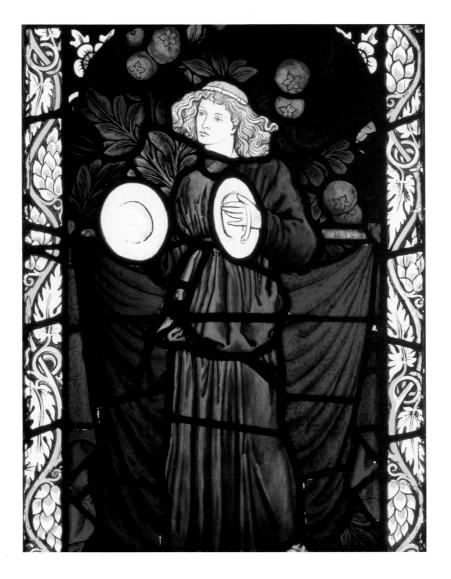

Morris & Co.

Gold frame enclosing a lock of hair

The Victorians' passion for collecting photographs and ephemera was a reflection of their age, when the family unit was vital to the infrastructure of society. The Victorian age saw a huge increase in Britain's population, more than doubling the 14 million people recorded in 1821 to nearly 30 million in the 1871 Census. There was also a huge increase in the availability of photographic reproduction, with Victorians eagerly sitting for family portraits in the many studios that had set up shop in all the major towns and cities.

William Morris and his family were also recorded for posterity, as were many of his friends. Morris's family consisted of his wife Janey and their two daughters, May and Jenny. Both girls were accomplished embroiderers and May continued as a designer and craftswoman after her father's death. Jenny suffered from epilepsy, a condition misunderstood at that time, and was constantly in need of care by her mother. There are also a number of informal photographic portraits at Kelmscott enabled by the development of more portable photographic equipment. The advent of these cameras, including the 'Brownie' in 1900, enabled many of the next generation of Arts and Crafts practitioners such as Gustav Stickley (1858–1942) to record their own work and studios.

CREATED

England

MEDIUM

Gold

RELATED WORKS

Designs for Liberty and Co. by Archibald Knox, c, 1900

Morris, May
Embroidery kit, c. 1890

William Morris's approach to socialism was radical and distinctive, in that he considered women's socialism (in the home) as important as men's (in the factory). For him it was important to introduce socialist doctrine into all aspects of life, work and home. He had a very strong Protestant work ethic, but one that was tinged with Marxism, believing that every man had a right to work. However, the Art Worker's Guild, of which Morris was Master, excluded women from its ranks despite having many female workers in his workshops including his daughter May. This was a trait of all guilds, until May's own Women's Arts Guild was formed in 1907.

Like Ruskin, Morris found society after the Industrial Revolution to be 'sick' and he was also concerned about the division of labour. Morris was a tireless speaker to, and on behalf of, the working class, often travelling great distances to speak. He also wrote extensively for the socialist cause, writing and editing *The Commonweal*, a weekly journal of the Socialist League. His devotion to socialism meant personal sacrifices of long absences from his home and family as well as considerable financial outlay. He was rewarded in 1892, however, by the election of Britain's first Independent Labour Party Members of Parliament.

CREATED

London, England

MEDIUM

Cotton with ink tracing, working in silk

RELATED WORKS

Various embroidery kits by May Morris, after 1885

May Morris *Born* 1862 Bexley, England

Died 1938

Morris, William

Bluebell or *Columbine* furnishing fabric, 1876

In 1878, William Morris became involved in political life, publishing a pamphlet called *Unjust War: To the Working Men of England*, which condemned the British government's apparent complacency concerning the recent heavy loss of lives in Bulgaria. The period from the 1870s onwards was also fertile for social change in favour of the working classes due to increased unemployment and poor factory conditions.

His move to the more radical socialist cause occurred later, after he attended a series of lectures on socialism. Although Karl Marx (1818–83) was living in London up to the time of his death, Morris never met him, but he was influenced by his work. He began to associate with other socialists during the 1880s who regularly met in the Coach House at Kelmscott House in Hammersmith. They included writers such as George Bernard Shaw (1856–1950) and William Butler Yeats (1865–1939). Morris became a member of the Social Democratic Federation, founded in 1884 as the first British socialist party, and its members included Marx's daughter Eleanor. More poignant was Morris's election as treasurer and publisher of its newsletter *Justice*. Nevertheless, Morris was never able to live down the criticism that invariably followed him, due to the contradiction between his position as a middle-class businessman and his socialist ideals.

CREATED

Leek, Staffordshire

MEDIUM

Printed textile

RELATED WORKS

Stafford woven silk by Bruce Talbert, 1875

William Morris *Born* 1834 Walthamstow, England

Died 1896

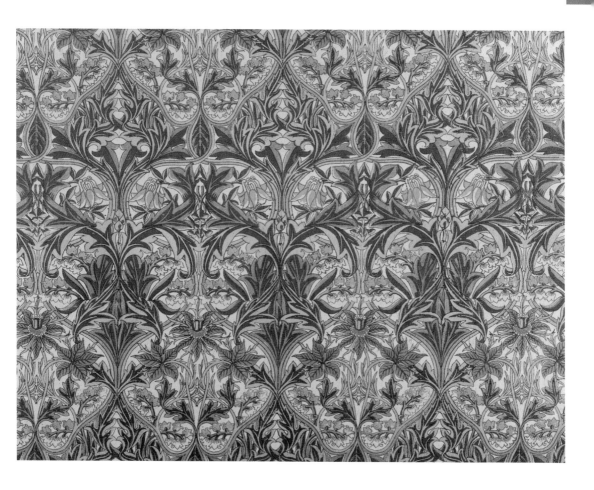

Mackmurdo, A. H.
Chair, 1883

Arthur Heygate Mackmurdo was among the earliest of the Arts and Crafts practitioners, whose style could be seen as a departure from the Gothic revival to a new organic style that some have seen as anticipating Art Nouveau. This shift in emphasis was seen at the time as curtailing the heavy and often cumbersome excesses of Gothic, in favour of a lighter touch. It was, as in this example, also seen as articulating the organic forms suggested by John Ruskin's continued espousal of the inspiration of nature. The emphasis on the organic forms in Mackmurdo's work should be seen in the light of his discipleship of Ruskin.

Mackmurdo's designs conform to a new simplicity that became popular from the 1880s onwards. An accommodating factor in this was the revival of the Queen Anne style, using combinations of lighter woods, often as inlays, within an overall mahogany structure. His designs must also be seen as a reflection of his interest in the Renaissance traditions of a unity in the arts. Although many of his designs were organic, Mackmurdo was also known for emphasizing the rectilinear aspects in his work, which influenced a number of later Arts and Crafts practitioners including Charles Voysey (1857–1941).

CREATED

England

MEDIUM

Mahogany and painted mahogany on fretwork

RELATED WORKS

Bloemenwerf chair by Henry van de Velde, 1895

A. H. Mackmurdo *Born* 1851 London, England

Died 1942

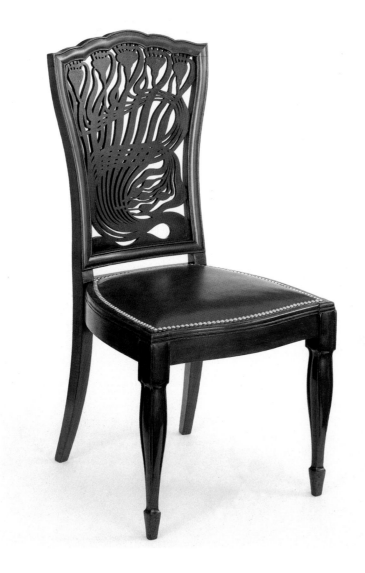

Mackmurdo, A. H.

Cromer Bird furnishing fabric, 1884

The 1880s was a 'coming of age' for Arts and Crafts as a movement. While William Morris was devoting himself more to the wider political and social issues of the day, other design reformers such as Arthur Mackmurdo organized more practical and cohesive ways of spreading the Arts and Crafts 'gospel'. Although Gothic as a style was by this time waning, the notions of medieval craftsmanship and its suitability as an alternative to mass production still had currency, not just by the Arts and Crafts practitioners, but also by their increasing numbers of clients in the middle classes, who sought accommodation outside of the metropolis in one of hundreds of 'new-builds' appearing in the new suburbs.

The practitioners had to decide how to organize themselves into a co-operative, which would provide good working practices and conditions and fair pay, rather than treat them as 'factory fodder'. In 1882 Mackmurdo tackled this problem by founding the Century Guild. Based on the Guilds of London and other medieval cities, a guild provided a guarantee that its members' work was of the highest standards, while ensuring they were paid properly for it.

CREATED

England

MEDIUM

Furnishing fabric

RELATED WORKS

The Angel with the Trumpet printed cotton by Herbert Horne, 1884

A. H. Mackmurdo *Born* 1851 London, England

Died 1942

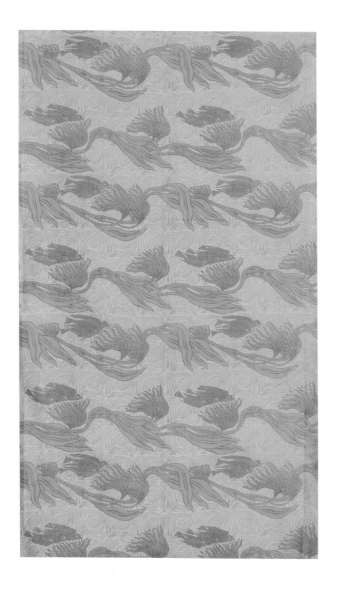

Mackmurdo, A. H.

Design for a wall decoration, c. 1882

John Ruskin's travelling companion to Italy in 1874 was Arthur Mackmurdo. Mackmurdo may well have been advised by his mentor that a modern guild based on medieval traditions would be advantageous to both the patron and the craftsman, despite the failure of Ruskin's own Guild of St George. Ruskin's ideas were not based on sentimental notions of a bygone age, but aimed for a pragmatic way of enriching the craftsman's working conditions, and in turn ensuring exacting standards for his patron.

Mackmurdo set up the Century Guild as a co-operative, with the help of his former student Herbert Horne (1864–1916) and the artist Selwyn Image (1849–1930), to 'render all branches of art the sphere no longer of the tradesman but of the artist'. Their aim was to ensure that craftsmanship was ranked as an equal to the fine arts of painting and sculpture. Although Mackmurdo and Horne were the designers of the Guild's work, many of the items were sold under the banner of the Century Guild. Their main products were furniture, metalwork, enamelling and textiles. Wallpapers were also designed in-house. Although the Century Guild only existed for six years, it was the first of its kind and set the parameters for other later guilds.

CREATED

England

RELATED WORKS

Strawberry Thief fabric design by William Morris, 1883

A. H. Mackmurdo *Born* 1851 London, England

Died 1942

Mackmurdo, A. H.
Cabinet, 1885–86

In order for Arthur Mackmurdo to disseminate the work of the Century Guild, he set up a quarterly journal called *Hobby Horse*, which began publication in April 1884, 'to encourage and establish a high standard of form and method'. *Hobby Horse* was the first of a number of journals to articulate the aims of the Arts and Crafts movement, and its contributors included such luminaries as John Ruskin and Oscar Wilde (1854–1900), as well as artists such as Edward Burne-Jones.

More importantly, *Hobby Horse* was the first journal to inform Europe of the Arts and Crafts movement and British design theories, as articulated by Ruskin and William Morris. The design of the journal was important too, with an emphasis on traditional printing and high-quality illustrations, often provided by Selwyn Image, a partner in the Century Guild. Chiswick Press, who had earlier printed a book of William Morris's poetry for him, printed the journal, using handmade papers; an indication of the importance that Mackmurdo attached to the magazine. As the official voice of the Century Guild, *Hobby Horse* had outlived its purpose when the Guild was wound up in 1888. However, it played a major role in setting a precedent for future Arts and Crafts journals.

CREATED

England

MEDIUM

Mahogany

RELATED WORKS

Cabinet for Kenton and Co. by Mervyn Macartney, 1891–95

A. H. Mackmurdo *Born* 1851 London, England

Died 1942

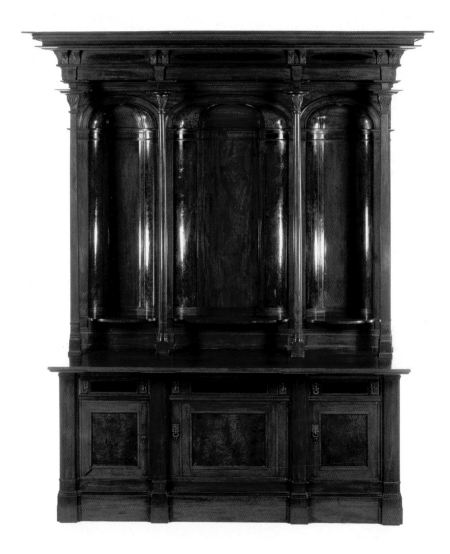

Mackmurdo, A. H.

Vertical swirling leaf design, c. 1884

By the 1890s, many new jobs had been created by the vast wealth of London as a commercial centre, itself creating a burgeoning aspirant middle class. The growth of the new middle class during this period was accommodated by the increasing numbers of 'villas' and smaller cottage-style homes being built in the new suburbs such as Streatham, now in south London. Many of their owners sought a more 'homely' atmosphere, with chintz soft furnishings, decorative but elegant wallpapers and simple, stylish furniture. There was also an increased demand for quality ornamentation such as pottery and wall hangings. An awareness of hygiene also increased the demand for kitchen and bathroom tiles.

However, the increased demand for these products necessitated the contracting out of many items, a dilemma for many of the Arts and Crafts artisans. A great deal of the furniture was made by the Century Guild craftsmen, including Mackmurdo, but they also used a major cabinet-making firm, Collinson and Lock. All of the wallpapers were made by Jeffrey and Co. and the textiles were printed by Simpson and Godlee.

CREATED

England

MEDIUM

Wallpaper

RELATED WORKS

Dove and Rose fabric design by William Morris, 1879

A. H. Mackmurdo *Born* 1851 London, England

Died 1942

Mackmurdo, A. H.
Writing desk, *c.* 1886

This writing desk typifies the style and elegance of the new middle classes of the 1880s and 1890s. It is also typical of a style that its artisans sought through an eclectic mix of the Queen Anne revival and the simplistic honesty of the Arts and Crafts tradition. Although it uses veneers for its drawer-fronts, as a decorative function they are subtle. The structure is basically rectangular and the tapered unornamented legs are simple but elegant. More importantly, its honesty lies in its form as a functional piece of furniture, and it anticipates twentieth-century design philosophy of 'form follows function'.

Its use as a piece of elegant and unobtrusive furniture for the middle classes was suited to modern suburban homes of the period, which were smaller and less cluttered. Many of these homes were in the developing suburbs of the major cities, particularly London. The electrification of London's existing rail network, together with the further development of the underground railway from the 1890s, enabled commuting to London from the idyllic leafy suburbs.

CREATED

England

MEDIUM

Mahogany with inlays

RELATED WORKS

Walnut cabinet by Ernest Gimson, *c.* 1895

A. H. Mackmurdo *Born* 1851 London, England

Died 1942

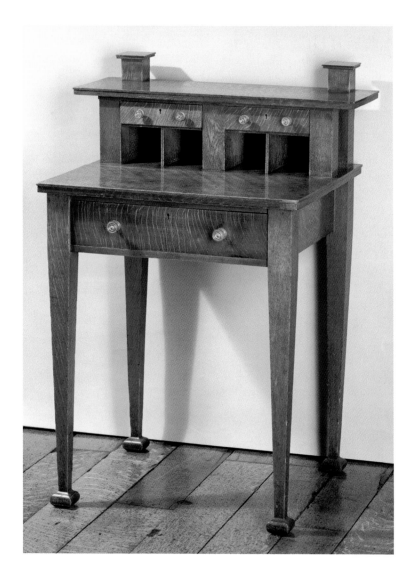

Mackmurdo, A. H.
Woven wall hanging, 1887–88

Arthur Mackmurdo was 91 when he died, his lifetime encompassing all of the changes that influenced and affected the Arts and Crafts movement. As an Arts and Crafts practitioner, his career was not unlike many others, having been 'schooled' in the Gothic revival and influenced firstly by John Ruskin and then William Morris, both in terms of design and socialist ideals. However, Mackmurdo was a complex man and, unlike Ruskin, was also interested in Renaissance architecture, having made a detailed study of it on his numerous trips to Italy. He was also unlike Morris, who thought that the "Japanese have no architectural, and therefore no decorative, instinct" – Mackmurdo respected their aesthetic as a part of an English Aestheticism. What he brought to the Arts and Crafts movement in the 1880s and 1890s was a combination of this eclectic mix; a sense of the geometry of Renaissance architecture, the simplified forms of Japanese motifs, and the natural world of plants and flowers as advocated by Ruskin.

Although Mackmurdo produced many designs for furniture, textiles, wallpapers and even metalwork based on these ideas, by 1906 he had given up designing and spent most of his time in what he called 'the sphere of social politics'. Like Morris he was unable to 'square the circle'.

CREATED

England

MEDIUM

Woven wall hanging

RELATED WORKS

Woven silk by Samuel Rowe, 1895

A. H. Mackmurdo *Born* 1851 London, England

Died 1942

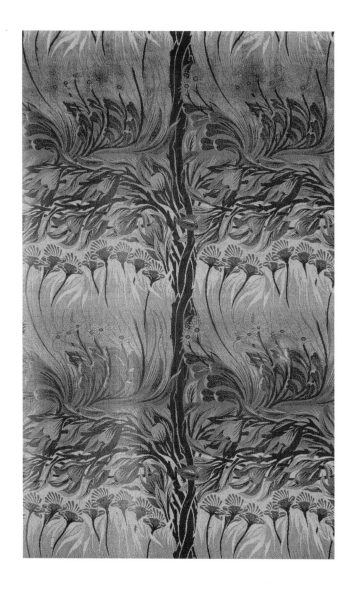

Lethaby, William

Oak dresser, c. 1900

The architect Richard Norman Shaw (1831–1912) was responsible for training a number of the second-generation Arts and Crafts designers who worked in his office, most notably William Richard Lethaby, Charles Voysey and Walter Crane. From Shaw, who designed many of the Queen Anne revival houses at Bedford Park and created the exuberant 'Cragside' house in Northumberland, they took a sense of theatricality, inventiveness and wit in design; necessary traits, if one were to be successful in the absurd excesses of Edwardian England.

Based on the Arts and Crafts principle of 'a work of art is a well made thing', Lethaby set up a furniture-making business called Kenton and Co. in 1890, in conjunction with Ernest Gimson (1864–1919) and Sidney Barnsley (1865–1926). In every sense this enterprise epitomized the Arts and Crafts ethos, to make the best well-designed furniture possible, using the best materials and the finest craftsmen. The designs, material selections and construction were all managed in-house, but despite modest success the venture closed two years later, through lack of working capital. Undeterred, Lethaby continued as a furniture designer and showed his work at the Arts and Crafts exhibitions he had helped to instigate in 1889.

CREATED

England

MEDIUM

Oak

RELATED WORKS

Dresser by Peter Behrens, 1902

William Lethaby *Born* 1857 Barnstaple, England

Died 1931

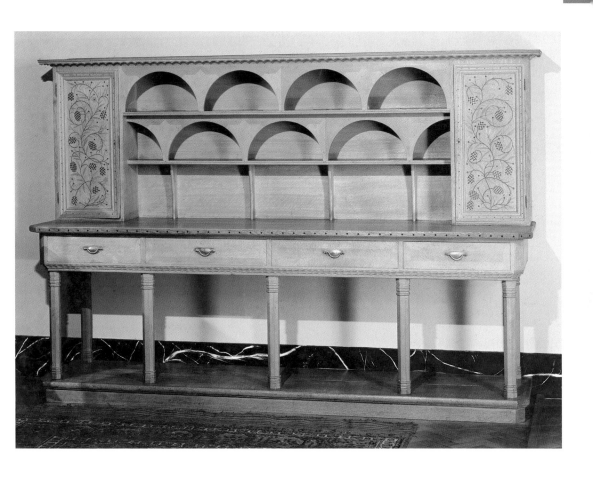

Lethaby, William
Design for a room, 1885

This design for a room was probably shown at the first exhibition of the Arts and Crafts Exhibition Society that William Lethaby had helped set up in 1887. He had also been instrumental in the setting up of the Art Workers' Guild, of which the Exhibition Society was a publicity-seeking faction, and it is as a publicist and educationalist that Lethaby's reputation was established. In 1893 Lethaby wrote an essay 'Carpenter's Furniture', as part of a book called *Arts and Crafts Essays*, in which he, like the other contributors, sought to distinguish the appropriateness of 'state' and 'cottage' furniture, and designs that would reflect 'the heart of the age'.

Lethaby's most significant contribution to the Arts and Crafts movement is as an educationalist. In 1896 he and the sculptor George Frampton (1860–1928), under the auspices of the London County Council, set up the Central School of Arts and Crafts to foster the 'industrial application of decorative design'. Lethaby insisted that the instructors were all practising designers, actively encouraging them to teach part-time in order for them to continue their own practices. He fostered a social harmony and a sense of egalitarianism in the student-staff relationship, and became sole principal in 1900 where he remained until 1912.

CREATED

England

MEDIUM

Pen and brown ink, watercolour and coloured chalks, heightened with white

RELATED WORKS

A Home by Carl Larsson, 1899

William Lethaby *Born* 1857 Barnstaple, England

Died 1931

Lethaby, William
Hall table, 1892–96

The Central School of Arts and Crafts, later shortened to the Central School to reflect a change in attitude to the notions of industrial design, was the starting point for many of the twentieth century's leading designers. In addition to the established crafts such as furniture design taught by Morris and Co.'s George Jack (1855–1932), there was also an emphasis on the revived skills of hand-crafted printing and book design. One of its most well-known students was Eric Gill (1882–1940), who went on to set up an artistic community in Sussex and design several new typefaces. Gill's tutor was probably Edward Johnston, who later developed the new typeface for the London Underground. The ethos of the school was based on Lethaby's own axiom, established during his time at Shaw's practice: 'Would you know the new, you must search for the old'. But Lethaby, and the Central School's move to purpose-built premises in 1908, signalled a change. Thereafter due deference was still paid to tradition, but with the pragmatic considerations of a machine age.

Following the failure of the 1912 exhibition of the Arts and Crafts Exhibition Society and the contrasting success of the *Deutscher Werkbund* exhibition two years later, a group of designers and retailers, which included Lethaby, started the Design Industries Association to address the problems of competing in the market of industrial design.

CREATED

England

MEDIUM

Mahogany, holly and ebony

RELATED WORKS

Oak table by Philip Webb, 1868

William Lethaby *Born* 1857 Barnstaple, England

Died 1931

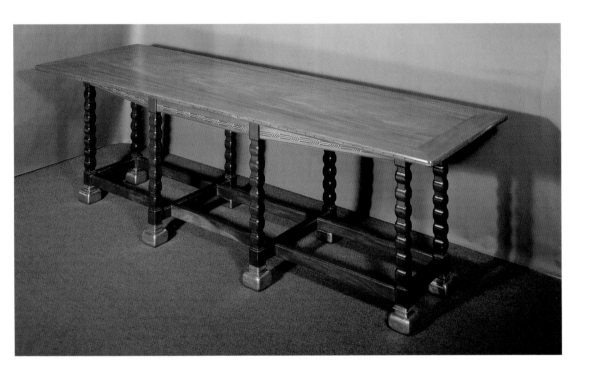

Crane, Walter

Five-panel embroidered screen, 1876

© Cheltenham Art Gallery & Museums, Gloucestershire, UK/www.bridgeman.co.uk

When the Royal School of Art Needlework exhibited this screen, and the embroidery hangings also designed by Walter Crane, at the Philadelphia Exposition of 1876, the school was only four years old. It had been founded as a philanthropic organization for the employment of poor gentlewomen, and by 1875 it was employing over a hundred workers executing designs by Crane and William Morris, among others. This exhibition was to be the first triumph of the school and a part of the defining moment when Philadelphia disseminated the Arts and Crafts movement's ideals to America.

Many of those ideals were expounded through Walter Crane in a number of subsequent lectures he gave in America and Britain, not just on aesthetics, but also, like Morris, on socialism. Crane became a Fabian, along with other notaries such as George Bernard Shaw and H. G. Wells, who sought to change society through education rather than revolt. He was less vehement in his lectures that Morris, managing nevertheless to articulate his points with drawings on a chalkboard that he executed for the assembly. He designed a number of banners for trade unions to be used at public demonstrations, as well as executing a number of satirical cartoons for socialist journals such as *Work*.

CREATED

London, England

MEDIUM

Crewel wool embroidery on cotton satin ground

RELATED WORKS

Screen by John Dearle, 1885–1910

Walter Crane *Born* 1845 Liverpool, England

Died 1915

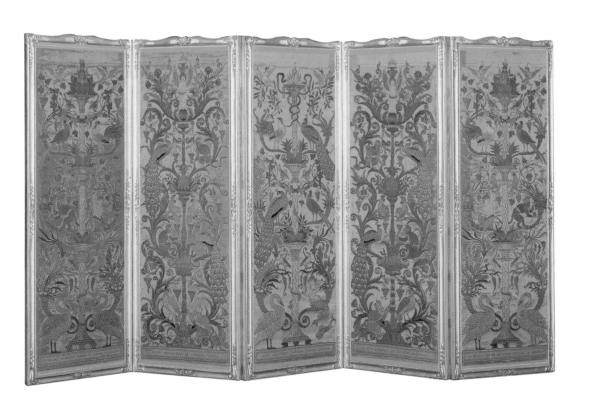

Crane, Walter

Ploughman tiles, c. 1889

In 1898, and after spending four years as director of design at Manchester School of Art, Walter Crane became principal of the Royal College of Art in London, in succession to Sir Edward Poynter (1836–1919), recently elevated to president of the Royal Academy. During Poynter's time, the school had become too biased towards fine-art students. The School of Design, as it was somewhat ironically called at its foundation in 1837, was given a royal charter in 1896.

Although Crane only held the appointment for a year, he managed to set in place a new ethos for the school based on the principles of the Art Workers' Guild. This was that education in the arts should be experimental and adaptive, rather than academic and prescriptive. In his own words "art is not science", indicating that it should be spontaneous rather than based on a 'system', and that design should be subjective rather than objective. This was clearly a jibe at the 'establishment' figures of, for example, Henry Cole (1808–82). Following Crane's reforms, the Royal College was split into four specialist schools: painting, sculpture, architecture and design. The first professor of design was William Lethaby, and he held this post until 1918.

CREATED

England

MEDIUM

Lustre painted earthenware

RELATED WORKS

Tabard Inn tiles by William de Morgan, 1880

Walter Crane *Born* 1845 Liverpool, England

Died 1915

Crane, Walter

Daffodil and Bluebell carpet, c. 1896

The Art Workers' Guild, formed in 1884, was an amalgamation of two societies who regularly met to discuss art, architecture and design. The first of these was the St George's Society, an iconoclastic group supported by the architect Richard Norman Shaw, who sought to unify the various artistic functions within both the Royal Academy and Institute of British Architects, who adopted a separatist policy. The second society was the Fifteen, a group set up by Lewis Day that included Walter Crane.

The Guild's original remit was to provide a forum for raising the profile and status of craftsmen in line with other artistic endeavours such as painting. However, the decision to avoid overt publicity ensured that it became little more than a gentleman's club, a situation perhaps exacerbated by the exclusion of membership for women craft workers. In this regard the Art Workers Guild can be seen as a copy of its medieval forebears, and progress was implemented by stealth. Membership of the Guild, which was by election, was seen to be a stepping stone to positions of higher responsibility in the art world, as, for example, in Walter Crane's case. The negative profile aspirations of some members resulted in the setting up of a publicity-seeking splinter group, the Arts and Crafts Exhibition Society.

CREATED

Glasgow, Scotland

MEDIUM

Wool and jute

RELATED WORKS

Bullerswood carpet by William Morris, 1889

Walter Crane *Born* 1845 Liverpool, England

Died 1915

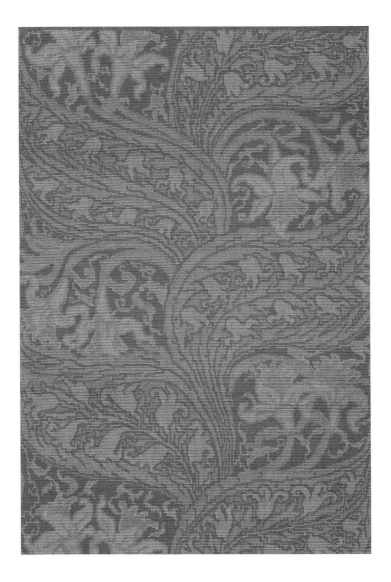

Crane, Walter

Vase, 1889

The term Arts and Crafts was apparently first used by T. J. Cobden-Sanderson (1840–1922), in a discussion forum set up by a splinter group of the Art Workers' Guild. The group met to discuss the lack of public recognition of the Guild's work, and it was mooted that exhibitions would be a good forum to achieve that end. Consequently, in 1887 the Arts and Crafts Exhibition Society was formed, with Walter Crane becoming its first president. Apart from Crane, the original committee members included William de Morgan (1839–1917), Lewis Day, William Benson (1854–1924) and William Lethaby. The first exhibition was in 1888, but was not repeated yearly. However, other benefits were derived from the exhibitions. Firstly, it provided an opportunity for lecturing on various crafts by some of the leading practitioners including William Morris; and secondly, the publications that were issued in support of the exhibitions helped to spread many of the ideals of the movement, including its socialist aspirations. Most of these ideals stem from those of Ruskin and Morris, succinctly espoused by Crane in *Arts and Craft Essays*. It was a protest against the so-called industrial progress that provided shoddy wares, the cheapness of which was paid for by the lives of their producers and the degradation of their users.

CREATED

Shropshire, England

MEDIUM

Earthenware painted with lustre colours

RELATED WORKS

Tall vase for the *Sunflower* pottery by Sir Edmund Elton, 1900

Walter Crane *Born* 1845 Liverpool, England

Died 1915

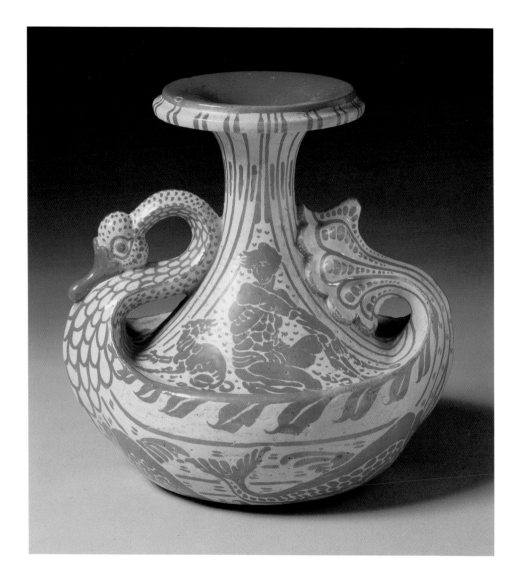

Crane, Walter

Group of six tiles, *c.* 1900

Although this group of tiles was produced in 1900, it shows Crane's continued appetite for an eclectic mix of the Neo-Classical and the lyrical organic lines he assumed during the Aesthetic period of his earlier work. His eloquent style of draughtsmanship and economy of line make these designs fresh and immediate and reinforce his talents as an illustrator. Between 1867 and 1871 Crane was creating decorative designs for Wedgwood, and the figures in the tiles are strikingly similar to the mannerist poses of Wedgwood's *Apollo and the Muses* designs from 1785, demonstrating Crane's deference to the Neo-Classical Greek revival.

Crane's historical eclecticism is unusual in its approach, in his rejection of the Gothic tradition in favour of the Neo-Classical. It is also symptomatic of a trend at the end of the century for Arts and Crafts practitioners to be more inclusive in their selection of motif. Moreover, Crane's designs have a dynamism that reflected the optimism of the Arts and Crafts movement at that time. Many of Crane's designs for wallpapers, textiles, book covers, tiles and pottery share this eclectic mix and dynamism, with the sinuous form and vocabulary of Art Nouveau.

CREATED

England

MEDIUM

Tiles

RELATED WORKS

Decorative scheme at Municipal House, Prague by Alphonse Mucha, 1900

Walter Crane *Born* 1845 Liverpool, England

Died 1915

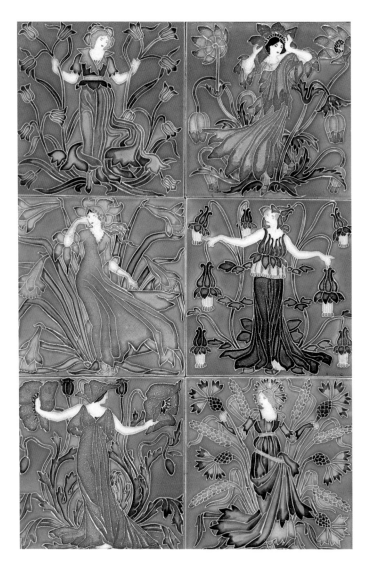

Crane, Walter

Saxon wallpaper, 1909

In his career, Walter Crane designed over 50 wallpapers and ceiling papers for Jeffrey and Company. Most were block printed by hand, like the *Saxon*, but some were machine printed, including his nursery papers such as *The House That Jack Built*. In Victorian houses patterned ceiling papers were fashionable, perhaps the best-known surviving example being Red House. Crane's early designs varied between the exuberant *Peacock* (1889), redolent of Morris's wallpapers, which combined stylized and natural motifs, and the widely used *La Margarete*, which adopted a much simpler motif.

In the 1888 Art and Crafts Exhibition Society catalogue, Crane included an essay on wallpapers that emphasized the limitations of materials and the need to consider machine manufacturing as an economical expedient. In the same year, Crane attended the first of a series of meetings of the National Association for the Advancement of Art and its Application to Industry. These meetings discussed how best to tackle the problem of design reform and how to make good design available for all. This issue dominated Crane's career as much as it had Morris's, and he began a series of lecture tours in Britain and America to explain his socialist ideals. He believed that "we must turn our artists into craftsmen, and our craftsmen into artists".

CREATED

London, England

MEDIUM

Wallpaper

RELATED WORKS

Silver Studio for Liberty and Co., 1909

Walter Crane *Born* 1845 Liverpool, England

Died 1915

Crane, Walter

Swan, Rush and Iris dado design, 1877

By the time Walter Crane became an exponent of the Arts and Crafts ideals in the 1870s, he was already an established and successful book illustrator. Often witty and lyrical in his approach, Crane had absorbed much of the current influences of the Aesthetic movement, which were mainly Japanese or the stylized Anglo-Japanese motifs of Edward Godwin (1833–86). What emanates from this background is that same lyrical approach to design expressed by many of the late Arts and Crafts practitioners such as Lewis Day and Crane. They were, as the writer Isabelle Anscombe points out, 'prevented from losing themselves in medieval nostalgia'.

The vogue for collecting Japanese prints began in the 1860s after Japan resumed trading with Britain after many years. At the 1862 International Exhibition, Japanese products were displayed and Godwin began using the motifs on his designs after decorating his own home in the 'Japanese style'. Liberty and Co. had established their reputation selling many of these Japanese goods in their store, before promoting their more renowned Arts and Crafts designs by Archibald Knox (1865–1933). This design for a dado wallpaper is typical of this Aesthetic influence, with the Japanese- inspired stylized swans so redolent of Crane's oeuvre.

CREATED

England

MEDIUM

Colour print from woodblocks

Walter Crane *Born* 1845 Liverpool, England

Died 1915

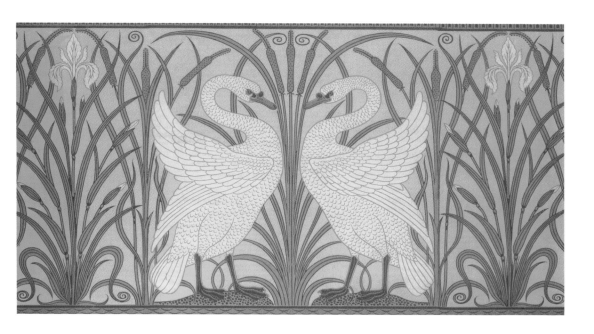

Ashbee, Charles

Detail of a piano cover, 1896–1903

Like many of his contemporaries in the Arts and Crafts movement, Charles Ashbee was from a privileged upper-middle class background. He was educated at a public school and sent up to Oxford where he read history. During his time there he met, and was influenced by, the 'simple-lifer' and socialist Edward Carpenter. Nothing could have prepared him for his subsequent visit to the East End of London in 1886, where he lived at the philanthropic institution Toynbee Hall while he was apprenticed to the architect G. F. Bodley (1827–1907).

Philanthropy had always been a feature of the Victorian age. However, Toynbee Hall, which was set up by Canon and Henrietta Barnett, differed in its approach to the poor. Their radical idea was to educate the poor using sympathetic university graduates, rather than simply to provide charity. Ashbee fulfiled two functions during his stay at Toynbee. Firstly he set up a 'Ruskin reading group' to disperse many of his ideas to the working-class residents. From this group Ashbee selected some of his more enthusiastic pupils to decorate the dining hall. He also taught them drawing skills and the rudiments of design. This group formed the nucleus of the Guild of Handicraft.

CREATED

England

MEDIUM

Needlework

Charles Ashbee *Born* 1863 Isleworth, England

Died 1942

Ashbee, Charles
Salt cellar with lid, 1899–1900

The Guild of Handicrafts, consisting of Ashbee and a handful of craftsmen, was set up in 1888. In 1890 they moved into the guild's first home at Essex House in Mile End, near Toynbee Hall, where they began producing furniture and metalwork. The example shown was produced at Essex House and is typical of Ashbee's silverware in its sinuous 'whiplash' design and use of semi-precious stones. The Guild's metalwork is hand beaten, and reveals its technique in the finish.

Ashbee was always a purist in his attitude to the non-use of machines. His craftsmen were all self-taught amid a Guild spirit of learning together through shared experience, which was fostered by Ashbee. He distrusted design schools and stamped his own ethos on his Guild-sponsored School of Handicraft. The Guild enjoyed many successes and gained significant respect from abroad. In 1898 they were commissioned to make the furniture for Mackay Hugh Baillie-Scott's (1865–1945) designs at Darmstadt, and the Guild influenced the setting up of the *Wiener Werkstätte* after their designs were shown at the Vienna Secession exhibition in 1900. At home, they were granted a royal warrant for the execution of jewellery for Queen Alexandra.

CREATED
Essex House, London

MEDIUM
Silver and semi-precious stones

RELATED WORKS
Cymric ware for Liberty and Co. by Archibald Knox, *c.* 1900

Charles Ashbee *Born* 1863 Isleworth, England

Died 1942

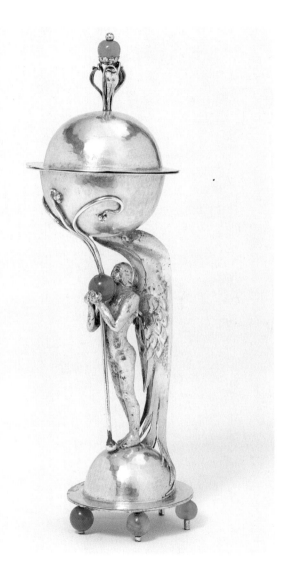

Ashbee, Charles

Cabinet, c. 1905

Ashbee believed, like Ruskin, that good design and craftsmanship depended on good social conditions for its practitioners. When the lease expired on Essex House in 1902, it was decided to relocate the workshops to Chipping Camden in the Cotswolds. Ashbee's idea was to live the Ruskin dream with the creation of a rural idyll where craftsmen could live and work. In true socialist fashion, the decision to relocate was taken democratically. In all there were some fifty craftsmen who, with their families, descended on the small village and began renovating old and dilapidated cottages and fitting the workshops to continue making the same products as before.

Despite a certain resentment and suspicion by the locals, Ashbee helped to educate some of their number with additional skills, with the Guild providing some of the amenities, for example a swimming pool and cookery workshops in addition to the carpentry facilities. Gardens were provided for the Guild workers and their families and lessons were given about growing vegetables in order for them to become and remain self-sufficient. There were also lectures given by outsiders such Edward Carpenter on self-sufficiency. Ashbee, who was interested in the theatre, also provided the equipment for a number of amateur productions and pageants involving the locals.

CREATED

Chipping Camden, England

MEDIUM

Walnut, sycamore carcass and cedar drawers, with gold-tooled Morocco leather

RELATED WORKS

Linen press by Charles Rennie Mackintosh, 1896

Charles Ashbee *Born* 1863 Isleworth, England

Died 1942

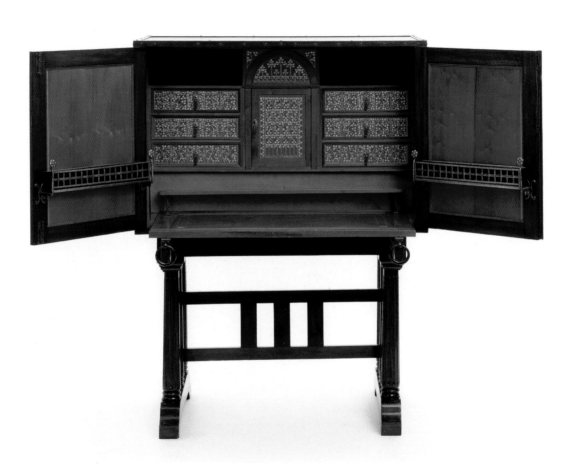

Ashbee, Charles

Decanter, 1904–05

When Ashbee first mooted the idea of a craftworkers' guild at Essex House, he tried to persuade William Morris of the viability of the venture, more in terms of its social rather than its commercial value. Morris was sceptical, suggesting that on such a small scale it would add little value to social change. Ashbee retorted that he would "forge him a weapon". Despite his best efforts to recreate the success at Essex House, the Guild of Handicraft at Chipping Camden was a financial failure and closed in 1908, due mainly to difficulties in logistics. Transport costs had obviously increased and Ashbee was unable to retain regular contact with his clients. In the wake of this failure, Ashbee wrote his polemical book, *Craftsmanship in Competitive Industry*:

> 'What I seek to show is that the Arts and Crafts movement... is not what the public thought it to be... a hothouse for the production of mere trivialities and useless things for the rich. It is a movement for the stamping out of such things by sound production on the one hand, and the inevitable regulation of machine production and cheap labour on the other.'

In essence, what Ashbee sought, based on the social implications of ignoring the plight of craftsmen, was a tariff on machine-manufactured goods.

CREATED

Chipping Camden, England

MEDIUM

Glass and silver

RELATED WORKS

Tea service by Henry van de Velde, 1905

Charles Ashbee *Born* 1863 Isleworth, England

Died 1942

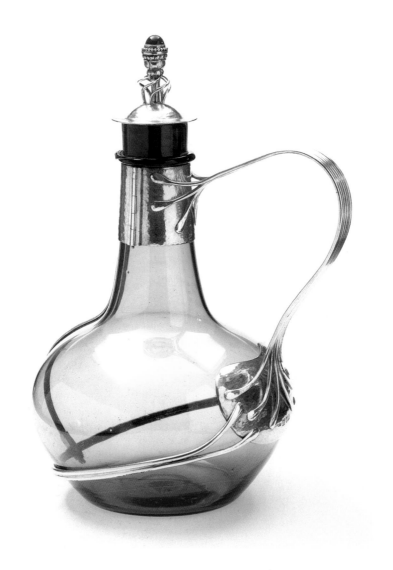

Ashbee, Charles

Brooch, chain necklace, ship pendant, *c.* 1896–1903

The idea of creating a rural community as an alternative way of life for the thousands of people living in the thick acrid stenches and squalor of urban life probably seemed ideal. Ashbee's ideas were not new, Port Sunlight being one example, but his was a radical step towards a genuine Utopian ideal rather than a philanthropic gesture to factory workers. His ideas had a growing currency in the early years of the twentieth century. The 1909 Housing and Town Planning Act was passed by Parliament to develop a number of suburban towns, each with a sense of rural community that could be constructed within commuting distance of London. These ideas were based on the successful garden cities, such as Letchworth (1903) and Hampstead Garden Suburb (1907), emanating from Ebenezer Howard's seminal work *Tomorrow; A Peaceful Path to Real Reform* (1898).

In 1910, Ashbee began work on the competition for an architectural scheme for Ruislip in Middlesex. Although his bid was unsuccessful, his plan shows a visionary Utopian ideal of a self-contained but accessible community, echoing William Morris's *News from Nowhere*.

CREATED

London and Chipping Camden, England

MEDIUM

Mixed, mainly gold and silver with semi-precious stones

RELATED WORKS

Silver girdle with river pearls by May Morris, 1906

Charles Ashbee *Born* 1863 Isleworth, England

Died 1942

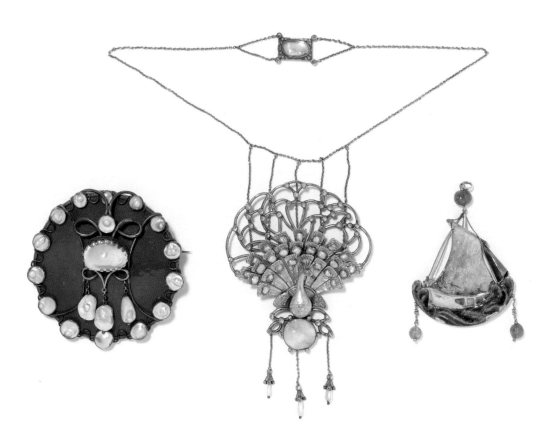

Ashbee, Charles

Interior of the dining room at 37 Cheyne Walk, Chelsea, *c.* 1901

The house at number 37 Cheyne Walk, Chelsea doubled as both the family home and the office of Ashbee's architectural practice. Originally it was the site of a public house, the Magpie and Stump, which had been destroyed. Ashbee's mother, having left her husband, arrived in London to live with her two daughters and purchased the vacant site. Ashbee designed the house and furnished it in the Arts and Crafts style and it was used by him as a showroom for the Guild of Handicraft.

The exterior of the house was in the favoured Queen Anne style, while the interior was lavishly decorated and furnished in an eclectic Aestheticism that utilized as many of the different Arts and Crafts skills as possible. The hallway demonstrated the use of embossed leatherwork and an elaborately tiled fireplace. The dining room, with its pale gessoed panels, provided a ground for the exuberant decorations incorporating the peacock, a favourite motif of both Ashbee and the Aesthetic movement. The work was all executed by Ashbee's Guild, including the metal electric light fittings designed by Ashbee. The design for this dining room was shown in the Viennese Arts and Crafts journal *Kunst und Kunstwerk* in 1901, demonstrating Ashbee's Continental influence.

CREATED

London, England

MEDIUM

Pencil and watercolour on paper

RELATED WORKS

The Rose Boudoir, Turin by Charles Rennie Mackintosh, 1902

Charles Ashbee *Born* 1863 Isleworth, England

Died 1942

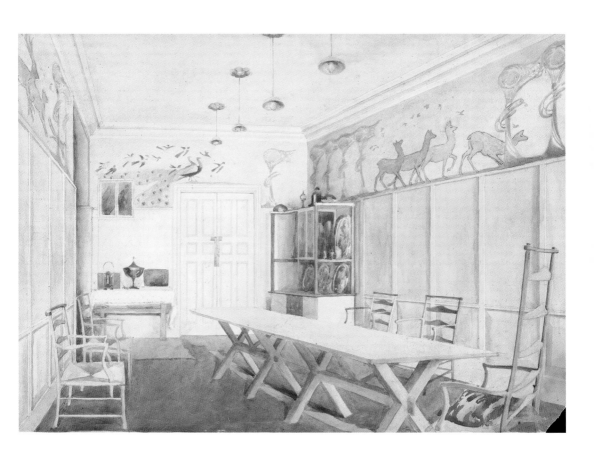

Ashbee, Charles

Inkwell with seven-sided floral design

© Estate of Charles Ashbee/Christie's Images Ltd

When William Morris died in 1896, some of his printing equipment, used at Kelmscott Press, was acquired by Ashbee for use in a new venture at Essex House, namely the Essex Press. The significance of the acquisition is that Ashbee, like Morris, wanted to use it as a 'private press' – that is, as an act of self-gratification rather than for commercial gain. When he took possession of the presses, they did not come equipped with letter type beyond basic typefaces. Consequently Ashbee designed one of his own, Endeavour, named after his own work, *An Endeavour Towards the Teaching of John Ruskin and William Morris*, which he published in 1901. Ashbee used the 'private press' as Morris had done, to promote his own writings and further his own socialist ideals, as well as publishing anything else that happened to interest him.

Like Morris, Ashbee was also interested in medievalism, and one of his first publications was Bunyan's *The Pilgrim's Progress*. Among Ashbee's other writings that he published were *The Last Records of a Cotswold Community* (1904), *Socialism and Politics: A Study in the Re-adjustment of Values*, and *On the Need for the Establishment of Country Schools of Arts and Crafts*, both from 1906.

CREATED

England

MEDIUM

White metal and enamel

RELATED WORKS

Cymric silver chamber stick with enamel by Archibald Knox, *c.* 1900

Charles Ashbee *Born* 1863 Isleworth, England

Died 1942

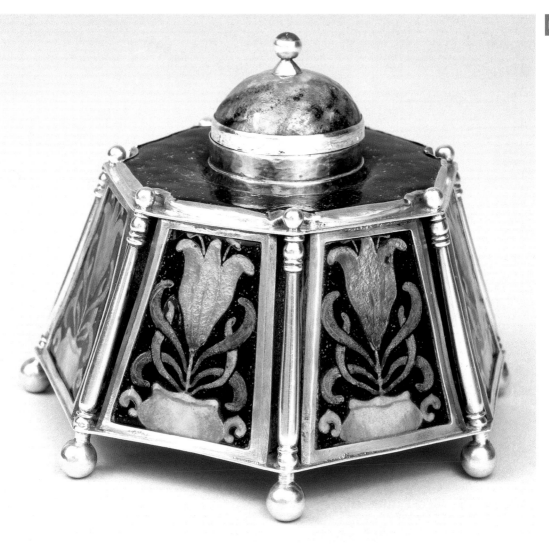

International Arts and Crafts

Places

Gimson, Ernest
Sideboard back, 1915

Following the demise of Gimson's first enterprise, Kenton and Co., he and the Barnsley brothers, Ernest (1863–1926) and Sidney (1865–1926), set up a craft workshop in the Cotswolds in 1893, the aim of which was to regenerate traditional craftsmanship. The site they chose was the former stables at Pinbury House, a run-down Elizabethan manor. After moving again, Gimson and Ernest Barnsley went into partnership at Daneway House, leaving Sidney to run his own workshop. After the partnership split, Gimson continued in the workshop employing specialist cabinet-makers such as Peter van der Waals, (1870–1937), who brought a Dutch influence to the firm.

Sideboard backs were used as temporary splashbacks and often commissioned to match an existing sideboard. This example is executed in English walnut, but is distinctly Dutch in its shaped top, resembling Dutch gables popular in the Queen Anne revival style. More significant to the Dutch connection is the use of Macassar ebony for the diamond-shaped inlays and for the construction of the candlesticks. Macassar was a strategic trading port in Indonesia for the Dutch East India Company. Apart from English vernacular furniture, Gimson made some exquisite and innovatively designed pieces often using inlays other than wood, such as mother of pearl.

CREATED

Cotswolds, England

MEDIUM

Mixed, mainly walnut

RELATED WORKS

Cabinet for J. S. Henry and Co. by George Montague Ellwood, 1904

Ernest Gimson *Born* 1864 Leicester, England

Died 1919

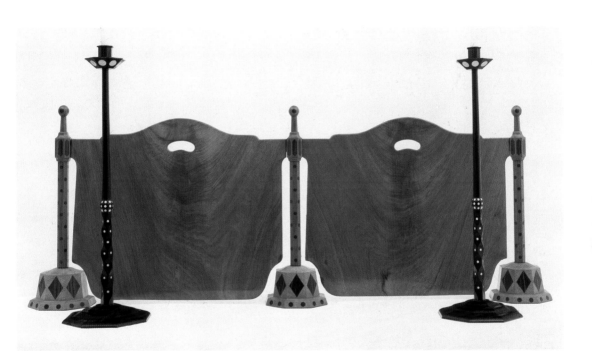

Gimson, Ernest
Cabinet of drawers, *c.* 1903–07

At the time this cabinet was made, there was a strong cross fertilization of ideas between England and Vienna. Charles Rennie Mackintosh (1868–1928) and Charles Ashbee 1863–1942) had exhibited at the Vienna Secession in 1900, and the Austrian designers Koloman Moser (1868–1918) and Josef Hoffman (1870–1956) reciprocated in 1903, visiting Mackintosh in Glasgow and Ashbee's Guild of Handicraft in the Cotswolds. It seems likely, therefore, that they would both have visited Gimson at the same time. The design for this cabinet bears strong characteristic similarities to some of Moser's designs for cabinets of this period, in the elaborate use of inlays, the complexity of the construction, and above all the structural linearity of the piece. Once again, this cabinet was probably also encouraged by Waals, following a tradition of Dutch eighteenth-century cabinet-making.

Gimson was at home designing and making furniture for both of the sectors that William Morris (1834–96) referred to as 'state' or 'cottage' use. He wanted to make furniture that was "good enough, but not too good for ordinary use" and, like Morris, he regretted not being able to produce simple well-crafted furniture that working-class people could afford.

CREATED
Cotswolds, England

MEDIUM
Mainly mahogany

RELATED WORKS
Desk by Koloman Moser 1903

Ernest Gimson *Born* 1864 Leicester, England

Died 1919

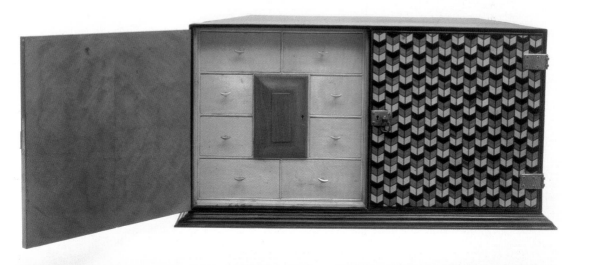

Gimson, Ernest

Ladder-back chair, c. 1895

Described by Nikolaus Pevsner as 'the greatest English artist-craftsman', Ernest Gimson had to look no further for inspiration than his own rural England. He was the consummate craftsman, who learned his skills by trial and error with the help of other accomplished craft workers. He believed that before a design could be started, it was necessary to understand the materials that were to be used and the skill required to execute it. He learnt all the skills necessary in cabinet-making and rush-work, and although he executed some of his own designs himself, such as the example shown here, he usually preferred to concentrate on designing.

Gimson is mainly known for his furniture designs, some of which were executed in the vernacular or domestic tradition. This design was repeated by Gimson and executed in a number of ways, with and without arms, and in a number of different English woods such as ash and beech, reflecting John Ruskin's (1819–1900) ideal of 'truth to materials'. Although there are similarities to Shaker chairs of the eighteenth century, the ladder-back chair is a medieval form that was repeated in England from the late seventeenth century, mainly for rural use.

CREATED

Cotswolds, England

MEDIUM

Ash and cane seat

RELATED WORKS

Sussex chair for Morris and Co. by Philip Webb, 1860 onwards

Ernest Gimson *Born* 1864 Leicester, England

Died 1919

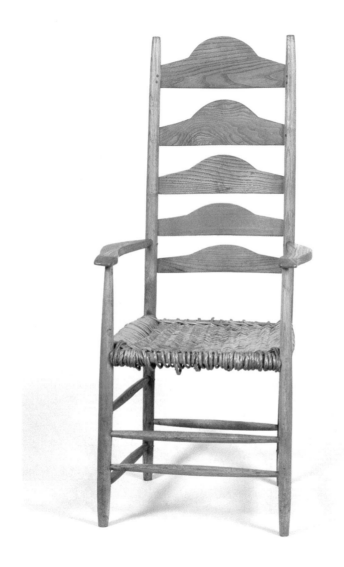

Baillie-Scott, Mackay Hugh
Darmstadt chair, c. 1900

© Estate of Mackay Hugh Baillie-Scott/Victoria & Albert Museum, 2005

Through the writings of John Ruskin, the regenerative aspects of the Arts and Crafts movement continued to be a concern for its practitioners, in Europe as well as Britain. In 1899, many artists, architects and designers were summoned to Darmstadt, Germany, where Ernst Ludwig von Hessen, The Grand Duke of Hesse and a grandson of Queen Victoria, had established an artistic colony. Ludwig, who had already seen the Arts and Crafts movement in Britain, believed that he could regenerate the economy of his dukedom by enticing the leading British and European Arts and Crafts practitioners to create the necessary buildings and interiors, which would in turn encourage more artists to visit. The group's unofficial leader was Joseph Maria Olbrich (1867–1908), a talented architect from Vienna who had recently designed their Secession building. Among the others was Peter Behrens (1869–1940) who went on to be Germany's foremost proponent of early industrial design at the *Deutscher Werkbund*.

Many of the items made for Darmstadt were shown at the *Exposition Universelle* in Paris in 1900, and thereafter at other expositions in Turin and St Louis, giving it truly international renown. Mackay Hugh Baillie-Scott was asked to contribute furniture and decorations for the drawing room and dining room of Ludwig's own house, items that were made at Charles Ashbee's Guild of Handicraft.

CREATED

England

MEDIUM

Mixed woods

RELATED WORKS

Barrel armchair by Frank Lloyd Wright, 1904–05

Mackay Hugh Ballie-Scott *Born* 1865 Ramsgate, England

Died 1945

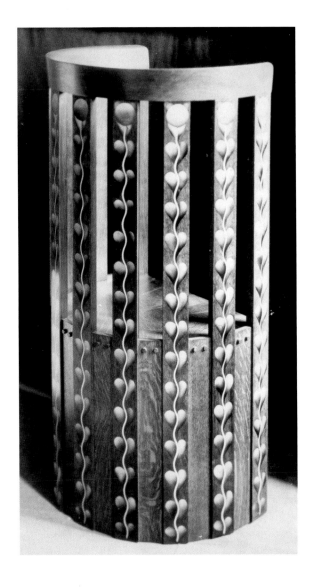

Baillie-Scott, Mackay Hugh

Manxman piano, c. 1896

© Estate of Mackay Hugh Baillie-Scott/Victoria & Albert Museum, 2005

Philip Webb's (1831–1915) was not the only Red House built by, and for, an Arts and Crafts practitioner. In 1892 Baillie-Scott began building his own Red House in Douglas, Isle of Man, where he moved to from Kent with his new bride. While the exterior was conventionally half-timbered and tile hung, it was the interior that became his hallmark, developing an informal space around his so-called 'living halls', a theme contemporaneously picked up by Frank Lloyd Wright (1867–1956). Like Wright, the focus for Baillie-Scott's interiors was the fireplace, and both designers often incorporated an inglenook with built-in benches, to create a 'homely' interior. Many of these ideas had a common international currency in the Arts and Crafts movement, without necessarily being attributed to any one practitioner.

The piano, seen very much as an essential part of Victorian and Edwardian interiors for most middle-class families, was nevertheless an awkward-looking item. Baillie-Scott sought to rectify this problem with an elaborate cabinet based on earlier European models of cabinet, such as those found in sixteenth-century Spain and Elizabethan England. The design was later copied by Charles Ashbee and manufactured by the piano makers John Broadwood and Sons. There is an example of this at Standen, in Sussex.

CREATED

England

MEDIUM

Ebonized mahogany with inlays

RELATED WORKS

Writing cabinet by Charles Rennie Mackintosh, 1904

Mackay Hugh Ballie-Scott *Born* 1865 Ramsgate, England

Died 1945

Baillie-Scott, Mackay Hugh
Design for a Country Cottage, 1902

From the 1890s and into the twentieth century, the Arts and Crafts movement gained currency in much of Europe and the United States of America. Although Britain had led the way for the Arts and Crafts 'style', by the turn of the century it had become international property, with each country regionalizing the aesthetic according to its own environment, but using some of the ideas gleaned from other regions. This was facilitated by a burgeoning market for informative journals, which also satisfied an increasing demand for interior design.

Britain led the way in 1893 with *The Studio*, a monthly journal that published information about the Arts and Crafts, and more especially its application in architecture and interior design. At this time, with a growing affluent middle class, it was no longer only the preserve of the upper-middle classes to commission a house or an interior. *The Studio* was soon being read widely, and before the end of the century it was also showing international work. Baillie-Scott was one of the first architect-designers to exploit this opportunity, and regularly submitted articles on his designs. He also allied himself to J. P. White's renowned Pyghtle joinery works, that, apart from high-quality workmanship, also ran an efficient publicity operation that ensured their name was constantly in the forefront of leading architects.

CREATED

England

MEDIUM

Bookplate from *The Studio*

RELATED WORKS

A Home by Carl Larsson, 1899

Mackay Hugh Ballie-Scott *Born* 1865 Ramsgate, England

Died 1945

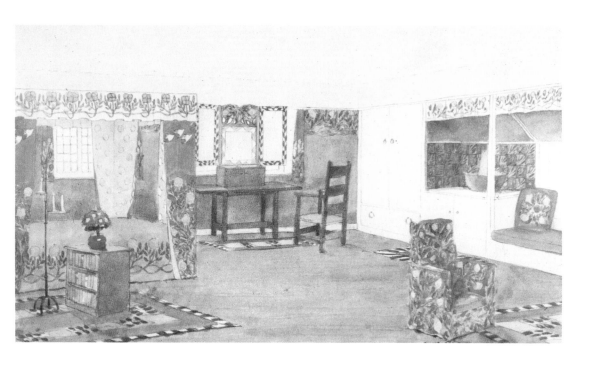

Morris, May
Christening mittens, 1910

By the time these christening mittens were made, May Morris had left Morris and Co. and was teaching embroidery at the Central School of Arts and Crafts, where William Lethaby (1857–1931) was still principal. Like most other designer-crafts persons, she was influenced by what she read and saw in *The Studio* and other contemporary journals.

By the early twentieth century, the Swedish artist Carl Larsson (1853–1919) was well known for an exhibition of paintings that he had executed of the interior of his summerhouse in Sweden during a particularly wet summer. The paintings were subsequently reproduced in 1899 as a book, *Ett Hem (A Home)*, which determined a particularly Swedish style for the Arts and Crafts. Larsson's interiors, which he had designed and executed with his wife Karin, were effused with a fresh style that encapsulated a fairy-story enchantment that was suited to the ideal of family life. This 'folk art' became very popular in both Scandinavia and Eastern Europe, where folk tradition was strong, spawning a new taste there for Arts and Crafts. May Morris's mittens are taken from that folk tradition and are strongly influenced by Scandinavian folk design.

CREATED

England

MEDIUM

Embroidered linen

May Morris *Born* 1862 Bexley, London

Died 1938

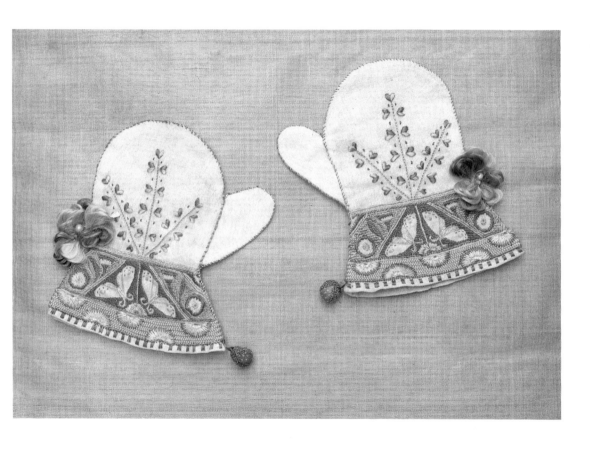

Morris, May

Jewellery: girdle, pins and pendant, 1906

The nostalgia that William Morris felt for the Middle Ages was based on the notion of a simple life, unencumbered by the Industrial Revolution and its consequent problems. However, under the feudal system in England, those 'simple-lifers' were peasants who would not have fashioned 'folk' jewellery themselves, for fear of confiscation to settle punitive taxes. Consequently, there was no history of 'folk' jewellery in England, as there was in Scandinavia and Eastern Europe. It was therefore necessary to 'borrow' designs from these countries for the British market.

The design shown here is borrowed from such a tradition. As in most Arts and Crafts jewellery, it is set in silver and uses semi-precious stones, in this case chrysoprase, cut cabochon-style, garnets and river pearls. At the time this was made, precious and semi-precious stones were always imbued with symbolism, usually religious. The four-heart motif signified love, for either the four Evangelists or the four testaments, and the garnets signified faith. The use of chrysoprase is typical of Italian-peasant jewellery and is replicated by other Arts and Crafts practitioners such as Arthur and Georgina Gaskin.

CREATED

England

MEDIUM

Silver and semi-precious stones

RELATED WORKS

Jewellery by Charles Ashbee, c. 1900–08

May Morris *Born* 1862 Bexley, London

Died 1938

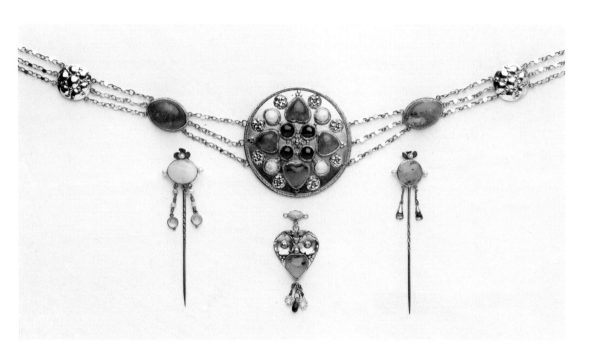

Morris, May
Design for an embroidery, *c.* 1885

At the first Arts and Crafts Society Exhibition in 1888, embroidery counted for 45 exhibits. Such was the increasing popularity of the medium both by professionals, such as May Morris, and by amateurs for whom she designed embroidery kits, that only two years later the number had increased to 120. Nevertheless, embroidery was considered to be a trivial pastime by her contemporaries.

William Morris considered embroidery to be an important and delicate skill, an idea certainly shared by his daughter, and he was particularly interested in reviving medieval skills. Although A. W. N. Pugin (1812–52) had previously revived embroidery as a craft, his designs were stylized. Morris made a detailed study of early English embroideries, but had not pursued the craft himself, preferring to leave it in the more capable hands of May, who became the author of the definitive *Decorative Needlework*. Apart from her teaching commitments at the Central School and in the United States, May was also a writer on needlecraft in a number of journals including *Hobby Horse*, *The Studio*, and *Building News* (an architectural journal), in which she contributed a thirteen-part series on ecclesiastical embroidery. Above all, May Morris was responsible for raising the profile of needlework internationally, as an equal partner in the Arts and Crafts movement.

CREATED

England

MEDIUM

Pencil and watercolour

RELATED WORKS

Design for *Rose and Thistle* textile by William Morris, 1881

May Morris *Born* 1862 Bexley, London

Died 1938

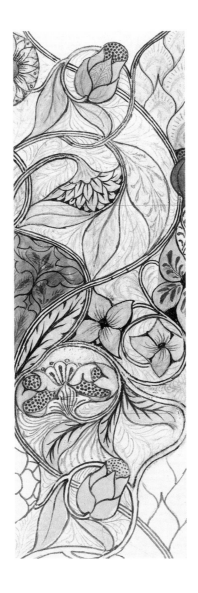

Stickley, Gustav
Oak spindle settle, c. 1908

In the last quarter of the nineteenth century, the Americans, like the British before them, were suffering from the overuse of ornament by their furniture makers, typified by the popular 'Empire' Rococo furniture. This was in evidence at the 1876 Centennial Exposition in Philadephia, which demonstrated the financial power of America but also its lack of its own architecture and design identity. In essence it was still 'borrowing' styles such as Gothic from Britain and Europe. At the same exhibition were examples of the British Arts and Crafts style of Richard Norman Shaw (1831–1912) and his Queen Anne revival, which coincided with an interest in America of the Shaker style that was currently being fostered by the centennial celebrations.

Gustav Stickley, who had learnt furniture making in a family-run business, eschewed this and other European styles such as Gothic, maintaining that "designers use their eyes and their memories too freely, and their reasoning powers too little". His solution was to provide a style of furniture suitable for the American way of life, based on American ideals and history. An avid reader of Ruskin, Stickley advocated a plainer, simpler design, which he later referred to as 'Mission', fit for his own 'region' and made with a 'truth to materials' ethos.

CREATED

New York, USA

MEDIUM

Oak

RELATED WORKS

Settee by Hans Vollmer, 1902

Gustav Stickley *Born* 1857 Wisconsin, USA

Died 1942

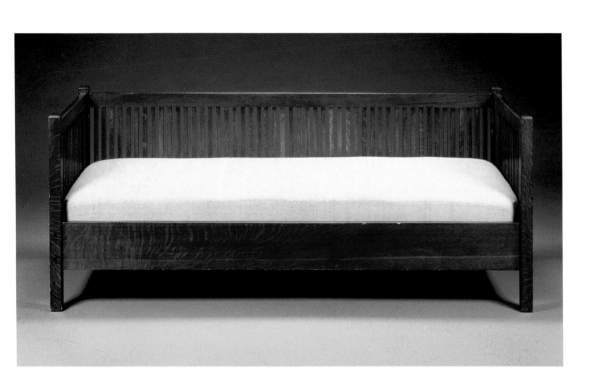

Stickley, Gustav
Two panelled Prairie cube chairs, c. 1915

Having read the works of both Ruskin and Morris, Stickley visited Britain in 1898 and saw much of the work of the British Arts and Crafts designers including Baillie-Scott and Charles Voysey. On his return to America he set up United Craftsman, later changed to United Crafts, a profit-sharing company loosely based on Ashbee's Guild of Handicraft, to produce household furnishings. Like Ashbee's Guild, United Craftsmen fostered a spirit of community and encouraged debate about working practices. Although much of the furniture that Stickley designed and produced was based on the traditional early Arts and Crafts English furniture of Philip Webb and William Morris, it was within the context of Ruskin's notions of the appropriateness of a style according to a region. He used many of the structural design ideas originally proposed by the early Arts and Crafts practitioners such as Pugin and Morris, which eliminated unnecessary ornament and honestly revealed construction.

Stickley's furniture was rugged and well-made in home-grown oak, which satisfied the honesty required of the 'truth to materials' ethos specified by Ruskin. However, in opposition to Ruskin's ideal, Stickley used the machine, albeit for laborious and repetitive tasks, whilst retaining an emphasis on handcraft in much the way Morris had already done.

CREATED

New York, USA

MEDIUM

Oak

RELATED WORKS

McKinley chair by David Walcott Kendall, 1894–1920s

Gustav Stickley *Born* 1857 Wisconsin, USA

Died 1942

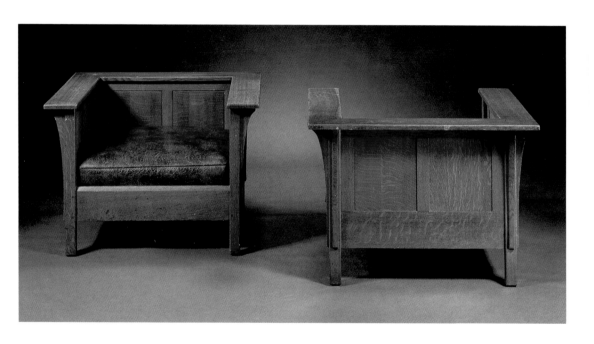

Stickley, Gustav
Double bookcase/cabinet, *c. 1902*

The simple and robust designs of Stickley's furniture owe a great deal to English Arts and Crafts, none more so than to Baillie-Scott, as much as to Morris and Webb. All of their designs were spread to an American audience through *The Studio*, which showed various room-sets, particularly those of Baillie-Scott, with furniture in an Arts and Crafts style. Baillie-Scott referred to this as 'Art Furniture' and his influence can be seen when Stickley states that art "should not be allowed to remain as a subject for critics, but become a part and parcel of their daily lives".

A distinguishing feature of English Arts and Crafts cabinets is the use of heavy hinges by Baillie-Scott and others, and by 1902 Stickley had opened a metalwork shop to produce heavyweight straps for his cupboards. Unlike Baillie-Scott though, in Stickley's hands the cabinets are given a distinctly medieval English look, more in keeping with Webb.

After 1903 Stickley was joined by Harvey Ellis (1852–1904), who helped to lighten the look of the furniture. He created a more distinctive colonial style, which became the hallmark of United Crafts.

CREATED

New York, USA

MEDIUM

Oak

RELATED WORKS

Writing cabinet by Charles Ashbee, 1898–99

Gustav Stickley *Born* 1857 Wisconsin, USA

Died 1942

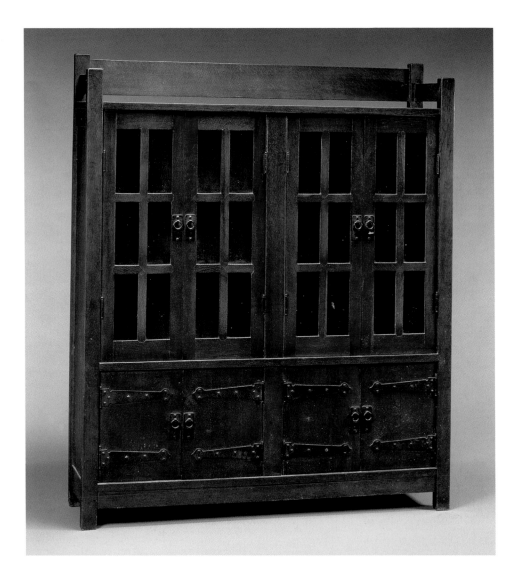

Stickley, Gustav

Interior of a Craftsman House, c. 1910–11

The public voice of Stickley's United Crafts was *The Craftsman*, based on *The Studio*, which he began publishing in 1901 in order to disseminate Arts and Crafts ideals and, of course, to promote his own furniture range. The first edition was dedicated to William Morris and contained articles about Ruskin and medieval guilds. The pretentious 'medieval' motto of the magazine was, 'The lyf so short the craft so long to lerne'. The page sample shown here is very much based on Baillie-Scott's own designs and format in *The Studio*, but in Stickley's scheme there is an 'angular' look not usually found in British Arts and Crafts, emphasizing the simplicity necessary for machine manufacture. The rectilinear aspects of the room also suggest a Japanese influence, which is heightened by the recessed wall hanging with stylized motifs.

Above all, what Stickley strove for in his furniture and interiors was a sense of the simple life, the pioneering spirit of a free America, that could be produced on a 'democratic' basis that was affordable by the majority rather than the minority. *The Craftsman*, which Stickley continued to edit until 1916, was also his political voice and, like William Morris, he sought a fairer society.

CREATED

New York, USA

MEDIUM

Journal plate

RELATED WORKS

The Studio by Mackay Hugh Baillie-Scott, 1902

Gustav Stickley *Born* 1857 Wisconsin, USA

Died 1942

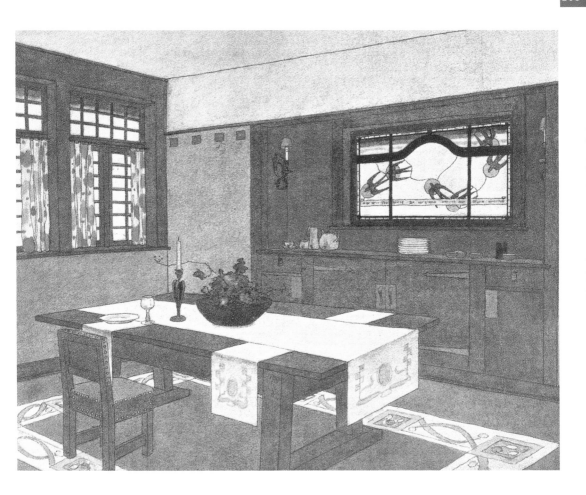

Lloyd Wright, Frank

The architect's house at Oak Park, Chicago, 1889

Courtesy of RIBA Library Photographs Collection/© ARS, NY and DACS, London 2005

Frank Lloyd Wright adopted a holistic approach to design. What he sought in his architecture was an organic vernacular design that was honest and respected the 'truth to materials' ethos, replacing inappropriate academic traditions – inappropriate because they were borrowed from Europe and did not suit America organically, particularly in Chicago and the Mid-West. After his architectural training under Louis Sullivan (1856–1924), the first design he undertook was for his own house in Oak Park, near Chicago, beginning in 1889. For this, and all his subsequent houses, Wright approached the problem ahistorically, in order for the building to respond to its own environment rather than depend on convention. This was to become the first of his so-called 'Prairie' houses, suitably named after the low, flat, windswept plains of the Mid-West.

The 'Prairie' house was a radical design, emphasizing the horizontal aspects of the building that reflect the low-lying landscape. Wright designed the interiors without separating walls and usually around a large centrally placed fireplace. The feeling of unencumbered space and the horizontality of the whole, including the interior, reflected Wright's interest in Japanese architecture and interiors following his visit to the Japanese pavilion at the 1893 World Columbian Exposition in Chicago. His use of American oak and other regional natural materials are a testimony to the Arts and Crafts ideal.

CREATED

Chicago, USA

MEDIUM

Architecture

RELATED WORKS

Broadleys by C. F. A. Voysey, 1898

Frank Lloyd Wright *Born* 1867 Wisconsin, USA

Died 1956

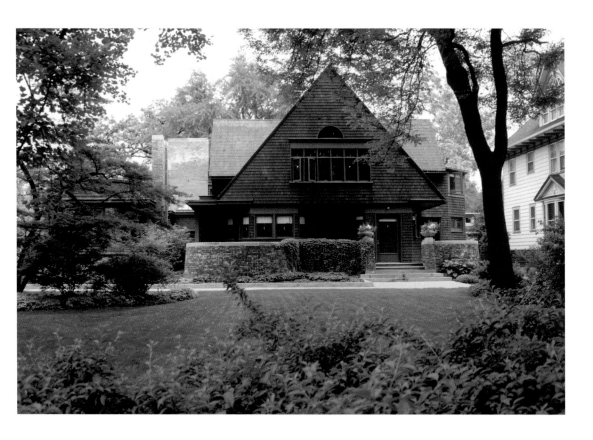

Lloyd Wright, Frank
Table, 1902

Courtesy of Victoria & Albert Museum, 2005/© ARS, NY and DACS, London 2005

Like many of the British Arts and Crafts practitioners, Wright wanted to design all aspects of a building, from specifying the materials of the construction, to the inside layout and its furnishings. The table illustrated here was used in a number of his early 'Prairie' homes in Oak Park, including his own. It was constructed of oak and, in this case, stained and polished. His furniture was never varnished as he maintained that it should be as natural as possible, the stain being applied only if it was essential to emphasize the grain. All of his furniture designs emphasize the rectilinear aspects in keeping with the house's structure. Often the chairs would be high backed and very rectilinear, as in his Robie House, Chicago of 1906–08, suggesting a debt to Japanese interiors, seen also in the actual house design.

Wright often used stained glass in his interior designs. Once again they are ahistorical, but the design motifs are organic. They are a curious mix, some of which appear to be derivative of Owen Jones's *The Grammar of Ornament*, a copy of which he owned, and some encorporate a playful use of primary colours that anticipate Piet Mondrian (1872–1944).

CREATED

Chicago, USA

MEDIUM

Oak

RELATED WORKS

Tables for the Willow Tea Rooms by Charles Rennie Mackintosh, 1903

Frank Lloyd Wright *Born* 1867 Wisconsin, USA

Died 1956

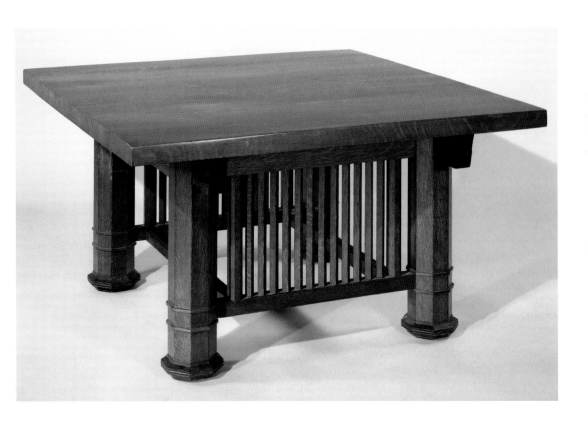

Lloyd Wright, Frank
Painted steel armchair, c. 1904

Wright's tutor and mentor Louis Sullivan is understood to have first coined the phrase 'form follows function'; a term later adopted by the Modernists as their credo. The chair illustrated here certainly anticipates that credo and, like many of Wright's designs, was radical for its time. Although it may not meet Arts and Crafts conventions stylistically and materially, it meets at least one of its criteria, having a simplified form without extraneous ornament.

In America, unlike Britain, Wright extended the Arts and Crafts ideal beyond the domestic into office life. In the Larkin Building in New York, for example, completed in 1906, there were no windows to look out on to an ugly urban site. Instead Wright had the staff facing inwards to an internal courtyard lit by natural daylight through skylights, creating a harmonious and pleasant working environment oblivious to the outside world. In true Ruskin spirit, Wright was keen to introduce wholesomeness to the Larkin workers. The chairs were designed to develop good postural habits and to assist with the office cleaning. A conservatory and 'window' boxes were provided in the courtyard to accentuate the open nature of the building's interior.

CREATED

USA

MEDIUM

Steel

RELATED WORKS

Painted settee for the Willow Tea Rooms by Charles Rennie Mackintosh, 1917

Frank Lloyd Wright *Born* 1867 Wisconsin, USA

Died 1956

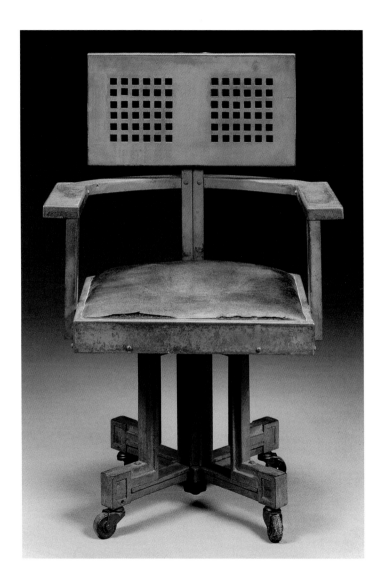

Lloyd Wright, Frank
Copper urn, 1898

In 1898, the Chicago Arts and Crafts Society was formed with Frank Lloyd Wright as one of its founder members. Its regular meetings were held at Hull House Settlement, a philanthropic organization with its own art gallery and a studio set up by the social reformer Jane Addams, and modelled on Toynbee Hall in London. Both Walter Crane and Charles Ashbee stayed at Hull House, and the latter was on very friendly terms with Wright. There was, however, one important difference between the men, concerning the use of the machine in Arts and Crafts work. Ashbee, the purist, considered it anathema, but for Wright it was the "normal tool of civilization". Wright argued, in his famous lecture 'The Art and Craft of the Machine', that the machine was essential in order for things to be made affordable. He believed that in the right hands, a machine could enhance the properties of wood and did not see it as an alternative to a craftsman, but as a tool for the craftsman. Wright's ideas were influential in educating the purists, including, for example, Ashbee, whom he visited in the Cotswolds in 1910.

CREATED

USA

MEDIUM

Copper

RELATED WORKS

Vase by Arequipa Pottery, USA, 1911–13

Frank Lloyd Wright *Born* 1867 Wisconsin, USA

Died 1956

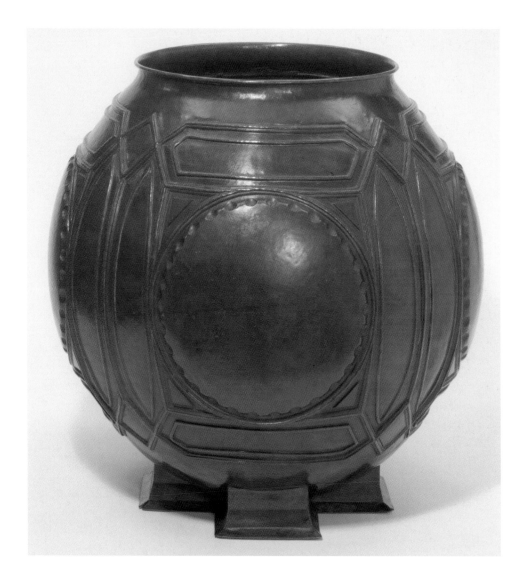

Hoffman, Josef
Palais Stoclet, Brussels, 1905–11

The British Arts and Crafts movement had established its credentials in Vienna, during the Secession exhibition in 1900, and at Darmstadt it became a major influence on its architects and designers. The Secession was set up as a reaction against the oppressive regime of the academic *Künstlerhaus*, and its members, which included Josef Hoffman, sought a new language for design that was ahistorical. Furthermore, using the British model, they wanted to eliminate the division between the fine and applied arts.

The Palais Stoclet is the culmination of that aim, a *gestamtkunstwerk* (a complete work of art), a hallmark of Secession aspiration. Its plain structure belies its interior's sumptuousness, with furniture by Koloman Moser and mosaics and murals by Gustav Klimt – it is considered by many to be one of the finest examples of Art Nouveau. Despite its deference to cuboid form, there is no reference to its Classical antecedents, except for the mocking Doric column that sits to no purpose in the rear garden. The plain Norwegian marble construction is 'framed' on all its edges using bronze, the only form of decoration on the outside. In this almost post-Art Nouveau period, when the Palais Stoclet was built, the emphasis had moved away from natural sinuous forms to geometry as an inspiration.

CREATED

Brussels

MEDIUM

Architecture

RELATED WORKS

North Elevation, Glasgow School of Art by Charles Rennie Mackintosh, 1905

Josef Hoffman *Born* 1870 Moravia

Died 1956

Hoffman, Josef
Design for a tablecloth, 1906

© Estate of Josef Hoffman/Victoria & Albert Museum, 2005

The Secessionist motto, literally set in tablets of stone above the entrance to the Secession building in Vienna, was 'To the Age its Art, to Art its Freedom'. This ahistorical aspect of the Secession is an important departure from the early aims of the British Arts and Crafts movement, and demonstrates an aspiration on the Continent for a move towards a more rational and logical approach to architecture and design, most apparent in Vienna and Germany. A part of that process involved the use of geometric forms, rather than the sinuous organic forms popular in France and Belgium, as well as Britain.

An influential aspect of that process was the regenerative design reforms of Charles Rennie Mackintosh, who departed from the English traditions in favour of a more ascetic look, a formal purity with an emphasis on geometry. Mackintosh showed his designs at the Secession exhibition of 1900, becoming something of a Viennese celebrity and an inspiration for Hoffman and the others of the Secession. Hoffman tended to overuse the squared motif, evident in many of his designs, including the windows of the Palais Stoclet, and was teasingly referred to as 'quadratl'.

CREATED

Vienna, Austria

MEDIUM

Woven textile

RELATED WORKS

Tapestries for the *Bauhaus* by Anni Albers, 1927

Josef Hoffman *Born* 1870 Moravia

Died 1956

Hoffman, Josef

Wiener Werkstätte silverware, c. 1903–06

Silverware formed an important part of the products of the *Wiener Werkstätte* studios, set up in 1903 by Hoffman and Koloman Moser and financed by a wealthy banker, Fritz Waerndorfer. He also used his influential contacts to promote the work. Despite their aims having little to do with socialist aspirations, there is a link to Ruskin and Morris in their desire to blur the distinction between fine and decorative arts and for the work to reveal both its crafted attributes and the innate qualities of the material itself.

Hoffman and Moser had both visited England in 1902 and were inspired by the sense of community spirit and workmanship engendered at Ashbee's Guild of Handicraft. Many of Hoffman's subsequent ideas and designs were disseminated through journals such as *The Studio*, which emphasized the debt owed by him to England. The *Wiener Werkstätte* had a high public profile and its members exhibited their work at major exhibitions in Rome and Paris, as well as Vienna, and many of their products were sold at up-market retailers in Germany and the United States. Their aim was to "help the worker recover the pleasure in his task and obtain humane conditions in which to carry it out".

CREATED

Vienna, Austria

MEDIUM

Silver

RELATED WORKS

Fish knife and fork by Charles Rennie Mackintosh, *c.* 1903

Josef Hoffman *Born* 1870 Moravia

Died 1956

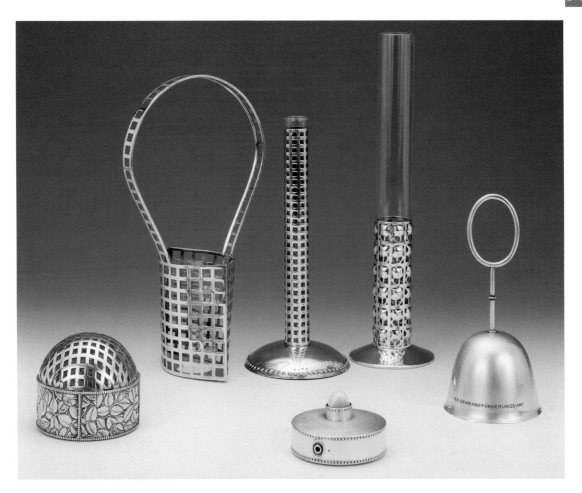

Moser, Koloman

Desk, 1903

The so-called '*Biedermeier* style' of furniture was popular in Vienna following the Napoleonic period with its over-ornamented and dark 'Empire' phase. Vienna was seeking to rid itself of the last remnants of France and French influence, and so adopted a fresher, lighter-coloured style that was purged of ornament. Although, strictly speaking, *Biedermeier* was not a style, its furniture makers shared these common aims. *Bieder* is in fact a German word that means the 'everyday', and so the furniture was intended as functional, characterizing the domestic aspirations of Vienna's middle classes. Hardly surprising, then, that in the wake of a resurgence of ornament in the latter part of the nineteenth century, Koloman Moser should seek to redefine furniture and its design and revive the spirit of *Biedermeier*.

The lady's writing desk shown here is similar to another made for the *Wiener Werkstätte's* financial backer Fritz Waerndorfer, an indication of the status of this piece of furniture. Yet, with its store-away chair, it has at the same time a functional and simplified form that make it identifiable with the aesthetic aims of the Arts and Crafts movement.

CREATED

Vienna, Austria

MEDIUM

Deal carcass and mahogany interior with various inlays

RELATED WORKS

Desk and chair by Pál Horti, *c.* 1905

Koloman Moser *Born* 1868 Brünn, Austria

Died 1918

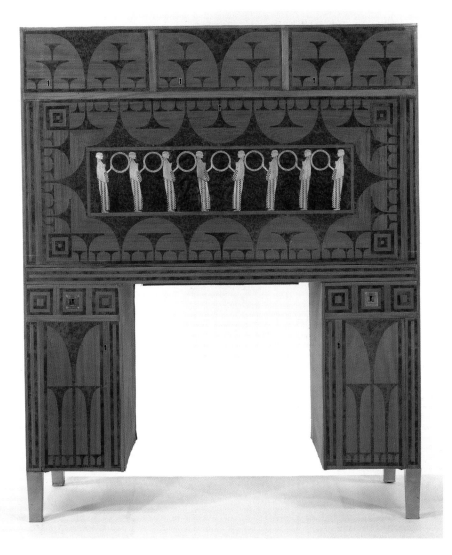

Moser, Koloman

Design for a woven wall hanging, 1901

Prior to adopting a purely geometrical approach in his designs, Koloman Moser produced a number of illustrations, including the cover designs for the Secessionist journal *Ver Sacrum*, in a more conventional Art Nouveau 'whiplash' organic style. The painter Gustav Klimt, the first president of the Secession, also executed many such designed illustrations. These designs are very heavily borrowed from British illustrators, combining Aubrey Beardsley's (1872–98) economy of line and eroticism, with Walter Crane's wit and use of colour. The typography, and indeed some of the more esoteric of Moser and Klimt's designs, were taken directly from the designs of Margaret MacDonald Mackintosh (1865–1933) and her sister, Frances McNair (1874–1921).

The design shown here is indebted to British Arts and Crafts. The stylized floral motif is a William Morris convention, and the typography is once again borrowed from the 'Glasgow Four'.

CREATED

Vienna, Austria

MEDIUM

Watercolour

RELATED WORKS

Silver studio for Liberty and Co. *c.* 1901–03

Koloman Moser *Born* 1868 Brünn, Austria

Died 1918

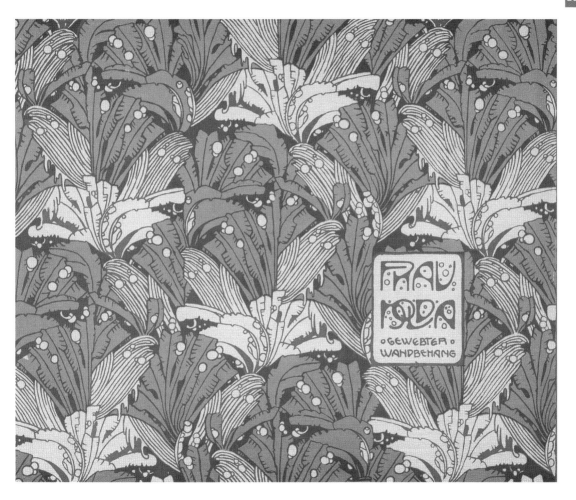

Moser, Koloman

Enchanted Princesses cabinet, *c.* 1900

Koloman Moser was originally trained as an Academic painter before studying design, and the cabinet shown here was painted by him shortly after the beginning of the Vienna Secession. The Secession's first president was the painter Gustav Klimt, who had recently begun a series of allegorical murals for the University of Vienna. In these images, and others by Klimt, women were often portrayed as seductive and alluring, reflecting a popular contemporary literary taste for *femmes fatales*. The paintings on the cabinet are clearly indebted to Klimt in the style. The emphasis on the cabinet's height, accentuated by the painted figures' narrow and elongated forms, suggest also a Japanese influence of *Kakemono*.

The taste for painted cabinets in the Arts and Crafts movement stems from the English taste for the medieval depictions of chivalry as personified by the Pre-Raphaelite painters, Dante Gabriel Rossetti (1828–82) and Edward Burne-Jones (1833–98). There is little evidence to suggest that Moser saw these cabinets and it is more likely that the idea was taken from Charles Rennie Mackintosh's designs, shown at the Secession exhibition of 1900, and which incorporated both painting and applied glass.

CREATED

Vienna, Austria

MEDIUM

Various woods, applied glass, nickel-plated copper

RELATED WORKS

Beethoven Frieze, Vienna by Gustav Klimt, 1901

Koloman Moser *Born* 1868 Brünn, Austria

Died 1918

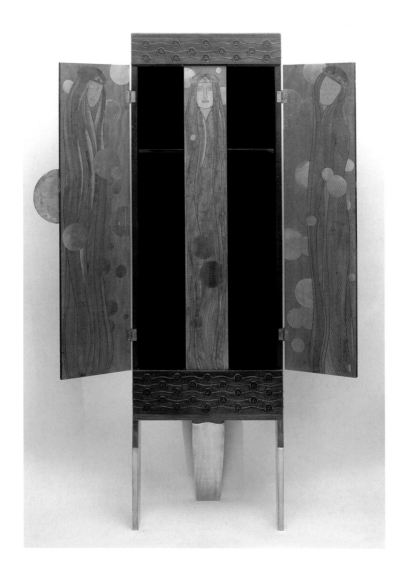

Riemerschmid, Richard
Table and chair, 1898–1900

Courtesy of Victoria & Albert Museum, 2005/© DACS 2005

As the Arts and Crafts movement gained momentum at the turn of the century, information about the activities of its practitioners was widely distributed through journals and mutual visits to other participating cities. Continental travel was easy at this time, since passports did not exist until after 1919. In addition, there was also a growing sense of close co-operation and idea-sharing between participants in the Continental Arts and Crafts movement, which included Britain.

After studying painting at the Munich Academy, Richard Riemerschmid began designing for the *Vereinigte Werkstätten für Kunst im Handwerk* (United Workshops for Art in Handwork) that were set up in 1898. Other designers at the *Werkstätten* included Peter Behrens (1869–1940) and Bruno Paul (1874–1968). Riemerschmid showed his designs at the 1900 *Exposition Universalle* in Paris. His designs for the *Werkstätten*, which included the chair illustrated here, were praised by influential Belgian designer Henry van de Velde (1863–1957) in the Darmstadt journal. This journal also sponsored the design competition, 'House for an Art Lover', for which Riemerschmid submitted, but which was won by the British designer Baillie-Scott. Van de Velde's enthusiasm for the designs was not surprising, as Riemerschmid used a similar 'bone-like' structure for the chair's frame, redolent of van de Velde's Art Nouveau motif.

CREATED

Germany

MEDIUM

Walnut and leather

RELATED WORKS

Chair for Cottage Philippe Wolfers by Paul Hankar, 1898–1900

Richard Riemerschmid *Born* 1868 Munich, Germany

Died 1957

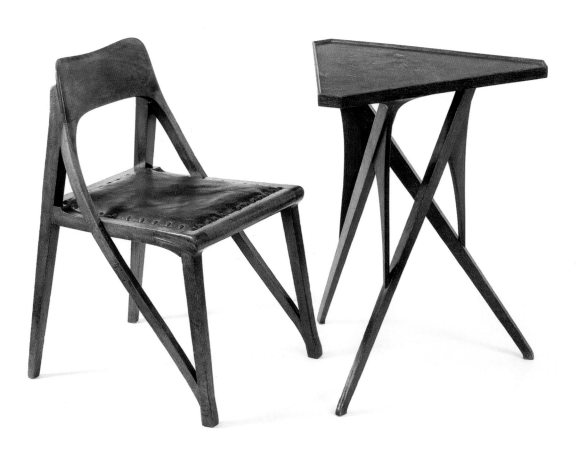

Riemerschmid, Richard

Tankard, 1902

Art Nouveau is seen as a Continental Arts and Crafts precursor to the development of industrial design, and one of the main protagonists in this development was Richard Riemerschmid. His Art Nouveau period embraced many designed objects including ceramics, as shown here. The German form of Art Nouveau, or *Jugenstil*, as practiced in Munich by Riemerschmid, was organic, but generally less opulent than its French and Belgian counterparts. It was also not geometric, unlike its Austrian neighbours. The body of the tankard distinctly resembles Scandinavian 'folk craft' and the lid is pure Bavarian, in keeping with Riemerschmid's native region and its folk traditions.

The fact that Riemerschmid used salt-glazed stoneware (*Steinzeug*) for the tankard is also a further reference to his homeland, since the process was developed in the Rhineland during the ninth century. The region became famous for the process up until the seventeenth century and it may well have been one of Riemerschmid's aspirations to revive the process, in line with Arts and Crafts practice.

CREATED

Germany

MEDIUM

Salt-glazed stoneware

RELATED WORKS

Toby jug by C. H. Brannam, 1899

Richard Riemerschmid *Born* 1868 Munich, Germany

Died 1957

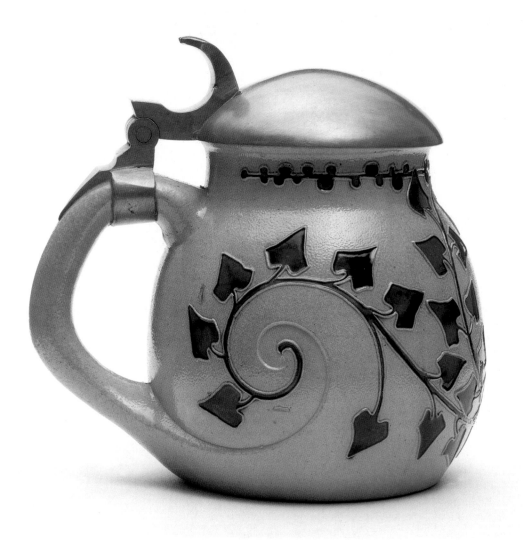

Riemerschmid, Richard

Dressing table, 1899

Riemerschmid continued with the theme of *Jugenstil* until about 1904, when he began collaborating on industrial design with his brother-in-law, the cabinet-maker Karl Schmidt (1873–1948). Some of their early designs were shown at the *Deutsche Werkstätten* exhibition in Dresden in 1905. By 1907, Riemerschmid was designing serial production items for the *Werkstätte* in Dresden and he began to introduce *Typenmöbel*, chairs and cabinets made from standard components. The workshops of Dresden and Munich amalgamated and organized a craft workshop community based in Hellau. These workshops, although based on the British models of Gimson and Ashbee, were not guilds in the accepted sense, and actively courted manufacturers as members. Contrary to the lack of financial viability in the British workshops at this time, the combined *Werkstätten* at Hellau were successful, paving the way for German industrial design.

In 1907 Riemerschmid became a co-founder of the *Deutscher Werkbund*, alongside Peter Behrens and others, including Hermann Muthesius (1861–1927). Muthesius, who became a German cultural attaché in London, studied British Arts and Crafts and was responsible for disseminating their ideals in Germany. In 1904 he published *Das Englische Haus* based on the work of the main Arts and Crafts practitioners in England, including Baillie-Scott and Charles Voysey.

CREATED

Germany

MEDIUM

Crown ash with brass fittings

RELATED WORKS

Cheval mirror by Charles Rennie Mackintosh, 1900

Richard Riemerschmid *Born* 1868 Munich, Germany

Died 1957

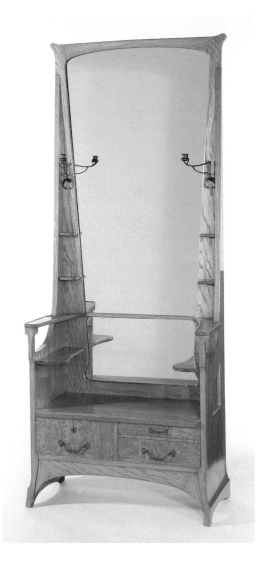

Della Robbia Pottery
Earthenware dish, c. 1885

The Della Robbia Pottery was set up in 1894, one of a number of small potteries set up along Arts and Crafts lines. The firm was set up by Harold Rathbone (1858–1929) and Conrad Dressler (1856–1940) to use local artists to make pottery that utilized local Birkenhead clay. In the event the clay proved to be unsatisfactory, but the pottery survived until 1906 using clays from other areas. The pottery fostered a community spirit, and employed technical staff from Royal Doulton and other potteries to train and oversee the local artists' work. Rathbone eschewed the notions of perfection and repetition in the work of the Della Robbia, insisting that the artists should have complete freedom of expression. Liberty and Co., who sold their work and promoted the smaller potteries, emphasized this point in their catalogue, stating, 'the designs are executed by Young Apprentices, and are in the main of their own device'. The dish shown here illustrates this point very well. The design, although loosely based on a Celtic cross, is executed in a freehand style that lacks symmetry, emphasizing its artistic freedom. Given its date, it anticipates the 'whiplash' Art Nouveau motif by a decade.

CREATED

Birkenhead, England

MEDIUM

Earthenware

RELATED WORKS

Isnik dishes by William de Morgan, 1888

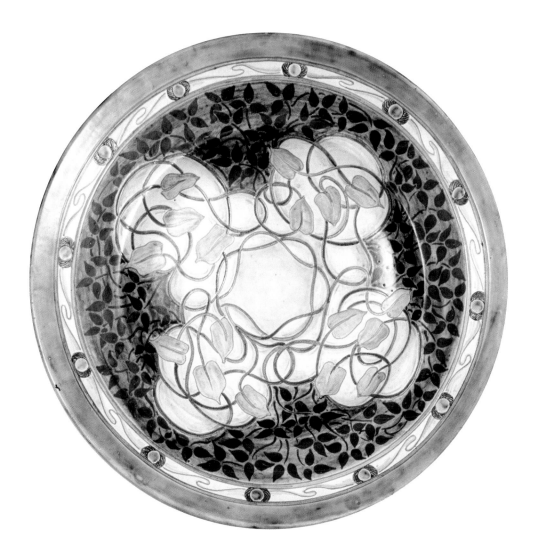

Moorcroft, William

Landscape vase, c. 1928

When William Moorcroft began his design career, it was as an employee of James MacIntyre and Co. of Burslem in Staffordshire. He was given a completely free hand to experiment with different clays, glazes and colourings in order that he could develop a distinctive style. His most distinctive design was the *Hazledene*, which he developed over a number of years and was sold in large numbers through Liberty and Co. at the turn of the century as part of their *Florian* range. At this time, Moorcroft was still experimenting, and *Florian* wares were only available in hues of blue, green and yellow glazes. Moorcroft maintained that his main influence was Chinese, as evidenced in the *Hazledene* design, with its 'stretched' tree-trunk and 'ballooned' foliage, that is redolent of similar Chinese motifs on eighteenth-century delftware teapots.

Moorcroft later set up his own studio and workshops in 1913, developing his own 'flambé glaze', a technique developed in mid-eighteenth century China using copper to provide a rich red hue. Moorcroft successfully combined his best-selling *Hazledene* tree motif with the highly developed 'flambé glaze' in this 1928 design.

CREATED

Staffordshire, England

MEDIUM

Glazed earthenware

RELATED WORKS

Pilkington's Lancastrian Pottery, from 1893 onwards

William Moorcroft *Born* 1873 Burslem, England

Died 1945

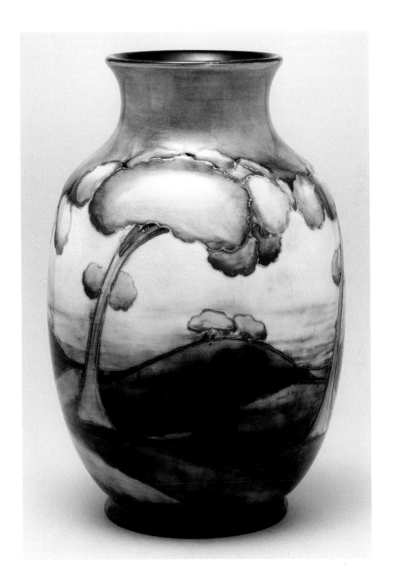

Paul Revere Pottery

Vase with flower motif, c. 1910

American 'art' pottery began in America in 1876 when Mary McLaughlin (1847–1939) exhibited her over-glaze decorated wares at the Centennial Exposition in Philadelphia. Although her work, which she called 'Cincinnati Limoges', was derivative of French Limoges, she created an awareness of the potential for Arts and Crafts pottery, particularly along the East Coast. McLaughlin claims to have been inspired by William Morris in setting up the Cincinnati Pottery Club. Many others followed suit, including Mary Nichols (1849–1932), who formed her own Rockwood Pottery in 1880 and was soon employing staff to keep up with demand for her Japanese-inspired glazed wares.

The Paul Revere Pottery, which opened in 1906, was founded on the principles of its philanthropic namesake, who in 1794 set up the Massachusetts Charitable Mechanics Association to improve the working conditions of artisans. With similar aims, the pottery was set up in Boston to provide occupations for young, disadvantaged girls from immigrant families. It was set up with some of Ruskin's principles: workers should receive fair pay and should enjoy their work. The designs were always much simpler than the Rockwood Pottery and reflected a degree of ethnicity and practicality as everyday objects.

CREATED

Boston, USA

MEDIUM

Painted and glazed ceramic

RELATED WORKS

Vase by Grueby Faience Co., 1905

Leach, Bernard

Earthenware dish, *c.* 1932

The son of a colonial judge, Bernard Leach was born in Hong Kong and spent the early years of his life living in Singapore and Japan. In 1903, after an education in England, he persuaded his father to allow him to attend the Slade, a progressive art school whose talented pupils included Augustus John (1878–1961). In 1909 he returned to Japan to teach etching, a skill he acquired at art school. It was at a subsequent *Raku* party in 1911 that Leach discovered the joys of pottery. *Raku* is a Japanese expression of joy that could be religious or philosophical, or a combination of both, and which was applied to a type of pottery developed in the late sixteenth century in Japan for tea ceremony ware. Leach recognized the Arts and Crafts ethos in *Raku* and developed his own philosophical approach to pottery-making using its tenets and techniques.

The *Raku* process involves moulding, rather than 'throwing', the clay and the application of simple paint marks, often in slip and heavy, dark and somber glazes, followed by low firing. Its handcrafted look and asymmetry are its hallmarks. Leach believed that pottery was a craft and not an industry.

CREATED

England

MEDIUM

Earthenware

RELATED WORKS

Earthenware charger by Michael Cardew, 1930

Bernard Leach *Born* 1887 Hong Kong

Died 1979

Hamada, Shoji
Flower vase

When Bernard Leach returned to England again in 1920 after studying Japanese pottery techniques in Kyoto, he was accompanied by the Japanese ceramicist Shoji Hamada. Hamada had graduated in ceramics at the Tokyo Advanced Technical College before further studies and visits to famous potters such as Kenkichi Tomimoto (1886–1963). He had also travelled to Korea and China to study their pottery traditions.

After working with Leach in England until 1923, Hamada returned to Japan and was influenced by the philosophical teachings of Soetsu Yanagi (1889–1961), who sought a return to the Japanese 'folk art' tradition that was being eroded by industrialization and standardization. In response to this, Hamada and another potter Kanjiro Kawai (1890–1966), set up a traditional kiln at Mashiko in 1925 and subsequently founded the Japan Folk Art Association. It was successful in re-educating Japanese people to respect handmade crafts, through its journal *Mingei*, which means 'folk art'. Yanagi was instrumental in disseminating Japanese craft tradition to the West through his book *The Unknown Craftsman*, in which he emphasized the function of objects rather than their aesthetic. The philosophy of *Mingei* influenced Bernard Leach and the subsequent generations of British potters.

CREATED

Japan

MEDIUM

Stoneware

Shoji Hamada *Born* 1894 Tokyo, Japan

Died 1978

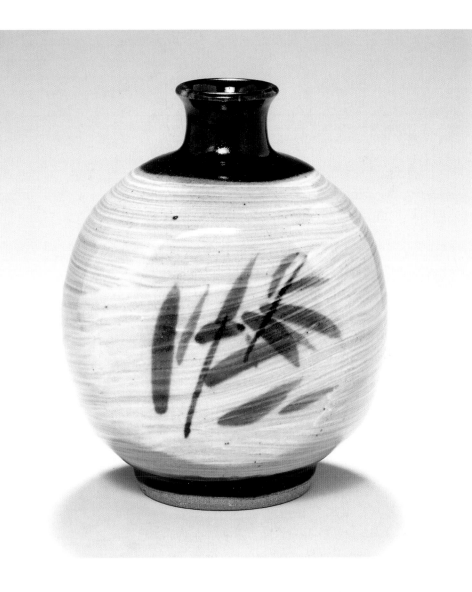

Leach, Bernard

Stoneware vase, c. 1931

Having developed a very distinctive style of 'art' pottery, which fused the elements of English and Japanese traditions, Bernard Leach continued to evolve a number of other influences on his craft. These involved both materials and other cultures. Stoneware differs from earthenware in that the clay contains stone, usually feldspar. Its use can be traced back to fourth-century China, but was used in the Rhineland from about the ninth century and certainly through the Middle Ages. The technique was adapted for use in Staffordshire in the seventeenth century using salt glazes and later became known as Creamware, typically off-white or grey in colour.

The vase is more Chinese than Japanese in nature, reflecting Leach's somewhat peripatetic upbringing. What makes it remarkable, though, is its asymmetry, attention to detail and lack of finish, in keeping with his status as an Arts and Crafts practitioner in the *Raku* tradition. Leach believed that perfection was not desirable in pottery, less it resemble an industrial product. For him, the artefact should be judged on its own merit, rather as a painting is judged, and not after being compared with similar objects. His work and ethos were influential to subsequent 'art' potters, particularly after the publication of his work *A Potter's Book*, in 1940.

CREATED

England

MEDIUM

Stoneware

RELATED WORKS

Stoneware bowl with fish motif by Henry Hammond, 1958

Bernard Leach *Born* 1887 Hong Kong

Died 1979

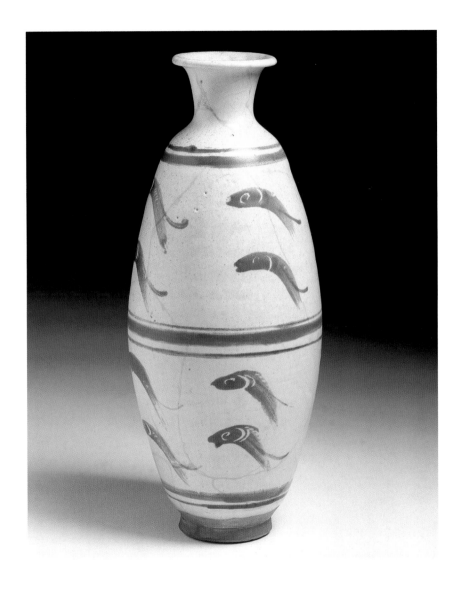

International Arts and Crafts

Influences

Webb, Philip
St George cabinet, 1861–62

The St George cabinet is another example of the collaborative work undertaken by Morris and Co. in their early days. Philip Webb designed the cabinet and the panels depicting medieval scenes were painted by William Morris (1834–96), as an example of what Morris referred to as 'work-day furniture', its opposite being what he called 'state furniture'.

Webb met Morris while they were both draughtsmen at the office of the Gothic revival architect G. E. Street (1824–81), in Oxford. Having learned about Gothic as a revival style, and having examined the original medieval structures in Oxford, they both embarked on a tour of the ancient cathedrals of northern France, armed with some of John Ruskin's (1819–1900) writings. While there, they made copious notes and drawings of medieval artefacts and motifs, as well as the architecture itself. This was the beginning of a period in which both men used these artefacts as a reference point for their future designs in a revival of medieval style. Although the revival as such had already begun in the work of A. W. N. Pugin (1812–52), his designs were almost entirely ecclesiastical, for patrons who shared his religious convictions, or state buildings. Morris and Webb were interested in extending its use to include the vernacular.

CREATED

London, England

MEDIUM

Painted and gilded mahogany, pine and oak with copper mounts

RELATED WORKS

The Prioress's Tale decorated wardrobe by Philip Webb, 1853

Philip Webb *Born* 1831 Oxford, England

Died 1915

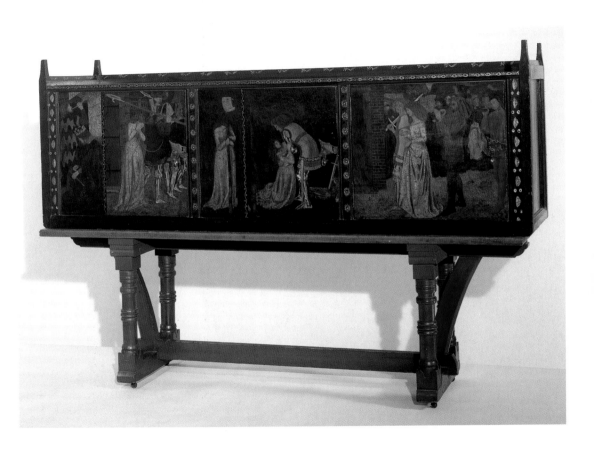

Webb, Philip

Red House, c. 1860

Red House was designed by Philip Webb as the first home of his associate, William Morris, and his new bride Janey in 1859. Although it is based on Gothic revival and incorporates some of its motifs, it is essentially a vernacular architecture. The 'vernacular style' was originally developed by Webb's tutor, G. E. Street, and other Gothic revivalists, such as William Butterfield (1814–1900) in their use of red brick and tall chimneys. The style also appeared in the rustic domestic architecture of George Devey (1820–86), for example at Penshurst Place in Kent. However, it was Webb who was the first to develop it as a distinctive style, and as a part of the Arts and Crafts movement through the offices of Morris and Co.

Webb and Morris's interest in the medieval is reflected in many of the features of the house, particularly internally. The hallway has a vaulted ceiling with exposed rafters and its oaken staircase has newel posts with a carved castellated motif. Many of the room entrances have pointed brick archways above and the entrance porch is suitably inscribed with a Latin motto: 'God preserve your going out and your coming in'. The 'vernacular style' became an important feature for a number of later Arts and Crafts architects, particularly Charles Voysey (1857–1941).

CREATED

Bexleyheath, Kent

MEDIUM

Architecture

RELATED WORKS

Cragside by Richard Norman Shaw, 1870

Philip Webb *Born* 1831 Oxford, England

Died 1915

Webb, Philip

Tracery design for a stained-glass window

© Victoria & Albert Museum, 2005

The Gothic revival of the 1840s and after was concerned as much with the restoration of medieval churches and cathedrals, as it was about the appropriate style for new ones. Many of the older churches had been stripped of their decorations and ornament during the Reformation, and often the stained-glass panels had been replaced by plain glass during the subsequent Puritan regime. During the nineteenth century the fabric of many of these churches had deteriorated, and it became an ideal opportunity to replace the stained glass during restoration.

The challenge was met by Morris and Co. whose individual artist-craftsmen, including Philip Webb, had been greatly influenced by many of the medieval stained-glass windows encountered on their travels in northern France. The window shown was part of the huge east window at Jesus Church in Troutbeck, Cumbria. Edward Burne-Jones (1833–98) executed most of the commission, with contributions from Webb and Morris himself. The window is a full-plate tracery design depicting Christ and the four Evangelists surrounded by various biblical tableaux. Such an elaborate tracery would normally only be found in cathedrals or in one of Pugin's schemes, such as Erdington Abbey, and therefore it was a somewhat ambitious undertaking for a small parish church.

CREATED

London, England

MEDIUM

Indian ink and watercolour

RELATED WORKS

Window for All Saints Church, Dedworth by Edward Burne-Jones, 1863

Philip Webb *Born* 1831 Oxford, England

Died 1915

Webb, Philip

Settle with gilded gesso decoration, *c.* 1865

The settle was an ideal piece of furniture for Philip Webb to express his ideas concerning his interest in medieval tradition and the vernacular. Webb designed a number of pieces of mostly rude furniture, intended as examples of the vernacular and, although usually decorative, they were also functional. Settles were used in the Middle Ages in taverns and later in farmhouses right up until the nineteenth century, and performed two functions: seating and storage.

Its construction has a 'truth to materials' in its use of English oak and it is decorated using another medieval tradition – gesso-based painting and gilding, which were not usually applied to furniture but were used as a ground for mural work. The gesso base provided an ultra-smooth ground on which to apply the paint and the gold leaf. In the Middle Ages the usual medium would have been egg tempera, but as this would be impractical for furniture, the design was executed in oil paint. The settle, or bench, would become characteristic of many Arts and Crafts interiors as a feature that emphasized 'homeliness', as exemplified by Mackay Hugh Baillie-Scott (1865–1945) and Frank Lloyd Wright (1867–1956).

CREATED

England

MEDIUM

Oak

RELATED WORKS

Cabinet by Richard Norman Shaw, 1861

Philip Webb *Born* 1831 Oxford, England

Died 1915

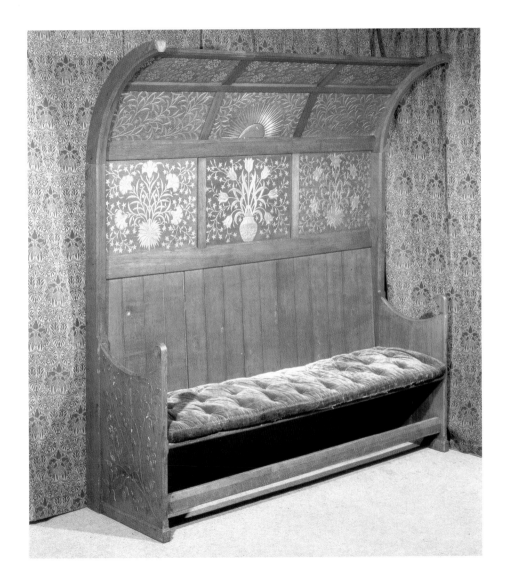

Webb, Philip
Adjustable-back chair, *c. 1866*

Warrington Taylor (*c.* 1837–70) became the business manager of Morris and Co. in 1865, and in the following year discovered the prototype for the adjustable chair in a workshop in Hurstmonceaux, Sussex. Philip Webb, who designed most of the firm's early furniture, subsequently designed the chair illustrated here from that basic design, but incorporated a number of features to make it a fashionable piece of furniture for their middle-class clientele. The frame was ebonized, reflecting a vogue for japanning, and in this example used a Utrecht velvet fabric that was an adaptation of a Heaton and Co. existing pattern inspired by seventeenth-century Dutch designs.

The chair was very popular and became a standard 'production' item for Morris and Co., who often used their 'chintz' patterns for the upholstery. Taylor referred to the chair, as he did all the Morris and Co. furniture, as having "its own style, it is in fact Victorian". Its commercial success encouraged Gustav Stickley (1857–1942) to make his own version for the American market. It was also replicated by Liberty and Co. in London.

CREATED

London, England

MEDIUM

Ebonized wood with Utrecht velvet upholstery

RELATED WORKS

Saville armchair by George Jack, 1890

Philip Webb *Born* 1831 Oxford, England

Died 1915

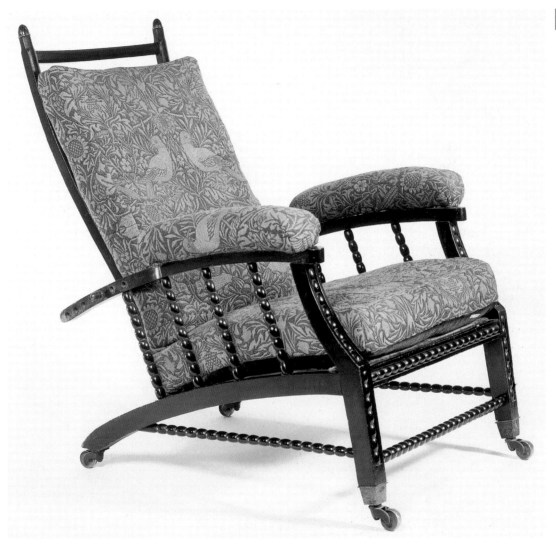

Day, Lewis F.

Wisteria decorative panel, *c.* 1890

Lewis F. Day and Walter Crane were contemporaries, both members of the Fifteen, founded in 1882, and which became the Art Workers' Guild in 1884. More importantly for the Arts and Crafts movement they were both educationalists, developing similar ideas concerning the application of design and the use of ornament. Many of Day's ideas emanate from Crane's and vice versa. Crane's first wallpaper designs are derivative of Day's, particularly the aptly named *Awakening Day*, although there appears to have been no pun intended. When Crane became superintendent of the newly formed London Decorating Company, a firm specializing in the manufacture of encaustic tiles, he worked with Day on the designs for *Ploughman* shown on pages 152–153.

Crane and Day shared common design principles concerning the suitability of design applied to particular materials and not just the application of ornament. In many respects they adhere to principles laid down by Day in *Nature in Ornament* (1892), which expressed the importance of a creative process that depended on knowledge of historical forms and the study of nature. For that, Day is indebted to Christopher Dresser (1843–1904). However, he often displayed an asymmetrical aspect to his designs reflecting the perversity of natural forms, rather than Dresser's formal stylized designs.

CREATED

England

MEDIUM

Painted leather

RELATED WORKS

Screen by John Dearle, 1885–1910

Lewis F. Day *Born* 1845 England

Died 1910

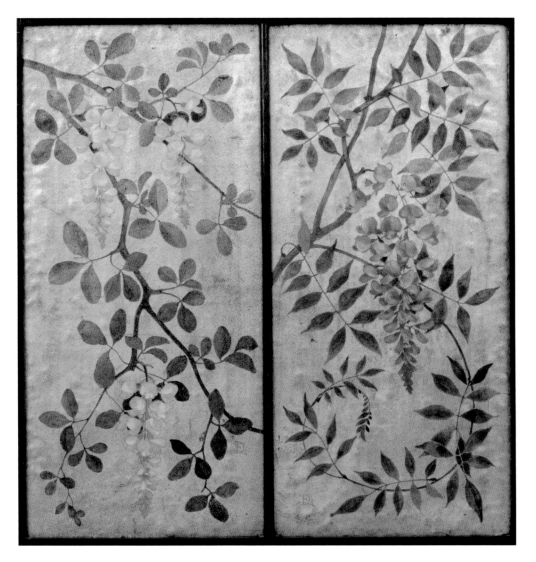

Day, Lewis F.

The Grotesque, design for a printed textile, 1886

This design for *The Grotesque* encapsulates Day's ideas of the combining his knowledge of historical ornament with the study of nature. The acanthus leaves, used so often in classical ornament for Corinthian capitals, are given a modern, stylized take. Their design accords with Arts and Crafts ideals of detracting from the illusionist sham without compromising the authenticity of the natural form. In this respect it is remiscent of Morris, but much lighter in aesthetic. *The Grotesque* is also taken from ancient Roman Classicism and was 'discovered' during the Italian Renaissance where it was adopted as a decorative motif. 'Grotesque' is defined as an unnatural composition of an animal, plant or fish, but often depicted a man or a combination of man and beast.

The Grotesque made an appearance in late nineteenth-century illustrations for books such as Lewis Carroll's *Through the Looking Glass* and in the Symbolist paintings of, for example, Odilon Redon. These illustrations and paintings reflected an interest in spiritualism and anti-materialism during this period. The vogue for *The Grotesque* had no better articulation in the Arts and Crafts movement than in the work of the Martin Brothers, who made a number of quirky pots and vessels at their own pottery in Southall during the 1880s and 1890s.

CREATED

England

MEDIUM

Pencil and watercolour

Lewis F. Day *Born* 1845 England

Died 1910

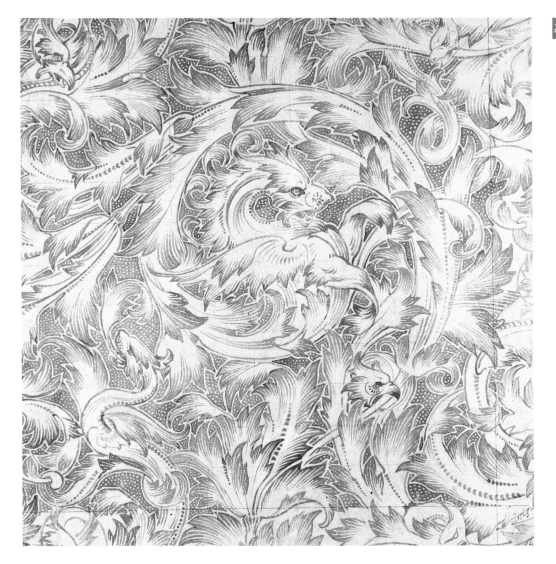

Day, Lewis F.

Sunflower dial clock, *c.* 1880

Day brings a number of eclectic elements into the design for this clock, in accordance with the contemporary Aesthetic movement. The sunflower motif and the black 'oriental' ebonized case were commonplace in the 1880s and exploited by retailers such as Liberty and Co. The application of Japan laquer had been somewhat ad hoc until Christopher Dresser's return from Japan, when he began importing genuine Japanese artefacts for his firm Dresser and Holme. However, until Dresser produced his magnum opus, *Japan, Its Architecture, Art and Art Manufacturer*s in 1882, designers such as Day, as evidenced in this clock-case design, were still misappropriating authentic Japanese design in favour of pandering to retailers such as Liberty's.

Although the design for the porcelain clock face is proficient, it lacks the gravitas of his later work. He did not formulate his design theories until the 1880s and 1890s, beginning with his *Instances in Everday Ornament* of 1880. It is through these books and the numerous articles that he published on the decorative arts that he is recognized, rather than his actual designs.

CREATED

England

MEDIUM

Ebonized birchwood and porcelain face

RELATED WORKS

Large *Tudric* clock by Achibald Knox, 1901

Lewis F. Day *Born* 1845 England

Died 1910

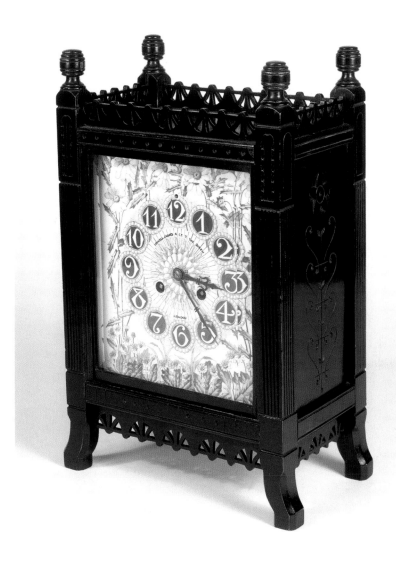

Day, Lewis F.

Earthenware dish with painted decoration, 1877

Although Lewis Day is best known for his textile and wallpaper designs, he advocated certain design principles that he maintained could be applied to any medium. Most of his designs were based on floral forms, advocating a conventional treatment without containing the characteristics of a specifically recognizable species. In the few designs he did for pottery, he used the same design principles as those employed in textiles and wallpapers. For Day, the circle (as in this dish) represented the most important element in geometric pattern because it allowed the design to flow. He maintained that, prior to the development of geometric forms by Pugin and others, man practiced them intuitively.

Typically, Day approached this design with a consideration for the distribution of the flower motif and its repetition as the first step. Having established that, the whole design could either radiate from the centre or flow, or do both. In the case of this design it does not radiate at all, but flows as part of an organic cycle. Day's ideas were articulated in his many books, including *Pattern Design* published in 1903.

CREATED

England

MEDIUM

Earthenware

RELATED WORKS

Dish with Persian decoration by William de Morgan, 1890

Lewis F. Day *Born* 1845 England

Died 1910

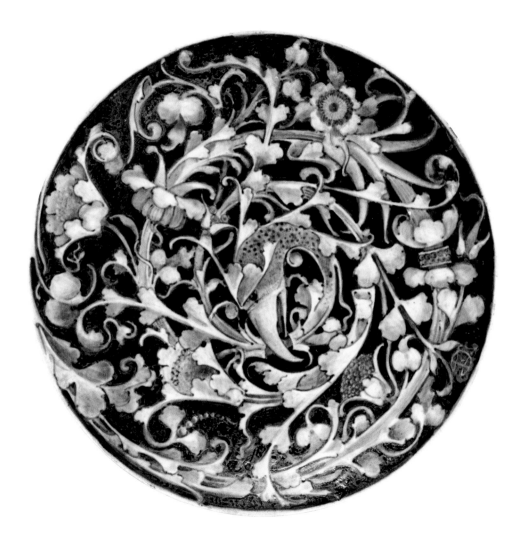

Day, Lewis F.
Printed velveteen furnishing fabric, 1888

Following William Morris's lead of using organic natural dyes, as opposed to commercial aniline dyes, Lewis Day designed a number of textiles for, among others, Turnbull and Stockdale. They used Thomas Wardle natural dyes, similar to those used by Morris. Turnbull and Stockdale was a new company set up in 1881, employing Day as their artistic director. The patterns used in his later designs show that Day has absorbed the formal lessons of both Owen Jones and Christopher Dresser and reinterpreted them into his own design manuals.

In his book *Pattern Design*, Day stressed the importance of controlling pattern 'within given bounds', such strictness of bounds being a challenge to a designer's invention. In this book written in 1903, Day is resigned to industrial design with the manufacturer as 'autocrat', and implores others to follow suit. However, he still sees himself and his associates as artists, who should "come to the aid of manufacture, which, without help from art, is given over to the ugliness which they deplore". By the turn of the last century, natural dyes and hand printing of textiles and wallpapers were on the wane, as retailers such as Liberty and Co. sought to increase production to meet the demand of the early twentieth century.

CREATED

England

MEDIUM

Block-printed cotton velveteen

RELATED WORKS

Fabric for G. P. Baker by G. C. Haité, 1890

Lewis F. Day *Born* 1845 England

Died 1910

Butterfield, Lindsay P.
Design for a textile, 1904

In a lecture given in 1881, William Morris said, "Set yourselves as much as possible against all machine work. But if you have to design for machine work, at least let your design show clearly what it is. Make it mechanical with a vengeance, at the same time as simple as possible". Even at this time, Morris came to realize that in order to democratize the printing of wallpapers and textiles such as chintzes, not all of them could be hand block-printed. The process was labour-intensive and therefore more expensive than machine printing.

Notwithstanding this aspect, William Morris had set the precedent for high-quality designs that most of the next generation of artist-designers sought to emulate. Although designing for the machine, they heeded Morris's credo that the peculiar characteristics of the material, and therefore its limitations, should not be a hindrance to the designer, but a pleasure. One such designer was Lindsay Butterfield, whose designs for machine production were clearly influenced by Morris: its repeating pattern is "mechanical with a vengeance, at the same time as simple as possible".

CREATED

England

RELATED WORKS

Woven wool and cotton by A. H. Lee and Sons, 1899

Lindsay P. Butterfield *Born* 1869 England
Died 1948

Butterfield, Lindsay P.

Iveagh furnishing fabric, *c.* 1901

© Estate of Lindsay P. Butterfield/Warner & Sons/Victoria & Albert Museum, 2005

Lindsay Butterfield was one of a new generation of artists who were trained at art school specifically to become a designer. His early designs included work for Morris and Co. and by the turn of the century he was designing for a number of outlets, including Liberty and Co., and a number of manufacturers who in turn supplied the retail trade. Butterfield's fabric is clearly derivative of Morris's printed designs such as *Chrysanthemum*, a stylized floral motif that had been popularized by Morris. Although Morris used a jacquard loom for silk and wool weaving, his designs, such as *Acanthus*, were formal, themselves derivative of Owen Jones's designs of the 1870s. Morris had been instrumental in reintroducing the jacquard loom into England in the late 1870s, and began weaving silks by hand operation.

Due to technological improvements and the increased awareness of the jacquard loom's possibilities, designers such as Butterfield began to extend the range of design possibilities, using the lighter designs of Morris's chintzes and wallpapers and weaving them as fabrics. Butterfield's designs became highly innovative, because they lost the appearance of symmetry that had dominated Morris's woven fabrics, and yet were elegantly 'framed' in order to facilitate pattern repeats.

CREATED

England

MEDIUM

Jacquard woven silk

RELATED WORKS

Fabric for A. H. Lee and Sons by Samuel Rowe, 1895–1900

Lindsay P. Butterfield *Born* 1869 England

Died 1948

Butterfield, Lindsay P.
Design for a floral woven textile, *c.* 1905

The *fin de siècle* marked a design transition from the desire to hang on to historicist motifs, to the dawn of a new modernity; a realization that rationalism and efficiency were necessary for the new century. Continental Europe best expressed that transition in the Art Nouveau style that reached its apogee at the *Exposition Universelle* in Paris in 1900. In the opening years of the twentieth century, there was also a move away from the influence of natural forms to one that used geometry, as demonstrated by Charles Rennie Mackintosh (1868–1928) and his influence in Europe. Although most British designers eschewed notions of the Art Nouveau aesthetic, the English public flocked in their thousands to the essentially Art Nouveau retailers Liberty and Co. in London during the 1890s. More importantly, Liberty's began to commission designers to create designs based on the burgeoning market for the Art Nouveau aesthetic, which, by the time this fabric was produced in 1905, was on the wane in Europe, but still in vogue in England.

Butterfield's design is based on the sinuous but abstract lines used, for example, in his stained-glass window designed for the Hotel Otlet in Brussels. Yet it also retained an element of natural form that appealed to the English market. In addition it shares a common vocabulary in textile design with C. F. A. Voysey (1857–1941).

CREATED

England

MEDIUM

Woven textile

RELATED WORKS

Thistle for Liberty and Co. by Harry Napper, 1900

Lindsay P. Butterfield *Born* 1869 England

Died 1948

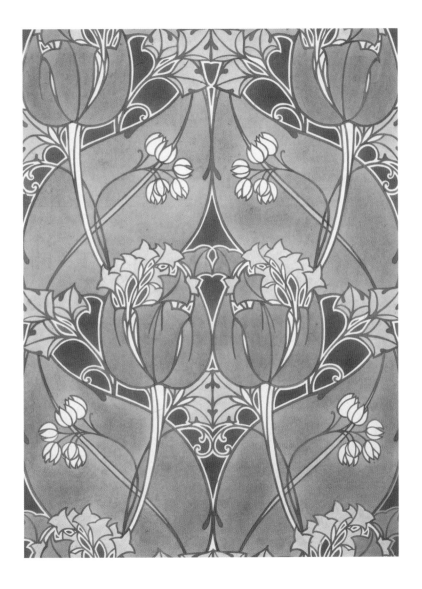

Butterfield, Lindsay P.

Poppies

In 1900 Gertrude Jekyll (1843–1932) published *Home and Garden*, a book that was to influence greatly the future of English garden design, which saw the creation of the herbaceous border as we know it today. Earlier, William Robinson (1838–1935) published *The English Flower Garden*, a seminal work that began a trend from the mid-1880s onwards for creating more natural-looking gardens. Until then, Victorian gardens were usually formal and geometric in layout, a regimented format of annuals and neatly-clipped box hedges. What Robinson, and others like him, advocated was the reintroduction of old garden favourites, such as poppy, sunflower, iris, lavender and pinks: natural looking and unpredictable flowers that created a more picturesque feel to the garden. Climbers with trailing flowers, used to cover garden walls and even house walls, reinforced this and reflected the season's changes.

The emphasis of returning to the 'natural' is of course a key ingredient of the Arts and Crafts movement, and Gertrude Jekyll's work is seen within this context. Designers such as Butterfield responded to this new interest in these old garden favourites, creating a range of designs such as *Poppy* and *Hydrangea* for printing on chintzes and wallpapers.

CREATED

England

MEDIUM

Printed cotton

RELATED WORKS

Fabric for F. Steiner and Co. by Christopher Dresser, 1899

Lindsay P. Butterfield *Born* 1869 England

Died 1948

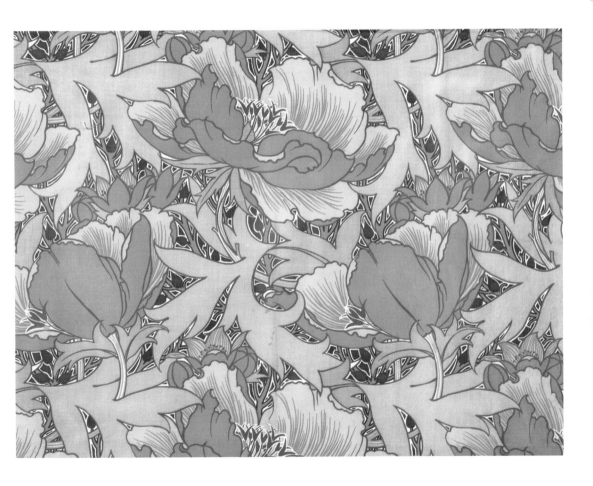

Butterfield, Lindsay P.

Design for a textile, c. 1902

© Estate of Lindsay P. Butterfield/Victoria & Albert Museum, 2005

At first glance, Butterfield's design has all the hallmarks of William Morris, with a richness of design that emphasizes natural form. Given the solid areas of definite colour and the dark ground of the design, it may well have been intended as an indigo-discharge hand block-printed textile. Using natural indigo dye was another Morris development. This process was far more expensive than roller printing but had the advantage of deeper colour rendition and permanency.

It is clear that Butterfield was indebted to Morris in his use of colours, being somewhere between Morris's *Evenlode* and *Strawberry Thief* designs. However, Butterfield's designs are less formal, more asymmetrical and reflect a more natural fluid approach to textile design at the turn of the century, begun by designers such as Walter Crane and continued by Charles Voysey, Lewis Day and Butterfield himself. These textiles, both woven and printed, were popular with Liberty and Co. and marketed under the generic name, Liberty Art Fabrics. They became well known in Europe during the 1890s after Liberty's opened their Parisian store at the beginning of the decade. At the turn of the century, Liberty's became synonymous with British textile design and many of their designs became influential to French, Belgian and American pattern designers.

CREATED

England

MEDIUM

Watercolour and body colour

RELATED WORKS

Silver Studio for Liberty and Co., 1899

Lindsay P. Butterfield *Born* 1869 England

Died 1948

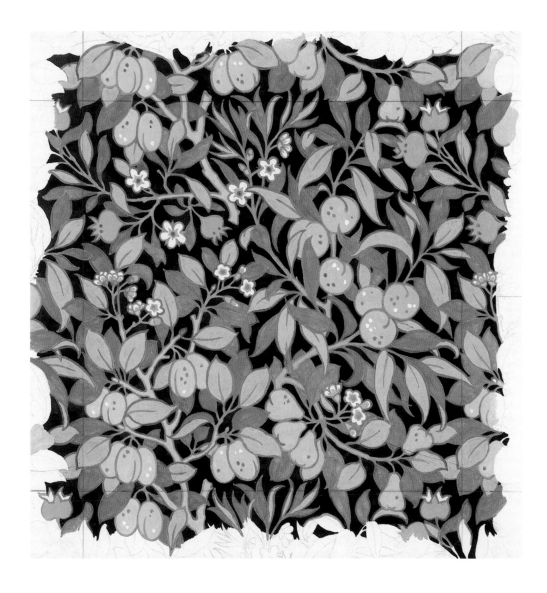

Voysey, Charles
Swan chair, 1883–85

In 1918, Charles Voysey designed a headpiece for an article that was to appear in the Royal Institute of British Architects' journal *Transactions*, praising A. W. N. Pugin's achievements. The complex design showed Voysey's knowledge and absorption of Pugin's *True Principles*. What Voysey admired most about Pugin was his 'truth to materials' and his sense of design integrity. He said of his hero, "the mode adapted by Pugin was one born and bred in Britain alone, thoroughly germane to the climate and national in character".

Although unlike Pugin stylistically, Voysey's chair shows his indebtedness to his ideas in the use of English oak and the honesty of the revealed construction of the joints in the side panels. Much of Pugin's secular furniture has the same honesty, particularly that made for his own home. The 'swan' motif articulated in this chair was a favourite of Voysey's, and was made to accompany a bookcase-writing desk also designed by him. Although the chair anticipates the curvilinear organic forms of Art Nouveau, Voysey eschewed this notion saying that it was "out of harmony with our national character and climate".

CREATED

England

MEDIUM

Oak

RELATED WORKS

Chair by Henry van de Velde, 1898

Charles Voysey *Born* 1857 Yorkshire, England

Died 1941

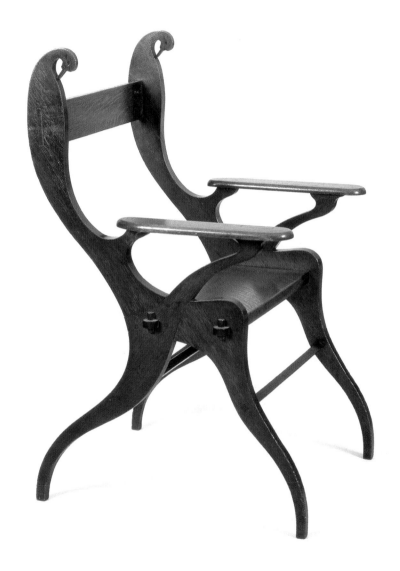

Voysey, Charles

Textile, *c.* 1905

Unlike many of his contemporaries, Voysey, although not poor, did not come from an affluent background. It is therefore not surprising that when he discussed his aspirations for designs that embraced "comfort, repose, cheerfulness and simplicity", he added, "rich and poor alike will appreciate its qualities". The democratizing aspects of his designs have much in common with Morris. He also shared with Morris the notion of bringing the garden into the house, seeing the birds and trees, a favoured motif, as symbols of an 'unspoilt nature'.

In 1888 Voysey showed his designs for textiles at the first Art Workers' Guild-sponsored Society Exhibition, where he would also have seen William Morris's latest designs, which had by this time lightened in style. He may well have seen Morris's *Willow Boughs* design at this exhibition, a more stylized and simplified design, which is a departure from his more naturalistic earlier designs, and which anticipates Voysey. The move towards these simplified stylized motifs is of course redolent of Pugin, but as with so many of the later Arts and Crafts designers, they were also influenced by Christopher Dresser. Although a trained botanist, Dresser used simplified and stylized plant motifs that were derivative of his Japanese influence.

CREATED

England

MEDIUM

Block-printed cotton

RELATED WORKS

Willow Boughs by William Morris, 1887

Charles Voysey *Born* 1857 Yorkshire, England

Died 1941

Voysey, Charles

Dining Room, The Orchard, Chorley Wood

Unlike its Gothic revival antecedent, Arts and Crafts architecture does not have discernable characteristics that make it a 'style' as such. Rather, it was the architects themselves who felt that changing the architecture, to a style that was ahistorical and non-dependent on convention, would improve the lives of its inhabitants. For these architects, the emphasis was on repose and comfort over style *per se*. Philip Webb had already cast the die at Red House, in which a return to the values of vernacular architecture, with an emphasis on homeliness, were manifest. The second generation of Arts and Crafts practitioners, which included Charles Voysey, built on that change of emphasis. Voysey's first undertaking was The Orchard, a home he built for himself and his wife at Chorley Wood in Hertfordshire.

Protection is a recurring theme in Arts and Crafts domestic architecture, both in Britain and America, precipitated by the extreme elements of weather. The architecture of Voysey and Frank Lloyd Wright share a common vocabulary, with an emphasis on wall solidity accentuated by recessed windows and a low, steep-sided roof that usually overhangs the house. The use of small windows and slender chimneys by both architects also reinforces the notions of wall solidity, and thus protection for its inhabitants.

CREATED

England

MEDIUM

Interior design

RELATED WORKS

Orchards by Edwin Lutyens, 1897

Charles Voysey *Born* 1857 Yorkshire, England

Died 1941

Voysey, Charles
Textile design, 1889

When Voysey was only twelve years old, his father, a Church of England vicar, was charged with heresy. Based on reason, he questioned the validity of traditional biblical orthodoxy. Despite support from, among others, John Ruskin, Voysey Senior was expelled from the Anglican Church in 1871 and subsequently founded the Theistic Church. This religion, based on reason and logic, attempted to reconcile Darwinism with traditional religion. Not only were Voysey's sermons popular with his congregations, but they also had a profound effect on his son's career as a designer.

In an unpublished document called 'Symbolism in Design', C. F. A. Voysey defined the role that his design motifs played as allegories. The heart motif, for example, signified emotions and affections. In 1918 he gave a lecture on 'Modern Symbolism' delivered with much of his father's passion for sermon. The design illustrated here shows that he was already beginning to formulate his own ideas about the role of symbolism in design. The snake symbolized fertility and the power to heal. In 1889, the same year as this design, the Voyseys gave birth to a son, having already lost two children in early infancy. The snake is also a symbol of logic, one of the Seven Liberal Arts.

CREATED

England

MEDIUM

Ink and wash

RELATED WORKS

Omar by C. Harrison Townsend, 1893

Charles Voysey *Born* 1857 Yorkshire, England

Died 1941

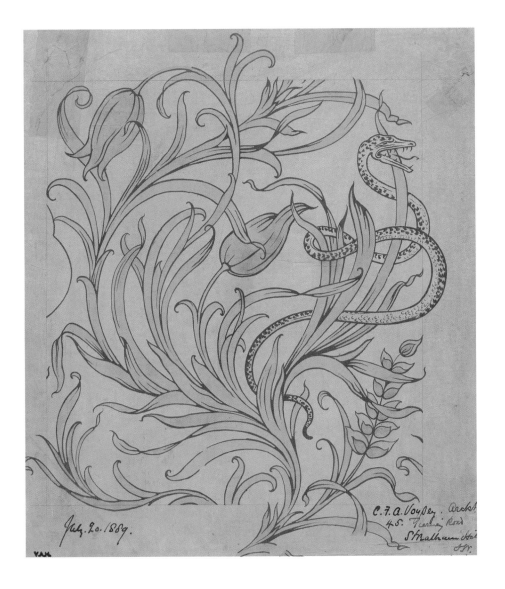

July. 20. 1889.

C.F.A. Voysey. Archt.
45. Tierney Road
Streatham Hill
S.W.

Voysey, Charles

Green-stained oak writing cabinet, c. 1896

Voysey was not a prodigious furniture designer like his tutor J. P. Seddon (1827–1906), to whom he was apprenticed in 1874. Neither was he as versatile a furniture designer as his friend Arthur Mackmurdo (1851–1942). Nevertheless, Voysey managed to design a range of furniture that could be adapted to suit different applications. In the example shown here, for instance, the cabinet is green-stained oak. Oak remained his first choice and he often used it in its original state, relying only on its textural quality for effect.

The chamfering of the tapered legs is borrowed from Arthur Mackmurdo, as is the rectilinear solidity of its construction. Although the use of heavy hinges can be seen in the work of Pugin, Arts and Crafts practitioners such as Baillie-Scott seemed to share its common vocabulary. The stylized use of the motif is Voysey's idea. He repeats the use of the bird and tree motif on the centre hinge, with the other two adopting another of his favourites, the tulip head. The lock at the top of the cabinet contains yet another of his motifs, the heart. The heart motif was used on his furniture in different ways, sometimes as a cutout on chair backs, an idea that was replicated by the Munich designer Richard Riemerschmid (1868–1957).

CREATED

England

MEDIUM

Oak

RELATED WORKS

Linen press by Charles Rennie Mackintosh, 1896

Charles Voysey *Born* 1857 Yorkshire, England

Died 1941

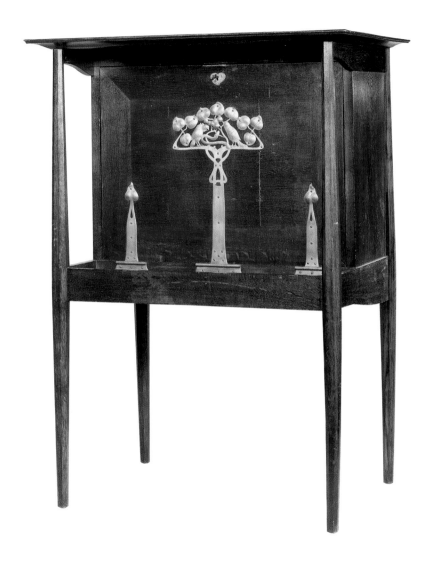

Voysey, Charles
Wallpaper design, *c.* 1900

By 1900, when this wallpaper was made, Voysey was designing under contract for Essex and Co., who referred to him as the 'genius of pattern' in their advertisements. Other manufacturers, such as Jeffrey and Co., were also making block papers for the more discerning clientele and machine-printed papers for the mass market. The market for Arts and Crafts had, by 1900, expanded to embrace house furnishings as well as craft objects, as its consumers followed aesthetic trends to 'keep up with the Joneses'. This expansion of the middle-class market was accommodated by an increasing number of department stores such as Debenham and Freebody, Harrods and later Selfridges. They all sought designs from the leading Arts and Crafts practitioners, seeing them as facilitators of a growing commercial market rather than as design reformers. Voysey was essentially an industrial designer who believed that the only way that 'art' design was accessible to the majority, instead of an elite, was through machine production.

In this design, the central motif adopts Mackmurdo's design for the *Sea Lily* of 1882, and his *Iris* wallpaper is similar in its combination of birds and plants. However, Voysey's are less natural, the stylization suggesting a Japanese influence.

CREATED

England

MEDIUM

Ink and watercolour

RELATED WORKS

Poppies by Lindsay P. Butterfield, 1901

Charles Voysey *Born* 1857 Yorkshire, England

Died 1941

Knox, Archibald

Dish, *c.* 1903

From an early age, Archibald Knox was interested in Celtic traditions. He was born on the Isle of Man, and while at Douglas Grammar School his headmaster, a keen archaeologist, took an interest in Knox's education, fostering an interest he had in local Celtic traditions. Knox's examination, to graduate from his subsequent education at Douglas Art School, for which he gained a distinction, was based on his research of historic ornament. His research probably involved visiting Dublin to look at the ancient *Book of Kells*, a not-too-difficult journey given the location of the Douglas school. It would also have been combined with the rich source of primary reference material on the Isle of Man. Although the School of Art would almost certainly have owned a copy of Owen Jones's *The Grammar of Ornament*, which was published in 1856 and contained many references to Celtic ornament, it is uncertain whether Knox made reference to it. Nevertheless, the Celtic tradition was familiar to designers through Jones's book, but as yet no one in England had used the motifs in a way that would constitute a revival.

After moving to London in 1897, Knox had a brief spell teaching before embarking on a range of designs for Liberty and Co. of London. The dish shown is from Liberty's *Tudric* range of pewter ware that Knox commenced around 1900.

CREATED

Birmingham, England

MEDIUM

Pewter

RELATED WORKS

Silver jardinère at Weimar by Henry van de Velde, 1902

Archibald Knox *Born* 1864 Isle of Man

Died 1933

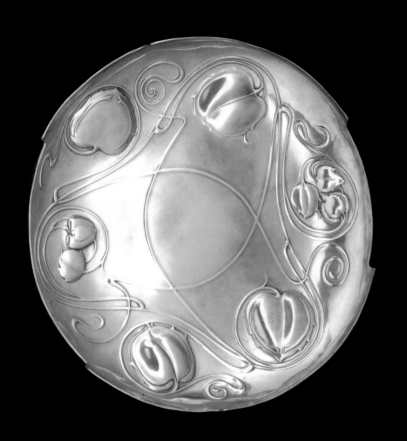

Knox, Archibald

Cymric cigarette box, 1903–04

By 1903, when Knox designed this cigarette box, Charles Ashbee (1863–1942) felt threatened by the onslaught of commercial production of Liberty's range of *Cymric* silverware and jewellery. He felt that the Liberty and Co. range had been plagiarized from his own designs for his Guild of Handicraft. By the time of the Guild's demise in 1907, Ashbee certainly viewed the ascendancy and price competitiveness of Liberty and Co. as a contributing factor. Certainly, it is not without some justification that Knox's fluidity of design motif and use of semi-precious stones was suggestive of Guild work. Ironically, the use of machines for the manufacture of the *Cymric* range enabled them to achieve a higher quality of finish than at Ashbee's Guild. Nevertheless, Liberty and Co. deliberately sought to imbue the finished articles with a 'hammered' finish.

The fluidity of this design, albeit indebted to Ashbee, also pays due deference to the vogue for Continental Art Nouveau that Liberty and Co. exploited, and can justifiably be held as the only example of an embodiment of English Art Nouveau. Liberty's successfully marketed this range to Italy where, even today, their knowledge of Art Nouveau is expressed as 'Liberty Stile'.

CREATED

Birmingham, England

MEDIUM

Silver, cedar-wood lining, with inlays of opal matrix

RELATED WORKS

Tea caddy by Joseph Maria Olbrich, 1900

Archibald Knox *Born* 1864 Isle of Man

Died 1933

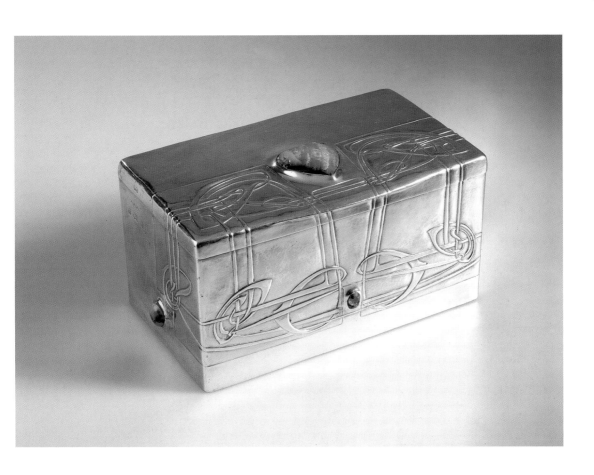

Knox, Archibald
Ring and necklace

As with his silverwork, Knox's designs for jewellery are clearly indebted to Charles Ashbee. What Knox probably observed in Ashbee's work was the capacity for the graceful linking of the mounted semi-precious stones, accommodated by a fine chain. Ashbee used a number of chains to construct a web of other linkages, enabling the necklace to 'swing' and this clearly influenced Knox, as seen in this design, who went on to create a number of these designs for Liberty and Co.

Knox also designed a range of *Cymric* jewellery in silver for Liberty's, although the designer remained anonymous until after production ceased, in order for the company to create a corporate identity through its products. Ironically, Liberty and Co. were allowed to show their range at the Art Workers' Guild-sponsored Exhibition Society in 1899 and again in 1903. Having breached the society's rules regarding anonymity, the company's founder Lasenby Liberty wrote to Knox asking him to provide a permit to circumvent the problem. Although the items were normally machine made, two craftsmen, in order once again to 'bend' the society's rules, executed the designs for the exhibition display.

CREATED

England

MEDIUM

Gold and semi-precious stones

RELATED WORKS

Jewellery for the Guild of Handicraft by Charles Ashbee, *c.* 1900

Archibald Knox *Born* 1864 Isle of Man

Died 1933

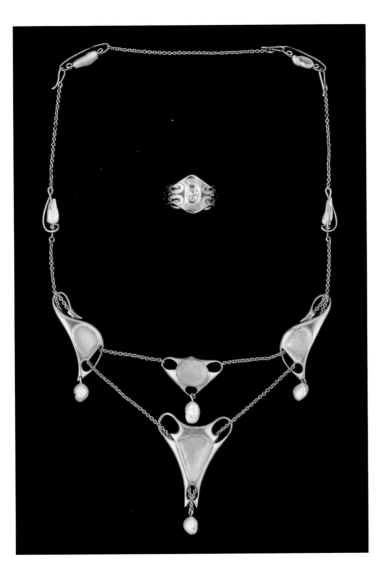

Knox, Archibald

Clock, *c.* 1905

© Victoria & Albert Museum, 2005

It is likely that, by 1898, Lasenby Liberty had discovered the traditional pewter products of the German firm of Kayser and Son, whose senior designer was Hugo Leven (1874–1956). Their 'Art Pewter' products were so-called because of their appropriation of organic motifs in their decoration that bear an uncanny resemblance to the 'style' of Charles Rennie Mackintosh, particularly in the use of the 'Glasgow rose'. This was clearly the 'spark' that energized Liberty to produce his own range of pewter wares from about 1900. His decision to use Knox for this range emanated from a lecture that he attended some years before in which the idea of a Celtic revival had been mooted.

Baillie-Scott, at whose office on the Isle of Man Knox had first been employed after leaving art school, introduced Knox to Liberty. Baillie-Scott was obviously aware of his talents and his familiarity with Celtic ornament, and he seemed the natural choice. This design includes some of the Celtic motifs, such as the shape of the clock, a reminder of Celtic tombstones, and the knot used in the tree root. In pagan myth, the tree was sacred, being the home of a god.

CREATED

England

MEDIUM

Pewter

RELATED WORKS

Rex silver for Liberty and Co., 1903

Archibald Knox *Born* 1864 Isle of Man

Died 1933

Knox, Archibald

Tudric teapot, 1903–04

Although Knox is credited with the majority of the *Tudric* and *Cymric* ranges of pewter and silverware products for Liberty and Co., there were a number of other designs used, mainly through the independent design studio of Rex Silver (1879–1965), for whom Knox worked when he first came to London. In line with Liberty's policy of anonymity, many of the accreditations were not given until many years later. This was also true for the manufacturers. As with all *Tudric* products, this design was manufactured by W. H. Haseler of Birmingham. To ensure production continuity as well as anonymity, Liberty purchased a sixty per cent stake in the company.

The relationship of Liberty and Knox epitomizes the dilemma faced by Arts and Crafts designers, particularly at the turn of the century, when machine technology was ever more evident. Could the Arts and Crafts practitioner design for industrial production? The design shown here is obviously, at a superficial level, influenced by Art Nouveau. At a deeper level, Christopher Dresser influences it, in its simplicity and fitness for purpose. It also suggests an affinity with Peter Behrens' designs of the same period in which he, too, sought answers to questions about compromising the Arts and Crafts for industrial design.

CREATED

England

MEDIUM

Pewter

RELATED WORKS

Teapot by William Benson, 1895–1900

Archibald Knox *Born* 1864 Isle of Man

Died 1933

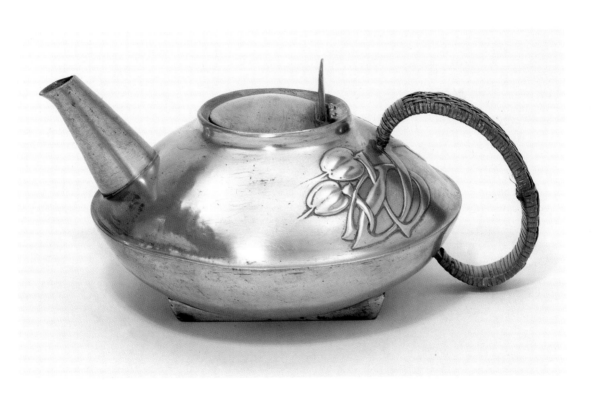

Knox, Archibald
Tea and coffee service, 1902–03

This design seems to sum up all the influences that Knox is likely to have encountered, and yet he still made it unique to him. The use of the semi-precious stones set into the silverware is pure Ashbee. The simplicity of the shape and elegant undecorated handles suggest the functionality of Dresser. The use of lapis lazuli is borrowed from the Renaissance period and yet its deep-blue qualities, as a foil to the polished silver, is turn of the century Knox.

Tea and coffee sets were popular at this time and were produced in an Art Nouveau style in both Germany and Austria. Friedrich Adler (1878–1942) in Munich had produced a number of striking designs, which combined a simple and ergonomic shape with the sinuous organic decoration normally found in France and Belgium. Meanwhile Josef Hoffman (1870–1956) in Austria produced a design that was both ergonomic and geometric in shape and was without decoration, except for the ebonized handles. While the shape of Knox's tea and coffee service is simple, he brings all his knowledge of Celtic decorative motifs to bear in this dynamic design.

CREATED

England

MEDIUM

Silver, ivory and lapis lazuli

RELATED WORKS

Tea and coffee service by Josef Hoffman, 1905

Archibald Knox *Born* 1864 Isle of Man

Died 1933

Mackintosh, Charles Rennie
Washstand, *c. 1900*

Perhaps more than any other British Arts and Crafts practitioner, the work of Charles Rennie Mackintosh seems to articulate the concerns for design reform, over and above a consideration of its social implications. This may have been a contributing factor to his marginalization, particularly by his English contemporaries, who referred to Mackintosh and the 'Glasgow Four' as the 'spook school'. With the possible exception of Knox's contribution to Liberty and Co., Mackintosh was also the only British practitioner whose work can be properly categorized as Art Nouveau: not only was he inspired by the style, but he actively sought to contribute to its aesthetic.

Like many other designers of his generation, he was inspired by the vogue for the Orient, and in particular Japanese design. Archive photographs of Mackintosh's first home in Glasgow, which he refurbished with his wife Margaret Macdonald (1865–1933), show that not only was he was an avid collector of Japanese prints, but that even the vases of flowers were arranged in a traditional Japanese manner. This cabinet's rectilinear mode and simple utilitarianism reflect this interest in Japanese style and its fitness for purpose. The application of a stylized, more geometric than natural, willow tree for the splashback had a profound effect on the application of Art Nouveau in Vienna.

CREATED

Scotland

MEDIUM

Mahogany

RELATED WORKS

Serving table by Gustav Stickley, 1901

Charles Rennie Mackintosh *Born* 1868 Glasgow, Scotland

Died 1928

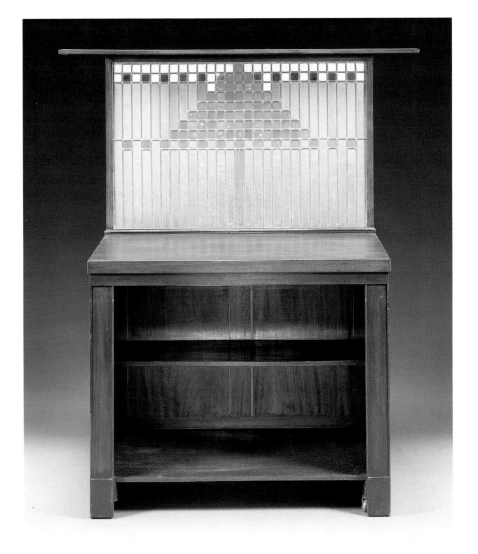

Mackintosh, Charles Rennie

White oval side table, *c.* 1902

This table came from Mackintosh's second home, at South Park Avenue, Glasgow, which he shared with his wife Margaret. Mackintosh adopted the 'Glasgow rose' as a motif, an expression of the Celtic revival that found favour with many of his Scottish patrons. The fretwork cutout in the legs continues the theme and pays homage to the organic forms of Art Nouveau. The Mackintoshes completely refurbished the house and created a completely new aesthetic look, redolent of the 'coolness' of the Aesthetic movement, as expressed in Ashbee's Arts and Crafts design for 37 Cheyne Walk, Chelsea. Mackintosh was also indebted to Lethaby for his book *Architecture, Mysticism and Myth*, in which the author called for his fellow practitioners to abandon the use of antiquarian detailing and return to nature. Mackintosh's response was to "clothe modern ideas with modern dress".

The 'whiteness' of Mackintosh's furniture was a cultural shock when he displayed a room-set at the 1900 Secession exhibition in Vienna. He was nevertheless treated as a celebrity and afforded a respect that he had not enjoyed in Britain. His most celebrated pieces were there, including the famous dark wood high-back chair, a foil to the white furniture of the room.

CREATED

Scotland

MEDIUM

Painted wood

RELATED WORKS

Painted furniture for *A Home* by Carl Larsson, 1899

Charles Rennie Mackintosh *Born* 1868 Glasgow, Scotland

Died 1928

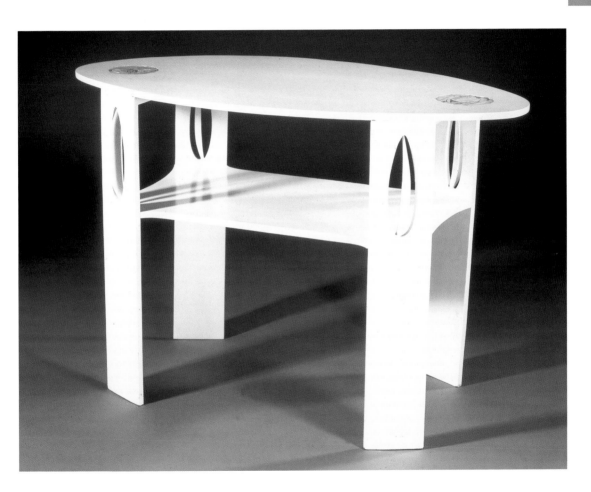

Mackintosh, Charles Rennie

The Wassail, 1900

Mackintosh's interiors have to be seen as part of the collaborative effort of the 'Glasgow Four' rather than in isolation. They had been together since attending the Glasgow School of Art in the 1890s, a school that had gained international renown. Their achievements as artist-designers earned them the nickname of 'spooks' because of their deference to the Symbolists, a loosely connected group of European painters who flourished from the mid-1880s onwards. The Symbolists reflected an anti-materialist approach largely inspired by literature, which sought to convey an evocation or suggestion of the spiritual, rather than a narrative. Among the painters to have a direct effect on the 'Glasgow Four' was Jan Toorop (1858–1928), a Dutch painter who sought to combine his Symbolist ideas with the vogue for the Art Nouveau 'whiplash' motif, suggested in the curvilinear form of his figures and the sinuous qualities in the depiction of their hair.

They were also influenced by the line drawings of their near contemporary, Aubrey Beardsley (1872–98), whose work was well known through the publication of *The Yellow Book*, and his scandalous illustrations for Oscar Wilde's (1854–1900) *Salome*. Beardsley also collected Japanese prints, and his replicated use of the hairstyle in his figures is repeated by the 'Glasgow Four' in their gessoed panels and fabrics.

CREATED

Scotland

MEDIUM

Watercolour and pencil on paper

RELATED WORKS

The Water Serpents by Gustav Klimt, 1904

Charles Rennie Mackintosh *Born* 1868 Glasgow, Scotland

Died 1928

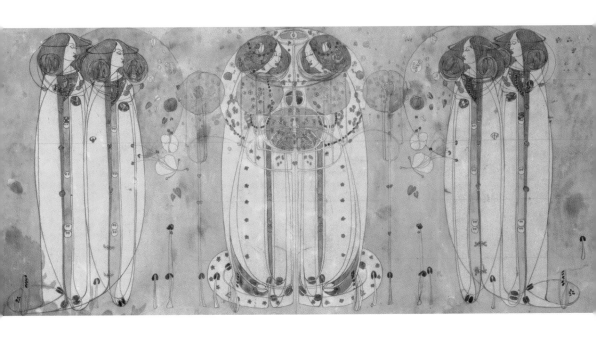

Mackintosh, Charles Rennie
Side chair, c. 1905–10

Christopher Dresser's seminal work *Japan, Its Architecture, Art and Art Manufacturers*, published in 1882, had a profound effect on Mackintosh while he was still a student. For the first time, Japan and its aesthetic culture could be explored by reference to a book written by a designer who had spent over a year there, rather than just the Western pastiche of its motifs.

Mackintosh absorbed the layout of traditional Japanese rooms, which used screens rather than walls, creating a feeling of spatial freedom. He began to use the idea of the quadrilateral screen motif in his first architectural commission, the Glasgow School of Art, which he began in 1896. The repeated motif was used extensively in the windows and again for many of the interior items, such as the chairs. The chair shown here is from a later date than the school project, but shows how the motif is repeated, emphasizing its Japanese influence with an ebonized finish. The quadrilateral motif had a considerable influence on the Vienna school and in particular Josef Hoffman, who over-used the motif on many of his designs for the *Wiener Werkstätte*.

CREATED

Scotland

MEDIUM

Ebonized wood

RELATED WORKS

Furniture for the *Punkersdorf Sanitorium* by Josef Hoffman, 1904

Charles Rennie Mackintosh *Born* 1868 Glasgow, Scotland

Died 1928

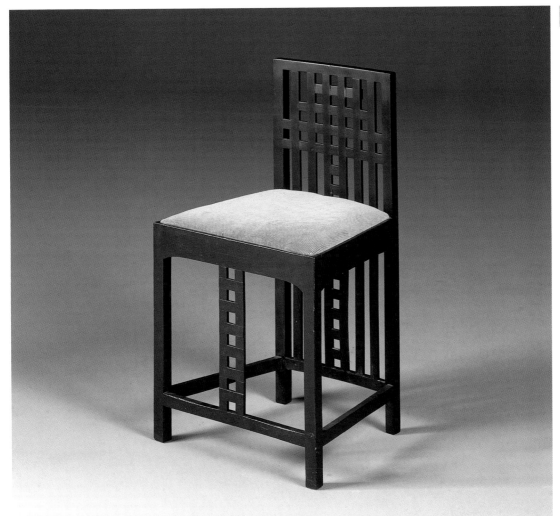

Mackintosh, Charles Rennie
Jewel box, *c.* 1900

Chis early piece by Mackintosh was made as a gift for his intended fiancée Jessie Keppie, who he was later to jilt in favour of Margaret MacDonald. It is made of wood overlaid with brass and decorated in *repoussé* work. *Repoussé* is one of the oldest styles of decoration, with known artefacts dating from around 6000 BC. As it relies solely on hand beating of a metal sheet, it is an ideal craft for the amateur. What this piece demonstrates is a lack of craftsmanship skills by Mackintosh, but a high degree of theatricality, something that was to be his hallmark in the future.

Although *repoussé* work was being undertaken during the Victorian period, it was usually on silverware as a delicate piece of finishing. The Arts and Crafts practitioners, particularly under Ashbee's hand, were much bolder in their approach. The influence for the piece comes from a desire to replicate Art Nouveau, but it is also inspired by the metalwork of Ashbee, particularly the design around the name plate on the inside of the lid. The motif on the front pays homage to the Celtic revival, but is clearly indebted to Baillie-Scott.

CREATED

Scotland

MEDIUM

Repoussé brass mounted on wood with glass inserts

RELATED WORKS

Cigar box for Liberty and Co. by Alexander Knox, *c.* 1900

Charles Rennie Mackintosh *Born* 1868 Glasgow, Scotland

Died 1928

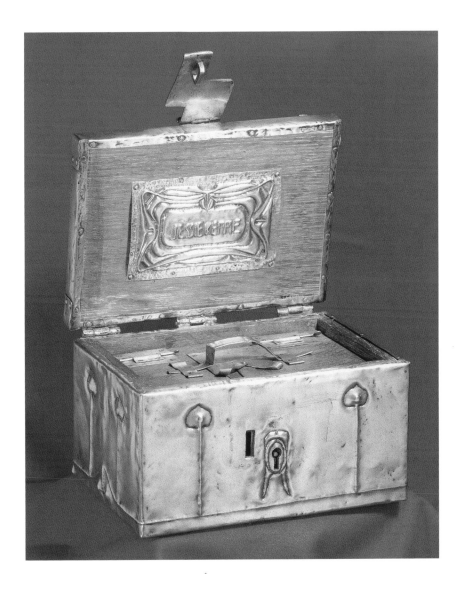

International Arts and Crafts

Techniques

Morris, William

Acanthus wallpaper, 1875

William Morris's attempts at achieving the flat patterning beloved of the design reform movement from the 1850s onward resulted in the design of a number of very successful wallpapers, beginning with *Trellis* in 1862. The simple designs of this first group of wallpapers, which also included *Daisy*, were subsequently executed by one of the leading 'art' wallpaper printers of the time Jeffrey and Co., using five or six distemper colours. Jeffrey and Co. were already established as printers for Owen Jones's designs of the 1850s.

Distemper is a type of paint that requires the dispersal of coloured pigments in water using a binding agent. When used in a printing process, the finish is very matt due to the inclusion of 'whiting', a form of crushed chalk. The distemper was applied to the paper using wooden blocks for the printing process, one for each colour. The process was very labour-intensive, requiring the careful alignment of each block to ensure correct colour registration with previously applied colours. Building on the success of these papers, Morris developed a more sophisticated range, beginning in 1874 with *Acanthus*. This design required 15 colours and, because of the design's complexity, it required 30 blocks, the pattern repeat requiring two blocks for each of its 15 colours.

CREATED

London, England

MEDIUM

Wallpaper

RELATED WORKS

Single Stem wallpaper by John Dearle, 1905

William Morris *Born* 1834 Walthamstow, England

Died 1896

Morris, William

Hammersmith carpet, c. 1890

William Morris did not believe in creating designs without learning the necessary craftsman's skills to execute them. Morris therefore began experiments on carpet weaving in 1878, at a time when he had successfully completed his earlier experiments on natural dyes. His first loom was set up the following year in the stables at Kelmscott House, Hammersmith, hence the name of his handmade carpets. Morris decided not to weave his carpets on the jacquard loom he had installed at Kelmscott, preferring instead to send most carpet designs out for machine weaving, while concentrating on specially commissioned carpets using hand-knotted techniques on a manual loom.

The hand-knotted carpets were slow to make, with weavers (all women) knotting only two inches of carpet per day, and they were consequently expensive. Typically a room carpet would cost over £100, with the average weekly wage of a lower middle class clerk being less than £3 per week. Morris and Co. also made handmade rugs and sold them through their retail outlet. More often than not, the carpets were used as wall hangings rather than floor coverings because of their cost. The design for this carpet is based on Persian designs Morris had seen in 1877, remarking, "I had no idea that such wonders could be done in carpets".

CREATED

London, England

MEDIUM

Hand-knotted carpet

RELATED WORKS

Design for a wall panel by Christopher Dresser, 1886

William Morris *Born* 1834 Walthamstow, England

Died 1896

Morris, William

Miniature carpet loom, late 19th century

This miniature loom was made at Merton Abbey for the instruction of carpet weavers, who were exclusively women. Following the success of his earlier experiments and the resultant sales, Morris transferred his textile and carpet operation to a disused former silk works at Merton Abbey in Surrey. The new premises were ideally situated, close to London and alongside the River Wandle, providing endless supplies of water for cleaning fabrics prior to weaving.

The weaving process involved the 'stringing' of the vertical warp threads, which were usually cotton or a cotton-mohair blend, and threading them through with various coloured weft threads, usually wool or mohair, to make the pattern. Unlike tapestry, the carpet weavers faced the design when knotting the threads. The looms were placed close to the windows for maximum lighting conditions. The wools employed were coloured using natural dyes by Thomas Wardle in Leek. Wardle, whose brother George was the general manager of Morris and Co., worked with William Morris in developing these dyes. He was well-travelled and had already begun experimenting with dyes following his visits to the Orient. Wardle also supplied naturally dyed threads to machine weavers such as Wilton carpets.

CREATED

England

MEDIUM

Wood and metal fittings

William Morris *Born* 1834 Walthamstow, England

Died 1896

Morris, William
Utrecht velvet, *c.* 1871

Traditional velvets came from Italy in the fourteenth century, inspired by Far Eastern imports, and were made of silk. By the seventeenth century, France, England and the Low Countries began their own velvet-weaving industry. Cutting the silk-fibre loops, specifically woven and held in place by the weft threads, created the original velvets. The length could be varied to create sculpted piles. The best examples of this style are the Genoese velvets, in which the pile is 'shaved' into intricate patterns.

The Utrecht velvet was a derivation of the process, which substituted the less expensive mohair, or a mixture of mohair and cotton, for the silk. It was made in the Low Countries beginning in the seventeenth century, and continued to be popular as a wall hanging throughout the eighteenth century. The English version of the Utrecht velvet, popularized by Morris and Co. from about 1871, bears a strong aesthetic resemblance to the Genoese velvet in its sculpted form, but it serves a more practical purpose than as a wall hanging. The Utrecht fabric was purchased by Morris and Co. and used for the upholstery of their chairs. It was available in a range of colours.

CREATED

England

MEDIUM

Embossed mohair plush

RELATED WORKS

Dahlia woven silk by Warner, Sillett and Ramm, 1870–75

William Morris *Born* 1834 Walthamstow, England

Died 1896

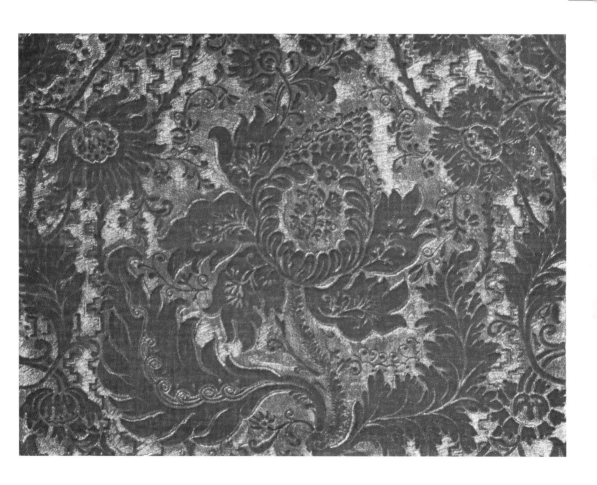

Morris, William

Printing blocks for *Strawberry Thief* textile, 1883

During the 1870s, dissatisfied with the poor colour quality of aniline dyes, William Morris began experimenting with natural dyes. His trips to Thomas Wardle's dye works, and their subsequent collaboration based on Wardle's own experiments using Indian dyes, enabled Morris to experiment with some of these 'difficult' colours, particularly indigo. The *Strawberry Thief* was the first of a number of designs that used the so-called 'indigo-discharge' method of printing. It involved dying the whole fabric in indigo, which then formed the background to the pattern. The design outlines were then bleached out using bleaching agents and pattern blocks cut in negative. The various colours of the design were then overprinted using separate wooden blocks for each hue.

Strawberry Thief was one of a series of printed chintz designs produced in the period from 1881 to 1885, after Morris's move to Merton Abbey. The increased capacity workshops afforded him the opportunity to be more adventurous. He also built his own indigo vats for dying the fabric rather than out-sourcing it. The blocks were made by the firm of Joseph Barrett and Son, of Bethnal Green Road, London. This design was Morris's most demanding, and probably most expensive, chintz, because of the length of time it took to produce.

CREATED

London, England

MEDIUM

Wood

William Morris *Born* 1834 Walthamstow, England

Died 1896

Morris, William

The Artichoke embroidered hanging, 1877

Another application for William Morris's success with natural dyes was the colouring of silks for embroidery. One of Morris's first designs to exploit this new technique was *Honeysuckle* (1876), which was worked by his wife Janey and daughter Jenny on a linen ground using a range of stitches to complete the pattern. The design, which was block printed on linen, formed a part of the Royal School of Art's needlework portfolio in the 1870s. This began a series of similarly printed designs for other embroiderers to work.

One such design emanated from a commission that Morris received from Ada Phoebe Goodman, an upper middle class woman who worked the design in crewel wools over many years for her home at Smeaton Manor in Yorkshire. The *Artichoke* design was not, however, exclusive, and was used again at Standen in Sussex by Mrs Beale and her daughters, who were also very accomplished embroiderers, working the design in silk. The design is a Classical motif based on the studies that Morris made at the South Kensington (now Victoria and Albert) Museum in the 1870s. In particular he studied Near Eastern and Italian designs. He continued to design embroidery patterns using large floriated motifs such as *Lotus* and *Acanthus*, until the mid-1880s when his daughter May (1862–1938) took over the embroidery department.

CREATED

London and Yorkshire

MEDIUM

Crewel wools on linen

RELATED WORKS

Stanhope woven silk for Warner, Sillett and Ramm by Owen Jones, 1872

William Morris *Born* 1834 Walthamstow, England

Died 1896

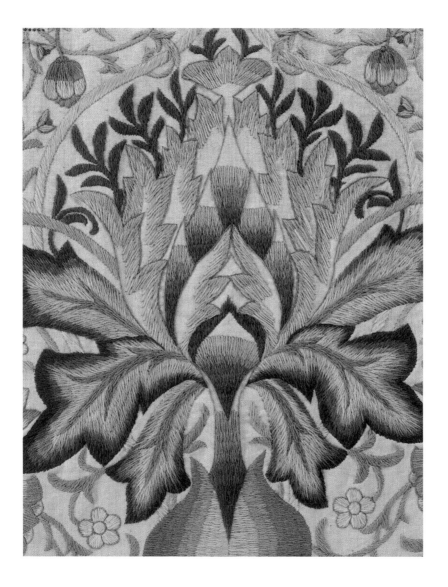

Dearle, John

Single Stem wallpaper, c. 1905

Until quite recently many of the designs by John Dearle had been wrongly attributed to William Morris, the result of working under the Morris and Co. umbrella. Dearle was taken in by William Morris as an eighteen-year-old apprentice in 1878. By 1890 he was the chief designer at Morris and Co., having acquired the necessary skills from Morris in textiles, weaving and the printing of wallpapers.

Dearle's first design for wallpaper was *Iris*, a simple design incorporating flowers and birds, much like Morris's first design for *Trellis*. The style of *Iris* is not unlike Morris's *Jasmine* of 1872, showing Dearle's indebtedness to his tutor. The design for *Single Stem* is again not dissimilar to Morris, and incorporates many of his motifs. The acanthus leaves, single-headed flower and background of leaves are redolent of Morris's *Chrysanthemum* design of 1876. By 1905, when this design was executed, Dearle had acquired the skills as a designer in his own right and, although indebted to Morris, his motifs are more stylized, reflecting a move towards a more modern aesthetic while retaining some of Morris's more natural forms.

CREATED

England

MEDIUM

Wallpaper

RELATED WORKS

Acanthus by William Morris, 1875

John Dearle *Born* 1860 England

Died 1932

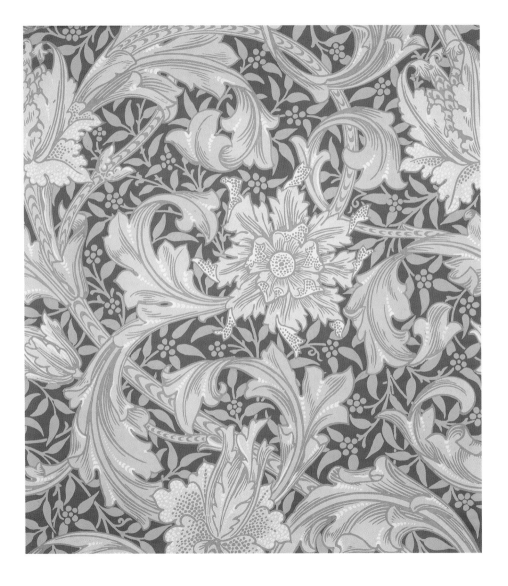

Dearle, John

Trail furnishing fabric, 1891

Some of Dearle's designs for fabrics were actually modified versions of William Morris's designs for wallpaper. *Trail* is such an example, taken from Morris's design for both *Grafton* (1883) and *Wild Tulip* (1884), using the meandering stems as a motif. The first of these designs was not executed as wallpaper and, during their collaborative period of the late 1880s, Morris may well have considered it opportune for Dearle to adapt this design. By 1891, when *Trail* was executed, Morris had very much taken a back seat at Merton Abbey, relying on Dearle's designs and George Wardle for production.

In their catalogues, Morris and Co. emphasized the differences in using hand-block colour for fabrics and wallpapers as opposed to machine-roller production. In essence the difference is in permanency of colour. Machine colour is applied as a thin coat to assist in the fast drying process required, resulting in a tendency to fade quickly. In the hand-block process, because the colour is applied liberally, it remains much more permanent. The downside to this was, of course, that the drying process was long, production slower and costs higher.

CREATED

England

MEDIUM

Block-printed cotton

RELATED WORKS

Wild Tulip by William Morris, 1884

John Dearle *Born* 1860 England

Died 1932

Dearle, John

Hand-knotted carpet, 1889

This carpet was one of two ordered from Morris and Co. in 1889 by the wool trader John Sanderson for his house, Bullerswood, at Chislehurst in Kent. Morris and Co. were commissioned to redecorate and furnish the house. The design for the carpet is similar to the Naworth Castle commission from 1881, designed by Morris and the first to be woven on the new looms installed at Merton Abbey. Dearle, an apprentice at this time, may well have been an operative on the weaving of this commission.

During the 1880s Dearle became more proficient in the techniques of tapestry and carpet weaving and, by the end of the decade, was collaborating with Morris on designs as well as production. The 'Bullerswood' carpet was the first of those collaborations. Although this carpet is similar to the 'Naworth' there are elements of Dearle's input that distinguish the two designs. Dearle used a more formal and stylized form in his motifs, reflecting his studies of Turkish carpets at the South Kensington Museum. The carpet was exhibited at the 1893 Arts and Crafts Society exhibition.

CREATED

London, England

MEDIUM

Hand-knotted carpet with woollen pile on cotton warp

RELATED WORKS

Donegal carpet for Morton and Co. by Charles Voysey, 1903

John Dearle *Born* 1860 England

Died 1932

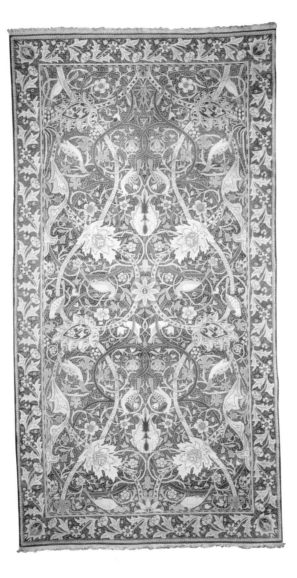

Dearle, John

Angeli Minstrantes tapestry (detail), 1894

William Morris always held tapestry to be "the noblest of the weaving arts, in which there is nothing mechanical". Having declared that the weaver should be an artist, it is surprising that beyond initial experiments, he contributed very little to tapestry designs beyond collaborations with Dearle, Edward Burne-Jones (1833–98) and Philip Webb (1831–1915). The major tapestries from 1891 are all based on medieval themes, culminating in the *Holy Grail* series.

Morris believed that small boys were suited to the weaving of tapestry because of their small, strong and flexible fingers, with Dearle becoming his first apprentice for this craft in 1878. They collaborated on *The Orchard* tapestry in 1891 and, as a mark of respect to Morris, Dearle reported that, "The colouring as well as the general design are by Mr Morris and parts of the figure have been woven by his own hand". *Angeli Ministrantes* was designed by Dearle and Burne-Jones as one of a pair of tapestries. They are based on angel figures designed by Burne-Jones for a stained-glass lancet window for the south aisle at Salisbury Cathedral in 1877–78. The borders, depicting pomegranates and oranges, were designed by Dearle and are typical of William Morris's use of the acanthus leaf and fruit motifs.

CREATED

London, England

MEDIUM

Wool, silk and mohair on a cotton warp

RELATED WORKS

Designs for tapestries depicting angels by Edward Burne-Jones, 1877

John Dearle *Born* 1860 England

Died 1932

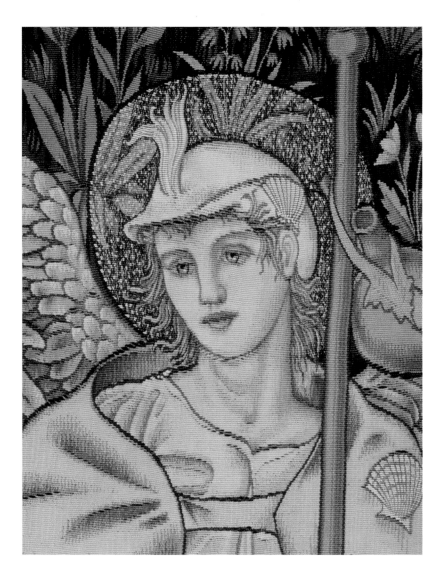

Dearle, John
Screen, 1885–1910

In many ways, Dearle epitomized Morris's ethos that the designer should "learn the practical way of carrying out the work for which he designs". During the 1880s, Dearle, as Morris's protégé, had overall responsibility for overseeing the weaving operation at Merton Abbey and was obviously being groomed as a successor to his tutor, who was spending more and more time on political activities. During this time, Morris's daughter May, who designed a number of embroideries herself, was also tutoring Dearle in embroidery techniques prior to his engagement as a designer for that craft as well. After taking over the embroidery department of Morris and Co. in 1885, Dearle also designed panels for wall hangings.

The design for the right-hand panel, *Anemone*, was originally for a wall hanging and was executed between 1885 and 1890. Dearle's designs can be distinguished from those of May Morris in his use of the meandering stem motif, as on his previous designs and exemplified in *Anemone*. Contemporary photographs of Morris and Co. interiors show that these wall hangings, adapted for use as folding screens, were popularly used in drawing rooms.

CREATED

London, England

MEDIUM

Glazed mahogany frame with panels of canvas embroidered with silks

RELATED WORKS

Embroidered screen by Walter Crane, 1876

John Dearle *Born* 1860 England

Died 1932

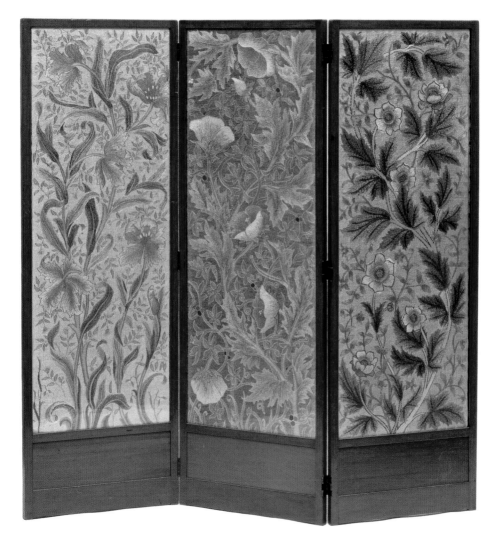

Dearle, John
Furnishing fabric, 1888

Although similarities can be seen between Dearle's design and Morris's *Granada* fabric of 1884, it is more redolent of Owen Jones's formalized style as seen in his *Stanhope* fabric of 1872. These stylized forms were popular with design reformers of the mid-nineteenth century, such as Jones and A. W. N. Pugin (1812–52), and continued to be an inspiration for later designers such as Dearle, Lewis Day (1845–1910) and Charles Voysey (1857–1941).

These elaborate yet subtle designs for use on furnishing could only be achieved in a woven fabric. In 1877 Morris employed a French weaver to set up a jacquard loom as an alternative to his earlier experiments on the standard draw loom. The draw loom requires the services of a 'draw boy', who, through a series of attached lines and pulleys, was required to pull the relevant vertical warp threads to accommodate the weaver 'throwing' the shuttle containing the weft wool or silk through the remainder. The jacquard loom replaced the 'draw boy' with a series of pre-cut punch cards placed in the loom. This could accommodate the weaving of more intricate patterns in the same time it took the draw loom to weave simpler ones.

CREATED

Merton Abbey, England

MEDIUM

Jacquard woven silk and cotton

RELATED WORKS

Stanhope textile by Owen Jones, 1872

John Dearle *Born* 1860 England

Died 1932

De Morgan, William

Vase, 1888–98

Of the many vases he designed, the one illustrated here is probably William de Morgan's most famous, its posterity assured after it was included in a portrait of the designer by his wife Evelyn, Pickering. De Morgan and his wife were married in 1887 and the following year he opened a factory at Sands End, Fulham, the beginning of a prolific period in his life in terms of the quantity and quality of his work. Prior to this he had worked in cramped conditions or, when he moved into William Morris's Merton Abbey works, had found the journey too difficult, as a consequence of a weak spine.

After initially working exclusively in ceramics, de Morgan turned his skills to hollow-wares, often using some of his ceramic designs on pottery. Many, but not all of his wares were hand painted, often commencing the work himself and giving instructions for its completion. What makes his work distinctive is the lustre glaze applied to the ware after painting. De Morgan used the 'reducing atmosphere' technique: at a critical point in the firing, the kiln was starved of oxygen, creating a reaction in the glaze that gave it its iridescence.

CREATED

London, England

MEDIUM

Earthenware painted in lustre

RELATED WORKS

Stoneware by the Martin Brothers, between 1890 and 1904

William de Morgan *Born* 1839 London, England

Died 1917

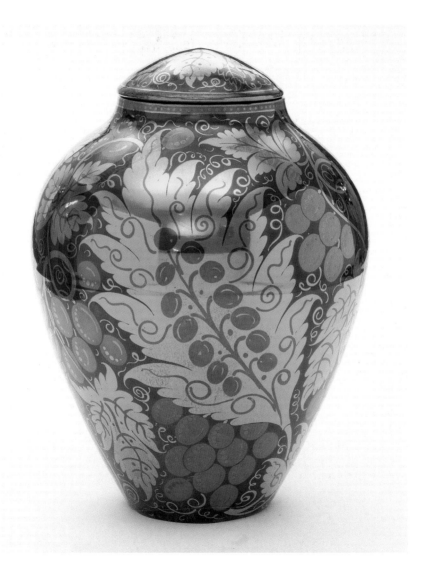

De Morgan William

Antelope with Fruit Tree dish, 1880–85

Most of William de Morgan's decorative work, other than tiles, was intended for show rather than everyday use. It was earnestly sought by discerning collectors of high-quality porcelain and pottery. Most of his work used blanks from Staffordshire, which he then turned into 'art' wares, this dish being an example. Like many of his designs for 'art' wares, this one is taken from a range of tiles that he developed in the 1860s as a designer for Morris and Co. Many of these designs are of animals and are often whimsical or even grotesque in nature. Some of the animals would be 'smiling', many would be stylized, reflecting a Japanese influence, and some would be mythical, such as unicorns or dragons.

The stylized foliage in the background of this design is similar to motifs used by William Morris, and it has been observed by recent design historians that de Morgan was the ceramic counterpart to Morris's textiles and wallpapers. This is not surprising since, apart from their friendship, they spent many hours together at the South Kensington Museum, studying Persian and Middle-Eastern designs and artefacts.

CREATED

London, England

MEDIUM

Earthenware, painted in ruby and yellow lustres

RELATED WORKS

Florianware by William Moorcroft, 1898–1905

William de Morgan *Born* 1839 London, England

Died 1917

De Morgan, William

Earthenware bottle, *c.* 1900

By the mid-1890s, William de Morgan was spending his winters in Florence, due to poor health. While there he would have seen Italian *Maiolica* wares (not to be confused with *Majolica* wares) that used tin glazes, a similar process to that used in England in the eighteenth century; so-called Delftware. Many items of Delftware employ intricate pattern-making and show the influence of its Hispano-Moresque origins. Clearly de Morgan was influenced by Delftware and *Maiolica*, but with the added richness of colour that he had seen in Persian design and Iznik earthenware.

A vigorous revival of pottery occurred in Persia in the late sixteenth century, following three centuries of Mongolian invasion and rule. *Safavid* potters developed new types of Chinese-influenced *Kubachi* – blue and white polychrome wares that included various shaped bottles and flasks from Isfahan. De Morgan produced a large number of vases and bottles, many of which were influenced by Persian design motifs and, although the shapes are uniquely his, they are clearly inspired by, if not influenced by, the Middle East. He produced a large number of bottles and vases in this style, although the designs, patterns and shapes changed. The ship is a recurring motif in de Morgan's designs.

CREATED

Sands End Pottery, London, England

MEDIUM

Earthenware, painted in lustre colours

RELATED WORKS

Designs for *Aesop's Fables* by Mintons & Co. China Works, *c.* 1885

William de Morgan *Born* 1839 London, England

Died 1917

De Morgan, William
Persian-style charger

The influence of Islamic pottery cannot be overstated in William de Morgan's work. During the mid-1870s he had studied Middle Eastern art and Islamic pottery and fabrics at the South Kensington Museum. Owen Jones's *The Grammar of Ornament* was a constant source of reference, with its six full-colour plates of Persian design motifs, and Persian influence can be seen in contemporary work at Minton's ceramic factory. Iznik (now Turkey) potteries were also influential to de Morgan. Its sixteenth-century designs incorporated a freer style of pattern making, devoid of perfect symmetry and arabesques, while maintaining a balanced pattern of stylized natural forms. They also introduced turquoise and sage green into the palette.

De Morgan employed a number of techniques to create his wares. One method used was the method of 'pouncing' a design, a traditional technique used by seventeenth-century Dutch tile makers to transfer a design on to the ware. The paper design was pinpricked, laid on to the slip-coated ware and then dusted with a black powder to outline the design, which was then 'filled in' before glazing. This process was ideal for one-off designs, but not for repetitive work such as tile making as it was labour-intensive.

CREATED

London, England

MEDIUM

Ceramic

RELATED WORKS

Earthenware dish by Lewis F. Day, 1877

William de Morgan *Born* 1839 London, England

Died 1917

De Morgan, William

BBB tiles, 1898

During his Florentine winters, William de Morgan employed Italian craftsmen to paint new patterns on tracing paper, under his supervision, which could then be sent to his Fulham factory for application in tile production. The tracing paper, containing the leading lines of the design, was pasted on to a piece of glass, the other side of which had a piece of thin tissue paper attached to it. By holding the 'sandwich' up to the light, the craftsman could then 'fill-in' the design with pigment, to a prescribed format, but still with a degree of artistic interpretation. The painted tissue was then placed onto the slip-faced tile with a sodium-silicate adhesive and sprinkled with powdered glaze. In the subsequent firing the tissue would be burnt off and fused with the glaze. At the time, this process was unique to de Morgan, and is consistent with Arts and Crafts ideals. Each tile was an individual interpretation of the design, while maintaining a uniformity necessary for the application of groups of tiles. Apart from sanitary applications, tiles such as these were used as decorative inserts for fireplaces. This design is known as '*BBB*' after a cast-iron fireplace manufacturer, Barnard, Bishop and Barnard.

CREATED

Sands End Pottery, London, England

MEDIUM

Earthenware, hand-painted decoration over white slip

RELATED WORKS

Majolica tiles by Minton Hollins and Co., 1895

William de Morgan *Born* 1839 London, England

Died 1917

De Morgan, William
Group of twenty tile designs

William de Morgan was probably the most prolific independent designer of tiles in the latter part of the nineteenth century. He was a close friend of William Morris, with whom he shared Ruskin's ideal of Arts and Crafts work based on the inspiration of nature. There were many changes that took place in the late nineteenth century, regarding natural history and man's understanding of strange and exotic creatures on other continents. The Victorians' understanding of animal and plant life came from visits to the newly created Natural History Museum, and the burgeoning quest for knowledge of far-flung lands came in the wake of Charles Darwin's *On the Origin of Species*, published in 1859.

De Morgan's designs with animals contrasted natural elements, as seen in, for example, the lizards, with stylized forms used in his depiction of lions. He often gave animals human traits, such as the frown on the ram's face, and sometimes they would be purely fanciful, as with the incisor-toothed hippopotamus. They could also be whimsical, as shown with the winking owl.

CREATED

London, England

MEDIUM

Watercolour and ink

William de Morgan *Born* 1839 London, England

Died 1917

Fisher, Alexander

The Peacock Sconce, c. 1899

An essential difference between a machine-made and a handmade object was the essence of the material and a craftsman's relationship with it. Alexander Fisher suggested that "he must get inside it, and live at ease there", in order to create an 'art' work rather than an artefact of factory fodder. For Fisher there was no separating the artist from the craftsman. Fisher was responsible for reintroducing the ancient craft of enamelling into Britain and teaching those skills to future generations. Until then, enamelling had been used by craftsmen such as Pugin, for example, simply as a way of colouring metal.

Fisher was trained as a painter and was also a goldsmith, but in 1886 he attended a lecture in London given by the French enameller Louis Dalpayrat. He subsequently stayed in Paris to learn all the skills of enamelling, and on his return to London set up his own workshops. He wanted to use enamels as a decorative device in place of the more expensive precious and semi-precious stones. Although much of his work was for wealthy clients, he also made everyday objects such as this sconce. It is designed using a peacock motif and with its curvilinear edge, is clearly appealing to the vogue for Art Nouveau.

CREATED

England

MEDIUM

Steel, brass and silver with enamel decoration

RELATED WORKS

Silver-plated tray by Paul Fallot, *c.* 1902

Alexander Fisher *Born* 1864 England

Died 1936

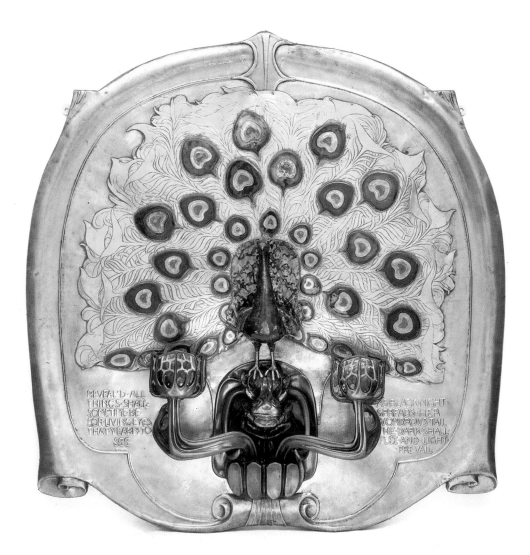

REVEAL'D·ALL·
THINGS·SHALL·
SOMETIME·BE·
FOR·LIVING·EYES·
THAT·YEARN·TO·
SEE·

AS·BLACK·NIGHT·
SPREADS·HER·
WONDROUS·TAIL·
THE·DARK·SHALL·
FLEE·AND·LIGHT·
PREVAIL·

Fisher, Alexander

The Wagner Girdle, 1896

The Wagner Girdle is probably Fisher's most famous piece, combining a number of medieval motifs and legends in one *tour de force*. The Girdle is a series of pictorial tableaux depicting scenes from Wagner's operas, including the tragic story of *Tristan and Isolde*, intricately painted in miniature in a late Pre-Raphaelite style, similar to that of Edward Burne-Jones, and enamelled. Enamelling involves the fusion of glass on to a metal base at a high temperature in a kiln. Historically most enamelling had been executed on gold or silver, but the Wagner Girdle is constructed of steel. It was made for Mrs (later Lady) Emslie Horniman.

Fisher remarked that, "the varieties of enamelling known as *champleve, cloisonné, baisse-taille, plique à jour* and Limoges painting I have mastered in turn... all these methods were used formerly before the present revival; but they were not so completely understood as they are today, nor were the whole methods practiced by any artist as they are now". The Wagner Girdle is an adaptation of the Limoges enamels of the Renaissance. Fisher believed that this approach was "the embodiment of thoughts, ideas, imaginings and for those parts of the world which exist only in our mind".

CREATED

London, England

MEDIUM

Steel with enamel

RELATED WORKS

Waist clasp by Oliver Baker, *c.* 1899

Alexander Fisher *Born* 1864 England

Died 1936

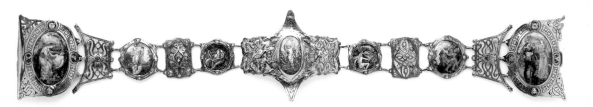

Dawson, Edith & Nelson
Pendant, 1900

As with many of the Arts and Crafts practitioners, Alexander Fisher was also a teacher, influential to a number of enamellers in the early twentieth century. He taught enamelling techniques at the newly formed Central School of Arts and Crafts from 1896 to 1898, and then from 1904 at his own school in Kensington. *The Studio* published a series of articles on Fisher's techniques, which were subsequently made into a book, *The Art of Enamelling Upon Metal* published in 1906. This book, which was a mix of instruction and historical reference, succeeded in introducing the skills of enamelling to a number of professionals, as well as amateurs who subsequently took up the craft as a pastime.

Among his students were Lady Gibson Carmichael, Phoebe Traquair and the Honourable Mrs Madeleine Wyndham, to whom Fisher dedicated his book. His most renowned student was Nelson Dawson, who taught his wife Edith, becoming one of the most celebrated husband-and-wife design teams in the Arts and Crafts era. Edith was also a keen botanist, and introduced floral motifs into her work.

CREATED

London, England

MEDIUM

Enamel, gold, amythyst and opal

RELATED WORKS

Cupid the Earth Upholder by Phoebe Traquair, 1902

Edith Dawson *Born* 1862 England

Died 1928

Nelson Dawson *Born* 1859 England

Died 1941

Fisher, Alexander
Morse, *c.* 1902

Fisher's design for this cope morse (a fastening for a cope, a sort of ecclesiastical cape), is based on a medieval precedent in terms of both the technique and the motif. The technique used is *champlevé* enamelling, in which a design is carved into the metal base, in this case gold, and then filled with a suitably coloured enamel paste. It is then polished until is level with the metal surface. *Champlevé* was originally used as a technique by the Celts and medieval enamellers, particularly in northern and central France where it was perfected in the Mosan enamels of the twelfth century, for use in reliquaries. This is highly significant to its use by Fisher as a symbolic religious object. The depiction of Christ is in a medieval style, complete with nimbus. He is also depicted on a cross that appears to emanate as a branch of the tree, a medieval legend that suggested the cross was made from the 'Tree of Knowledge' in the Garden of Eden.

Symbolism was important for Fisher, who held that "enamels should never be copies of anything in nature nor of any processes of painting in art. They should be creations".

CREATED

London, England

MEDIUM

Silver, gold and enamel

RELATED WORKS

Silver and enamel buckle by Jessie M. King, 1903

Alexander Fisher *Born* 1864 England

Died 1936

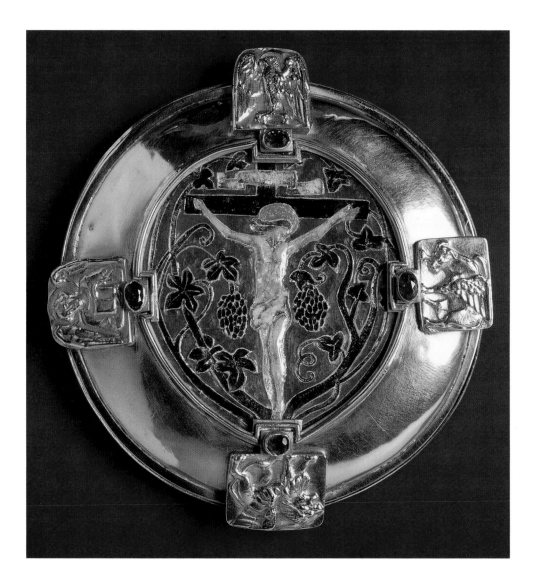

Benson, William
Candle holder, c. 1900

Unlike many other Arts and Crafts metalworkers, such as Charles Ashbee (1863–1942), William Benson designed but did not execute the work, preferring instead the high finish afforded by the machine. In that respect he is like Pugin, except that Benson's designs are much simpler and more functional, as befitting their domestic, rather than ecclesiastical, purpose.

Through his friendship with Edward Burne-Jones, Benson was introduced to William Morris who in turn persuaded him to set up a metal workshop in 1880. He subsequently opened a factory in Hammersmith, equipped with all the latest machine equipment, and then a shop in Bond Street selling his own products from about 1887. He was also selling many of his products through Morris and Co., for both retail and interior schemes, and in 1896, following Morris's death, Benson became the firm's managing director. The candlestick shown here is made of a base metal, such as copper, which has been silver plated by electrolysis. The design is clearly influenced by the taste for Art Nouveau, but the use of the heart motif is indebted to Charles Voysey who, like Benson, was a member of the Art Workers' Guild and the Arts and Crafts Exhibition Society.

CREATED
London, England

MEDIUM
Silver plate

RELATED WORKS
Cymric candle holder for Liberty and Co. by Alexander Knox, 1903

William Benson *Born* 1854 London, England
Died 1924

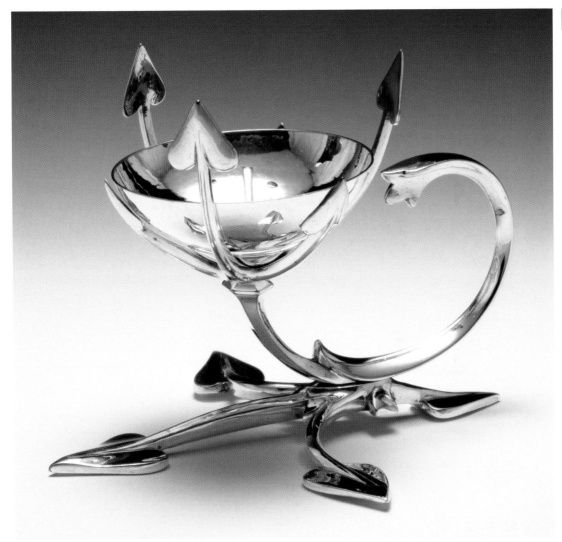

Benson, William

Chafing dish with cover, *c.* 1895

Although Benson subscribed to the machine aesthetic, his designs are seen as an integral part of the Arts and Crafts movement because of their adherence to the principle of honesty in construction. One can be left in no doubt as to the function of this chafing dish as revealed in its utilitarian aesthetic. In addition it is made of copper, a base metal, which serves a practical purpose as a good conductor of heat. The silver lining on the inside of the dish is purely functional to avoid the food being tainted while it is heating. The use of brass is also functional; being a slower conductor of heat, it allows the user to lift the tray and its lid without being burned.

One of the dilemmas faced by metalworkers, apart from the appropriateness of machine production, was the use of alloys and the casting of base metals. For example, why was it acceptable to cast gold but not iron? In Arts and Crafts practices much of this orthodoxy was challenged, with rules being arbitrarily made. Benson was no exception. His use of brass and copper as 'revealed' metalwork was unprecedented in British Arts and Crafts, although it was popular in America at this time.

CREATED

London, England

MEDIUM

Copper and brass, electroplate in silver on inside

RELATED WORKS

Silver-plated muffin dish by Charles Ashbee, 1904

William Benson *Born* 1854 London, England

Died 1924

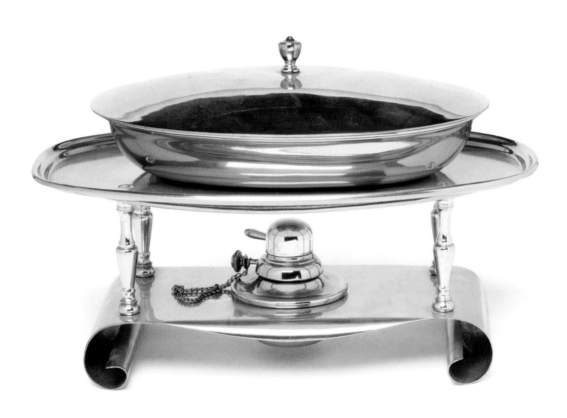

Benson, William

Tray, 1894

© Victoria & Albert Museum, 2005

In line with the pragmatic considerations Benson gave to his designs, this tray fulfils the criteria of functionalism, the ribbed dividers suggesting divisions for different foods while also acting as a decorative motif. The 'ribs' were created using a stamping press, once again revealing Benson's reliance on the machine as opposed to handcraft, providing a structural support to the base to prevent buckling. Benson was a very pragmatic designer, an aspirant engineer who sought practical solutions to design problems. He was the natural successor to Christopher Dresser (1834–1904), who in the previous decade produced a number of metalwork designs for domestic appliances that bear a similarity to Benson's, both in aesthetic and function.

In the twentieth century, Benson was even more committed to the notion of industrial design and became a founder member of the Design Industries Association, a group of, ostensibly, Arts and Crafts designers, who sought design reform along the modern lines of the *Deutscher Werkbund*. The DIA as it became known was, however, slow to adopt European Modernist design until the early 1930s.

CREATED

London, England

MEDIUM

Copper

RELATED WORKS

Silver tray for tea service by Josef Hoffman, 1903

William Benson *Born* 1854 London, England

Died 1924

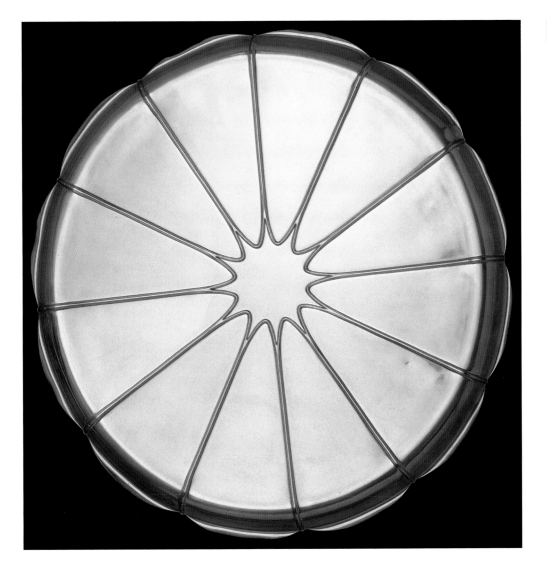

Benson, William
Electric table lamp, c. 1900

The advent of electric light enabled Benson to undertake a design with no historical precedent, in terms of solution or aesthetic. It was a modern phenomenon requiring a modern solution and there were a number of practical problems to solve. Questions regarding insulation materials, the reflective qualities necessary to provide adequate light and the lamp's stability, needed to be addressed. Through his work for Morris and Co., Benson was asked by Philip Webb to provide a number of standard and table-lamp fittings for the interior of Standen in Sussex, a house that Webb had designed in the last decade of the nineteenth century. Standen was one of the first private houses in England to be fitted with electricity and Webb had already designed the room light fittings, which were executed by the metalworking firm of John Pearson.

The design reformer Hermann Muthesius (1861–1927) published a number of articles in *Dekorative Kunst* in which he praised many of the Arts and Crafts designers including Benson, singling him out for his work on electrical fittings. He continued to praise him alongside other British designers in his influential book *Das Englische Haus*, published in 1904. Muthesius was instrumental in setting up the *Deutsche Werkbund* in 1907, which was so influential to subsequent European modern design.

CREATED

London, England

MEDIUM

Brass

RELATED WORKS

Drawing-room lights for Standen, Sussex by Philip Webb, 1890s

William Benson *Born* 1854 London, England

Died 1924

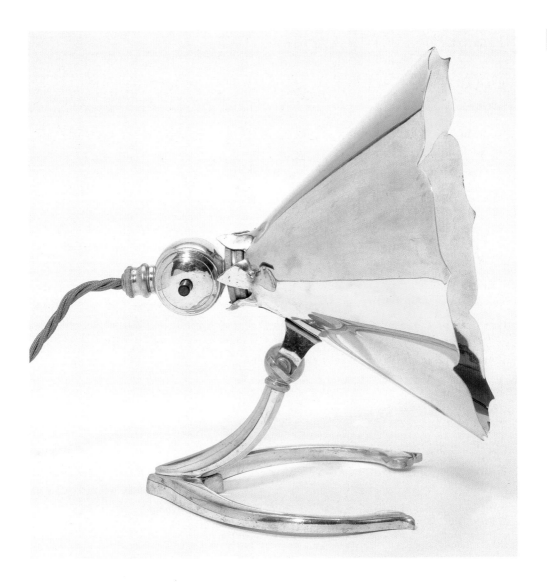

Benson, William

Coffee pot, *c.* 1910

It is interesting to compare Benson's coffee pot with Peter Behrens' (1868–1940) kettles of the same period, as both contain an element of handcraft in their handles. As participants in their respective design-reform organizations they were, however, to participate in very different design milieus. Behrens and the *Deutscher Werkbund* profoundly affected a progressive design aesthetic through Le Corbusier (1887–1965), Mies van der Rohe (1886–1969) and Walter Gropius (1883–1969), who were all in Behrens' practice in 1910. For Benson and the Decorative Industries Association it was a more conservative modernism, expressed through its Arts and Crafts heritage, that dominated British design until the 1930s.

Electroplating was used to prevent corrosion of the manufactured item and to give it an attractive finish, typically in silver or gold. A. W. N. Pugin and Christopher Dresser used the technology of electroplating in their metalwork designs, but, like Benson, they were not metalwork craftsmen. Charles Ashbee, the quintessential Arts and Crafts metalwork purist, would of course eschew its use. Nevertheless, the end of the nineteenth century was not just a period of Arts and Crafts ideals in a Ruskin sense, but a time of design reform that embraced the machine as just another tool of the designer.

CREATED

London, England

MEDIUM

Silver plated, cane handle

RELATED WORKS

Kettle for *Deutscher Werkbund* by Peter Behrens, 1909

William Benson *Born* 1854 London, England

Died 1924

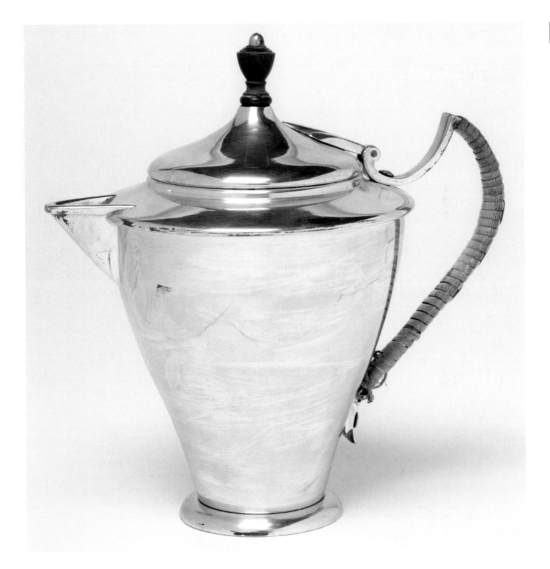

Leach, Bernard

Temmoku glazed vase, c. 1925–30

This vase was executed at the Leach Pottery, set up by Bernard Leach and Shoij Hamada (1894–1978) in 1920 to make a very distinctive range of Japanese traditional pots. Leach introduced a number of traditional techniques into 'art' pottery in Britain in this time, including some new glazes. Glazes were originally applied to pots as a vitreous coating to make vessels watertight, but they were also used for decoration. Glazes are made from silica, but because it has a very high melting point, it requires a flux to lower the temperature. The earliest type of glaze originated in China in the second century BC using lead oxide, but later glazes used oxides of other metals such as sodium. It was also discovered that these transparent glazes could be coloured to add to the effects.

The Temmoku glaze used by Leach originated from a Japanese term for the dark-brown glaze applied to stoneware pottery tea bowls imported from China. The term came to signify any iron-brown glaze applied to pottery of Chinese or Japanese origin. The shape of the bowl is similar to the flower vase and is used in Chinese tea ceremonies.

CREATED

St Ives, England

MEDIUM

Temmoku glazed earthenware

RELATED WORKS

Vase by W. Staite Murray, 1923

Bernard Leach *Born* 1887 Hong Kong

Died 1979

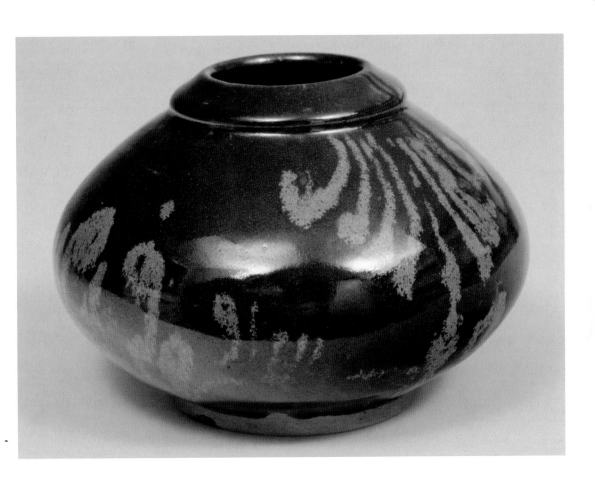

Hamada, Shoji

Persimmon-glazed stoneware dish

Hamada is responsible for introducing authentic Japanese, Chinese and Korean 'folk art' pottery into Britain, having travelled extensively and studied these ancient traditions in their respective regions. He brought most of this knowledge with him when he came to England in 1920 and helped set up the Leach Pottery in St Ives, which enabled him to practice his craft.

The persimmon (*Kakeimon*) glaze used by Hamada was developed over two hundred years following the discovery of kaolin (china clay) at Arita in Japan, which enabled potters to develop their own porcelain. By the early nineteenth century the Kakeimon family had developed more refined porcelain, using delicately painted asymmetric motifs, which enhanced the very prominent white ground. In Hamada's design this is reversed, with the asymmetrical white motif making the red ground prominent. Hamada never signed his work, although he signed their wooden containers. Hamada's approach to pottery is as important as the work itself, adopting a meditative philosophy that accorded him the title of 'Intangible Treasure' in Japan. He was influential to a whole generation of potters through his lectures and exhibitions.

CREATED

London, England

MEDIUM

Persimmon glazed stoneware

Shoji Hamada *Born* 1894 Tokyo, Japan

Died 1978

Ruskin Pottery

Group of earthenware vases and bowls, 1898–1935

© Haslam & Whiteway Ltd/www.bridgeman.co.uk

The Ruskin Pottery used *sang de boeuf*, a technique that originated in late seventeenth-century China, using copper. This glazing technique was used for some of their high-lustre wares, producing a deep plum-red iridescent lustre resembling oxblood. It was most effective on wares that had shoulders, since the glaze lay more thickly at the base, a result of the difficulties in firing.

The pottery was established in 1890 by William Howson Taylor (1876–1935) and his father, who set out to make unrivalled pottery. At first they used local clays but later imported china clay. The clay was finely and expertly thrown so that its thinness rivalled the finest porcelain. The wares were fired at very high temperatures and the oxygen was reduced as the glaze melted, so producing a violent reaction in the glaze that in turn altered the colour, somewhat unpredictably, to hues of red and purple. The Ruskin Pottery was also renowned for its 'flambé glazes'. On the death of Howson in 1935, the pottery closed down and his recipes and materials were all destroyed.

CREATED

Birmingham, England

MEDIUM

Earthenware

RELATED WORKS

Vases and dishes by William de Morgan, 1890s

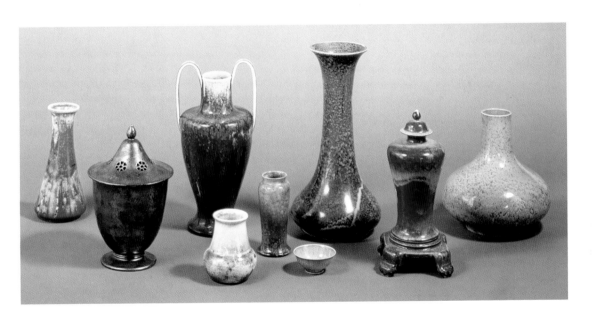

Moorcroft, William
Green and gold *Florian* vase, c. 1903

Just before the turn of the last century, Liberty and Co. introduced their best-selling *Florianware* range of vases and flowerpots, made by James MacIntyre and Co. and designed by their employee William Moorcroft. The design shapes are symmetrically Classical in nature, as emphasized in Liberty's catalogues of the period, but the motif pays homage to the Continental Art Nouveau style, as required for the Liberty and Co. clientele. The gold leaf motif was applied using 'honey gilding', a technique employed at the Sèvres porcelain factory during the eighteenth century. The process involved grinding up the gold leaf, applying it with a brush and then subjecting it to a light firing. It was more durable and softer in tone than the traditional size gilding of leaf.

After Moorcroft opened his own pottery in 1913, much of the capital needed was supplied by Liberty's, who in return controlled much of the voting shares of the company. Consequently they were able strictly to control production, design and stock. Moorcroft continued to supply Liberty's through the 1920s and 1930s, when their style became much brighter after the development of their 'flambé glazes'.

CREATED

England

MEDIUM

Earthenware

RELATED WORKS

Items by Pilkington's Lancastrian Pottery

William Moorcroft *Born* 1873 Burslem, England

Died 1945

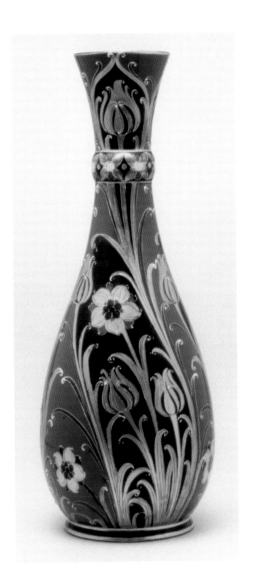

Rathbone, Harold

Gideon design for the Della Robbia Pottery, *c.* 1900

Although this design is correctly attributed to Harold Rathbone, the reverse of the ceramic is inscribed 'after Madox Brown', a reference to the Pre-Raphaelite artist. Brown's design was used in a secular stained-glass window for Morris and Co. in which he depicted Sir Lancelot for a scheme in the music room at Harden Grange in Yorkshire, one of 13 windows depicting *The Story of Tristram*. In the same year, 1862, Ford Madox Brown (1821–93) adapted the same motif for use in another stained-glass window at St Michael-on-the-Hill Church in Scarborough, in which the figure was transformed into Gideon, an Old Testament hero of the Israelites. In essence the only real change was the addition of a nimbus.

The ceramic suggests an attempt by Della Robbia to combine a number of design influences popular in the second half of the nineteenth century with a trend for Art Nouveau. From 1850 on, *majolica* wares became popular, with their use of heavy-coloured glazes that emphasized gold (yellow) and green, as well as a William Morris-inspired use of a medieval motif, in this case the knight.

CREATED

England

MEDIUM

Ceramic

RELATED WORKS

Tiles for Minton by Louis Salon, 1890

Harold Rathbone *Born* 1858 England

Died 1929

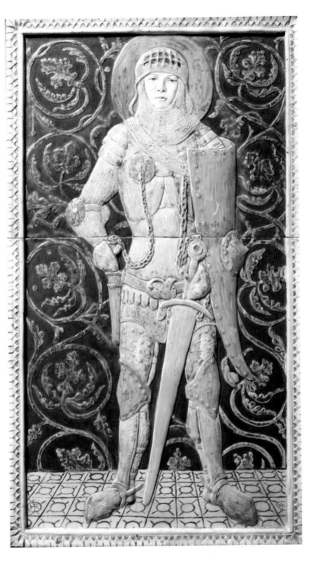

Hansen, Frida

Door curtain, (detail) 1900

As with their Scandinavian counterparts, Sweden, Finland and Denmark, Norway sought its own cultural identity through identifying with its heritage. In 1894 the *Folkmuseet* opened in Oslo, as a point of reference for Norwegian designers and craftspeople. The discovery of Viking ships in Norway in 1867 had fuelled a 'Viking revival' as part of the search for that cultural identity that separated them from other Scandinavians. There were a number of 'revival' items made in both iron and wood, which simulated medieval precedents in much the same way as the Gothic revivalists had done in England.

Woven textiles formed an important part of the craft tradition that Norwegians sought to preserve. Frida Hansen enjoyed success with her woven textiles at the Expositions in Paris (1900) and Turin (1902). At the first Scandinavian Exposition in 1897 she showed *Pentecostal Choir,* based on the Symbolist paintings of Maurice Denis (1870–1943). Hansen developed a highly innovative way of weaving that left many of the warp threads open, allowing the light to pass through the tapestry. Her work at home was, however, overshadowed by her contemporary Gerhard Munthe (1849–1929), whose narrative tapestries were considered 'more Norwegian' than Hansen's.

CREATED

Norway

MEDIUM

Tapestry using hand-dyed wools

RELATED WORKS

The Golden Hair by Gerhard Munthe, 1899

Frida Hansen *Born* 1855 Norway

Died 1935

Author Biographies

Michael Robinson (author)

Michael Robinson is a freelance lecturer and writer on British art and design history. Originally an art dealer with his own provincial gallery in Sussex, he entered academic life by way of a career change, having gained a first-class honours and Masters degree at Kingston University, Middlesex. He is currently working on his doctorate, a study of early modernist period British dealers. He continues to lecture on British and French art of the Modern period.

David Rudd (foreword)

David Rudd of Dalton's American Decorative Arts has been a dealer of decorative arts in Syracuse, New York since 1980, specializing in Gustav Stickley and the American Arts & Crafts movement. Mr Rudd studied art history, design, sculpture and photography at the State University of Buffalo and Syracuse University, USA. He has been consultant to several museums and major auction houses. In 1993 he was instrumental in starting the Arts & Crafts Society of Central New York and is president of its board of directors.

Picture Credits: Prelims & Introduction

Further Reading

Anscombe, I., *Arts and Crafts Style*, Phaidon Press, London, 1991

Atterbury, P. & Wainwright, C., *Pugin*, Yale University Press, New Haven and London, 1994

Barnard, J., *Victorian Ceramic Tiles*, Studio Vista, London, 1972

Comino, M., *Gimson and the Barnsleys*, Evans Bros, London, 1980

Cooper, J., *Victorian and Edwardian Furniture from the Gothic Revival to Art Nouveau*, Thames and Hudson, London, 1987

Crawford, A., *C. R. Ashbee , Architect, Designer & Romantic Socialist*, Yale University Press, New Haven and London, 1985

Cumming, E. & Kaplan, W., *The Arts and Crafts Movement*, Thames and Hudson, London, 1991

Durant, S., *Christopher Dresser*, Academy Editions, London, 1993

Greensted, M., *Gimson and the Barnsleys*, Alan Sutton, Stroud, 1991

Greenwood, M., *The Designs of William De Morgan*, Richard Dennis and William E. Wiltshire III, Ilminster, 1989

Hackney, F. & I., *The Art of Charles Rennie Mackintosh*, Silverdale Books, Leicester, 2004

Haigh, D., *Baillie-Scott, The Artistic House*, Academy Editions, London, 1995

Hanks, D. A., *The Decorative Designs of Frank Lloyd Wright*, Dutton, New York, 1979

Hitchmough, W., *C. F. A. Voysey*, Phaidon Press, London, 1995

Hogben, C., *The Art of Bernard Leach*, Faber, London, 1978

Kallir, J., *Viennese Design and the Wiener Werkstätte*, Thames and Hudson, London, 1986

Kaplan, W., *The Arts and Crafts Movement in Europe and America*, Thames and Hudson, London, 2004

Lewis, G., *A Collectors History of English Pottery*, Antique Collectors Club, Woodbridge, 1999.

MacCarthy, F., *The Simple Life , C. R. Ashbee in the Cotswolds*, Lund Humphries, London, 1981

Naylor, G., *The Arts and Crafts Movement – Its Sources, Ideals and Influence*, Studio Vista, London, 1971

Newton, C., *Victorian Designs for the Home*, V & A Publications, London, 1999

Parry, L., *William Morris*, Philip Wilson and the Victoria and Albert Museum, London, 1996

Parry, L, *The Victoria and Albert Museum's Textile Collection, 1850–1900*, V & A Publications, London, 1993

Rubens, G., *William Richard Lethaby, His Life and Work 1857–1931*, Architectural Press, London, 1986

Sembach, K., *Art Nouveau*, Taschen, Germany, 1999

Smith, M. A., *Gustav Stickley – The Craftsman*, Syracuse University Press, Syracuse, 1983

Spencer, I., *Walter Crane*, Studio Vista, London, 1975

Stansky, P., *William Morris, C. R. Ashbee and the Arts and Crafts*, Nine Elms, London, 1984

Thompson, P., *The Work of William Morris*, Oxford University Press, Oxford, 1993

Tilbrook, A.J., *The Designs of Archibald Knox for Liberty and Co.*, Ornament Press, London, 1976

Index by Work

General Index